Highland Living

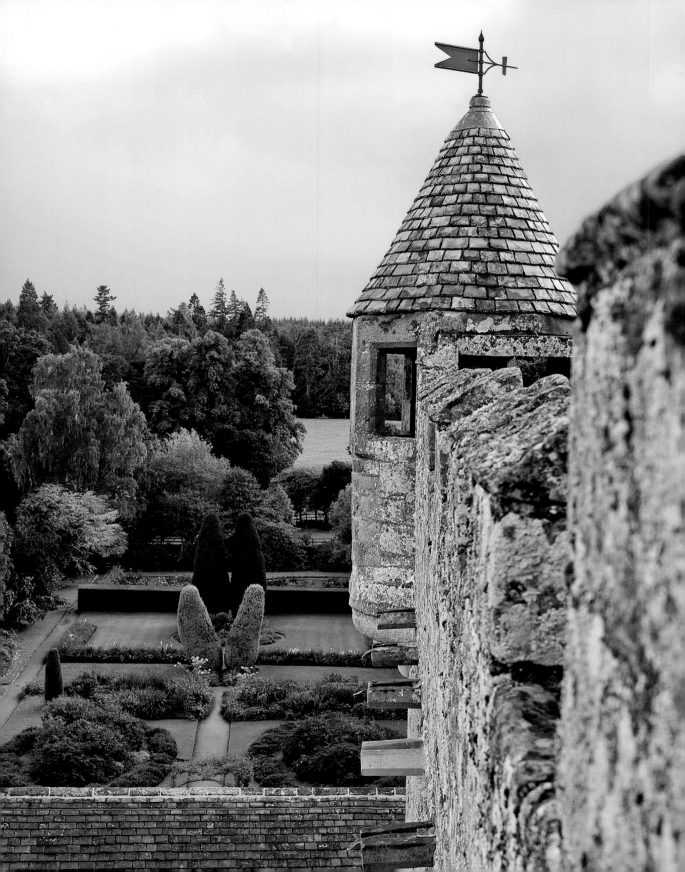

Stéphane Bern and Franck Ferrand
Photographs by Guillaume de Laubier

Highland Living
Landscape, Style, and Traditions of Scotland

Foreword by Angelika Cawdor

Flammarion

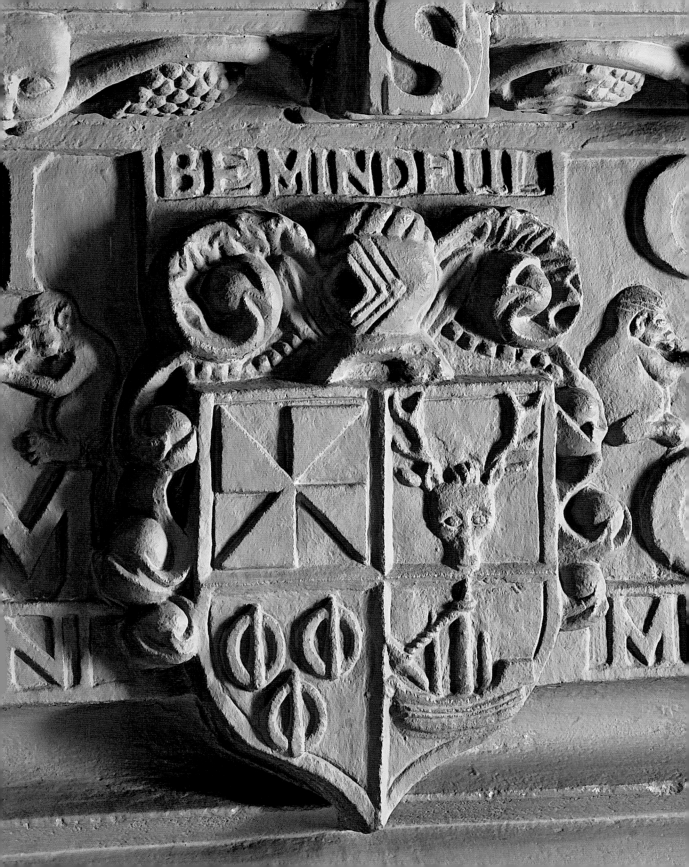

To Hugh

Angelika

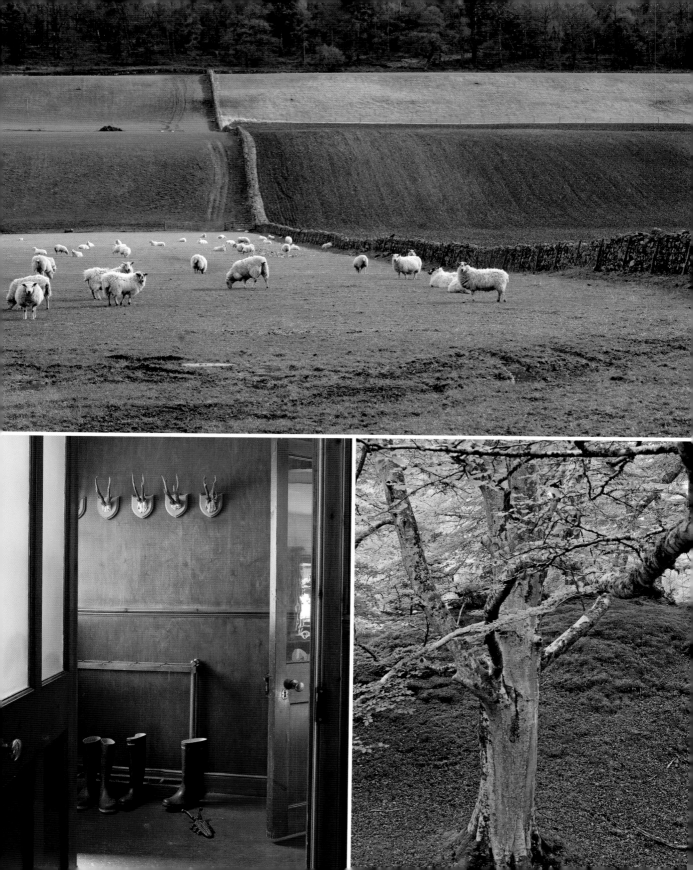

{ CONTENTS }

MY HEART'S IN THE HIGHLANDS
by Robert Burns

My heart's in the Highlands, my heart is not here,
My heart's in the Highlands a-chasing the deer—
A-chasing the wild deer, and following the roe;
My heart's in the Highlands, wherever I go.

Farewell to the Highlands, farewell to the North
The birth place of Valour, the country of Worth;
Wherever I wander, wherever I rove,
The hills of the Highlands for ever I love.

Farewell to the mountains high cover'd with snow;
Farewell to the straths and green valleys below;
Farewell to the forests and wild-hanging woods;
Farewell to the torrents and loud-pouring floods.

My heart's in the Highlands, my heart is not here,
My heart's in the Highlands a-chasing the deer—
Chasing the wild deer, and following the roe;
My heart's in the Highlands, wherever I go.

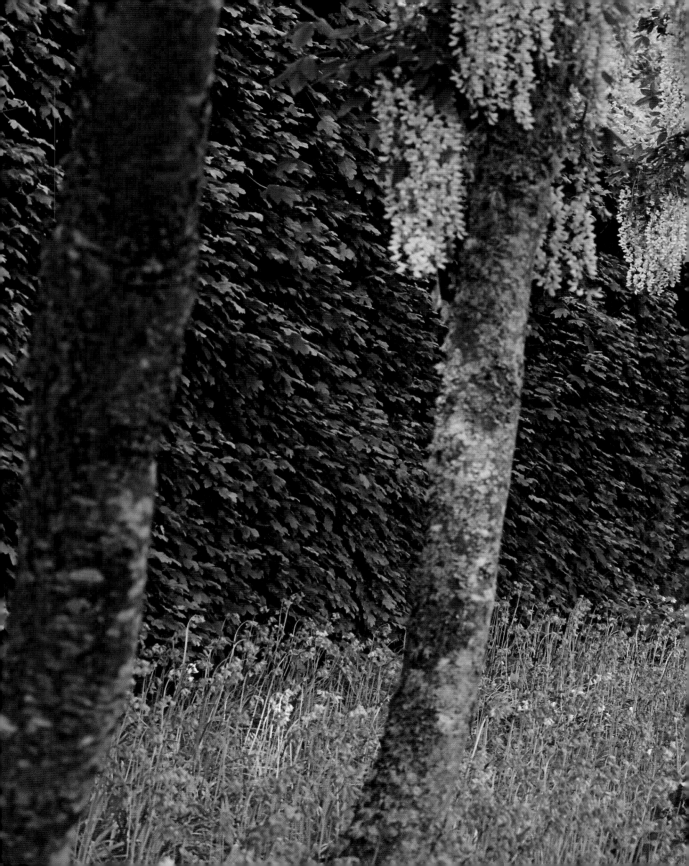

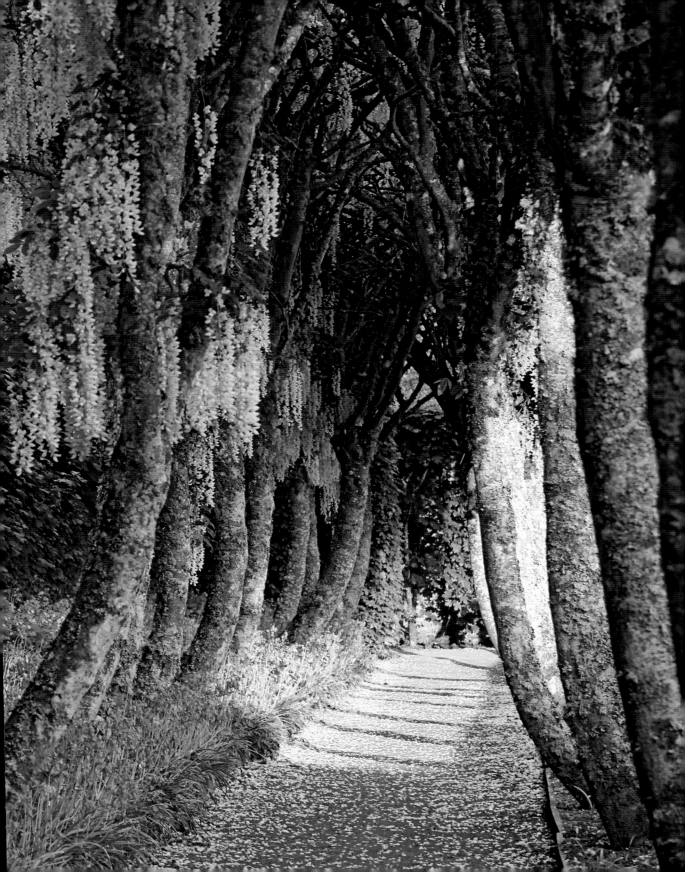

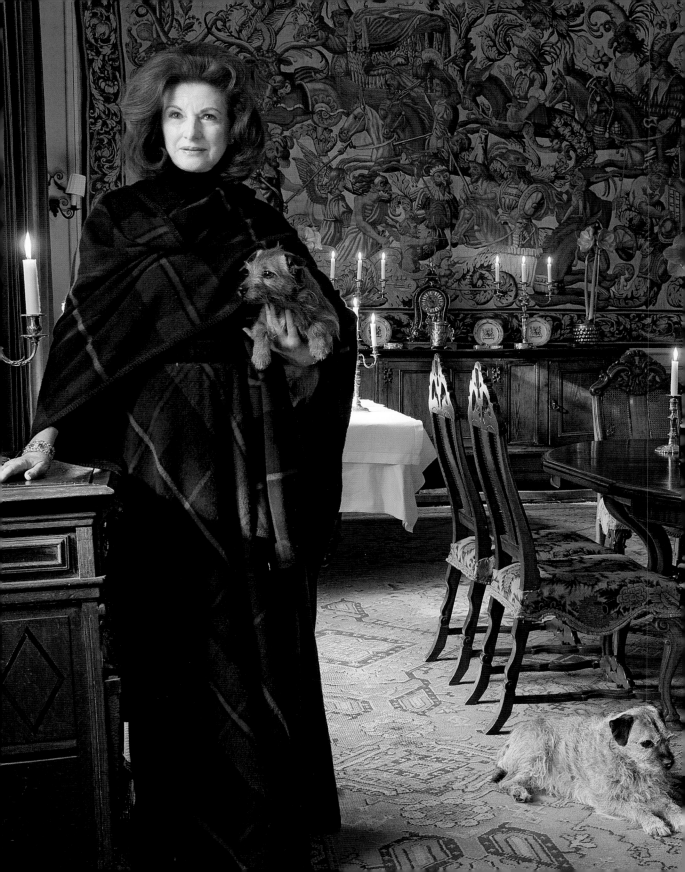

"Scotland, my dear girl"

P aris, in the 1960s … My younger self was preparing to sacrifice a portion of her savings, to buy one of the latest creations by Coco Chanel: a tweed and mohair suit in sublime, unexpected colors, a dissonant harmony of moss green and fire—exquisite in its perfection. The scene was a boutique on rue Cambon. Enter "Mademoiselle Coco" herself to supervise my fitting. Dazzled by the stunning, unprecedented color combination, I dared to ask where she had found the inspiration for the piece. I can still hear her answer: "*L'Écosse, ma chère!*"—"In Scotland, my dear girl!"

I was surprised to hear this at the time. I knew, of course, that Mademoiselle Chanel had traveled to Scotland in the past with her lover, the Duke of Westminster; it was even rumored that after a more than usually heated argument, she had thrown her pearl necklace into the waters of Loch Ness. But to me, the connection between Scotland and my Chanel suit was still not immediately apparent.

Only much later, walking through the flowering heather in the Cairngorm mountains, did I realize just how accurate the comparison was. Many readers will know the stunning beauty and intoxicating colors of the waking Scottish landscape in the golden spring sunshine. The Highlands exert a particular, enchanting magic that nothing can ever replace, once you have made it your own. For thirty years, I have lived under the delightful spell cast by Cawdor Castle.

I love everything about this place: the distant blue crest of the moors; the foliage of the ancient oaks in the Big Wood; the pure waters that allow for the distilling of whisky, and the washing and plumping of wool; the familiar silhouettes of the Highland cattle, the Scottish Hebridean sheep—totally black and sporting four horns; the dizzying views

from the castle watchtowers over the flowerbeds and topiary in the Flower Garden; the perspective across the symbolic gardens, the peat bricks burning brightly in the drawing-room fireplace, beneath the gaze of a host of painted Thanes—and of course, the indistinct, charming presence of the household ghosts. Yes, everything about Cawdor delights me, even the tragic story of Macbeth, immortalized by Shakespeare, of whom my father-in-law used to say: "Ah, if only the Bard hadn't written that damned play!" For my part, I thank him daily for being the finest copywriter imaginable.

Yes, Cawdor might well stand as the epitome of all things Scottish, or better—the quintessence of the Scottish soul. I think of houses like this as living beings in their own right: it follows naturally that we should not try to alter them. We are only ever their custodians. We should respect the heritage of the people who built, embellished, transformed, and restored them. And we should preserve that which has come down to us from so many generations.

When my husband died in 1993, I carried on his work at Cawdor. The task was immense, and I accepted it with a heavy heart; but at the same time, what could be more fulfilling than to carry forward the work of over six centuries? I see myself as the latest link in a long, uninterrupted chain.

As for Mademoiselle Coco, I often like to think that it was at Cawdor Castle—its walls carved with the cipher of the Campbells of Cawdor: an interlocking double C—that she found the inspiration for the logo that would make her fortune. Long may her house prosper; as long as our ancient stones.

Angelika Cawdor

The Dowager Countess Cawdor

Cawdor lends itself to striking visual effects and perspectives, as when looking toward the Flower Garden from the moss-covered battlements (page 2). Page 4: Detail of the drawing-room mantelpiece, commemorating the marriage of Muriel Cawdor and John Campbell in 1510. The carving includes the Cawdor family motto, "Be Mindful." A path in the gardens, lined with Scottish laburnum and a carpet of bluebells (pages 10–11). Page 12: Lady Angelika Cawdor, photographed in the Dining Room with her dogs Bessie and Kim. Lady Cawdor wears a Campbell of Cawdor tartan ensemble, designed by her friend Hubert de Givenchy. The shadowy reflection of the castle's west façade floats on the surface of Cawdor Burn, the estate's crystalline stream (facing page).

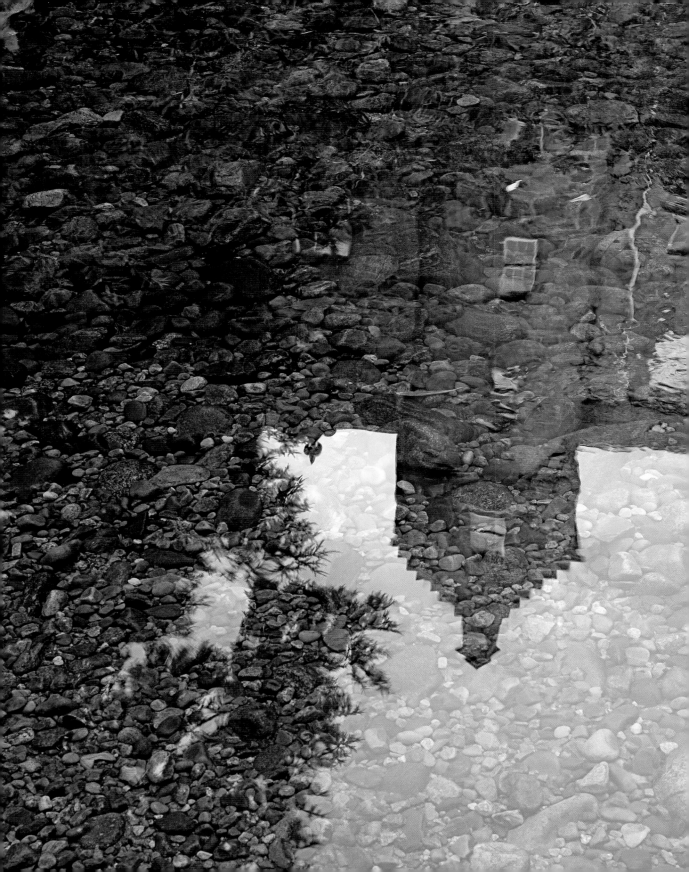

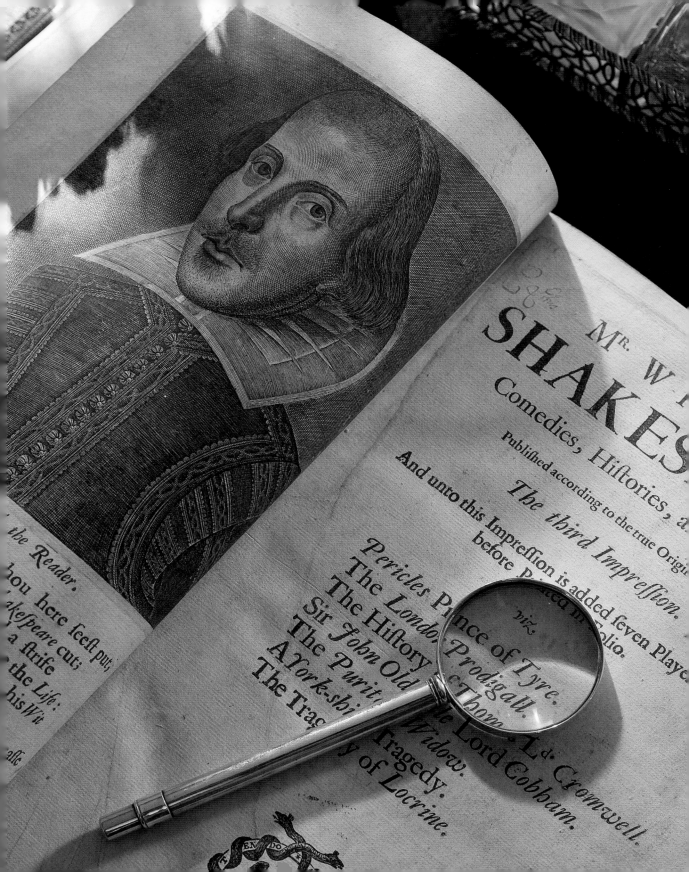

In the Land of Macbeth

A strange legend has been handed down in the family since the fourteenth century. The Thane of Cawdor (who was, at that time, the laird of the fortress of Old Calder, half a mile from the present castle) is said to have received instructions from an oracle in a dream: he should place his gold in a chest, load the chest onto the back of a donkey, follow the animal until nightfall and build a house on the spot where he slept for the night. In this way, the family would find a haven from danger. And this the Thane did. The donkey stopped at the foot of a thornbush— a hawthorn tree, according to the legend—and soon a tower and a splendid keep were built on the very spot.

The tree still exists at the heart of Cawdor Castle, apparently standing on a rock. The medieval builders were, it seems, careful to shelter the tree beneath the vaulted roof of a dark room. Deprived of light, the tree naturally weakened and died; but its stunted trunk remains, as if petrified, testifying to the legend.

"Hugh, my husband, would never have dreamt of telling such a fanciful, romantic tale to our visitors," says Lady Cawdor, the castle's present owner. "But science has provided the evidence he sought." Carbon dating has indeed confirmed the tree's great age: it died around 1372. According to the archives, the keep at Cawdor was built between 1370 and 1380 so the story that has passed down through generations of the family would appear to be corroborated.

Further analysis by dendrologists from Kew Gardens has identified the tree not as a hawthorn, but a holly, reputed at the time for its therapeutic properties, together with oak and mountain ash. Symbolic of life and good fortune, holly trees were thought to protect homes from being struck by lightning, as well as from the demons and fairies that, as everyone knows, haunt the Scottish moors.

In the Highlands, the supernatural is a part of everyday life. So much so that attempts have been made to encourage the ancient tree fragment to "talk." A medium has spent long hours working on the case. "Two paces from the old holly tree," he concluded, "was the tomb of a young hermit—a kind of local saint—who died from wounds to his left leg inflicted by a wild boar. Shortly afterwards, the tomb began to receive regular visits from an elderly man from the northeast, accompanied by two knights with very long swords. The old man often came to reflect and pray at the tombside." Disconcertingly, the original fortress of Old Calder lay to the northeast of the site. According to the medium, the knight-pilgrim was "a kingly figure" who exercised absolute rule over his lands. Might he have been the Thane of Cawdor?

The worn morocco leather of the castle's guest book (facing page), begun in 1889 and including the signatures of several British monarchs, Japanese emperors, eminent politicians, and film stars—Sophia Loren signed her name alongside Harold Macmillan. Shakespeare's signature does not grace the guest book, but the house holds a number of fine editions of his works (page 16), including (of course) the "Scottish play" *Macbeth*.

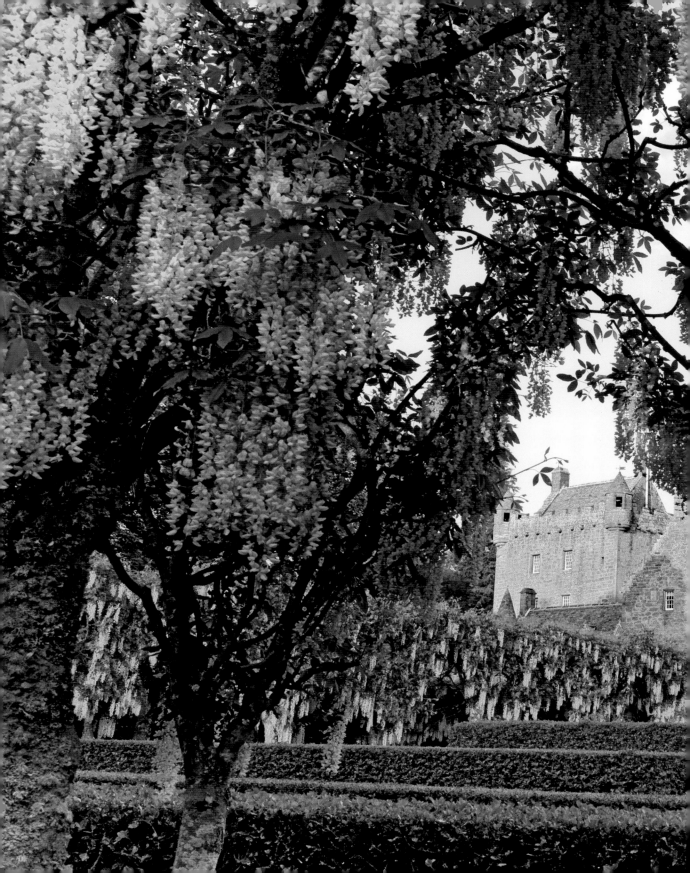

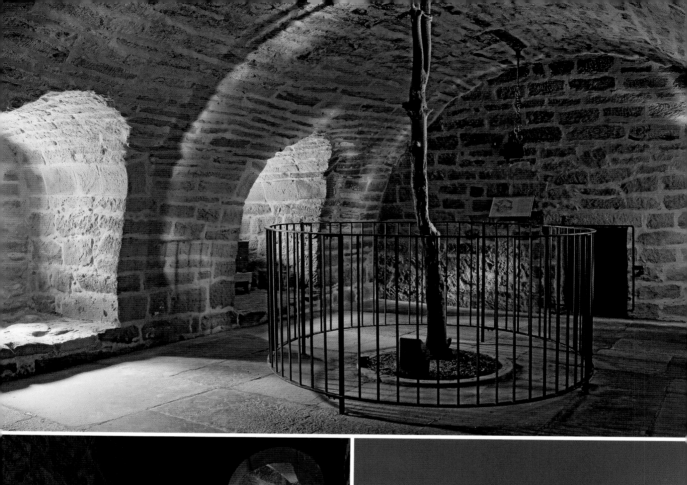
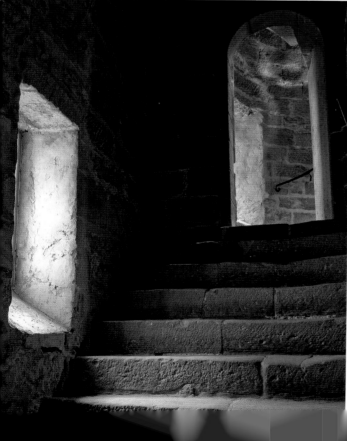

Near the old holly tree, a cavity yawns behind the heavy iron gates brought from the seat of the Murray clan at Lochindorb Castle. The void lay undiscovered until 1979. Then, during work to redress the mortar joints in the wall, a metal rod was inserted into the full thickness of the wall to test the solidity of the masonry; empty space was found within. Intrigued, Hugh, the 6th Earl Cawdor, had a small door drilled into the wall, revealing an "oubliette," or sealed cell, measuring 6 ½ by 13 feet (2 x 4 meters), some 10 feet (3 meters) high. The cell had doubtless been walled up after the fire of October 1819, and since forgotten: previously, it could be reached only by means of a trapdoor leading from the side of the present Tower Sitting Room. Items found in the room—chiefly toys and crockery—suggest that it was later used as a refuge by the castle's women and children in times of crisis.

This is all hypothesis, of course, but such is the charm of ancient houses: they have the power to stir the imagination and fuel new research that often seems to corroborate ancestral legends, handed down by word of mouth through the generations.

Cawdor, in Gaelic, means "wooded stream." The name has various spellings—often "Calder," or "Kauder." Originally, the lairds of Calder were provosts and hereditary sheriffs of the royal castle at Nairn. They bore the Nordic title of "thane." For the Vikings, a *thegn* was a "devoted servant of the king." But what of the hereditary title of thane in Scotland, where it is used by just three families today: those of Cawdor, Glamis, and Brodie? The rank corresponds roughly to that of a feudal baron, linked to the Crown

The ancient guardian holly tree, dead for more than six hundred years, corroborates and perpetuates the legend of the castle's founding. The iron grille surrounding it, dating from the thirteenth century, comes from Lochindorb Castle, destroyed long ago by royal command. The staircase is unchanged since it was built in 1370. These dark rooms contrast with the exterior of the castle in spring, glowing rose pink amid the bright yellow laburnums (pages 20–21).

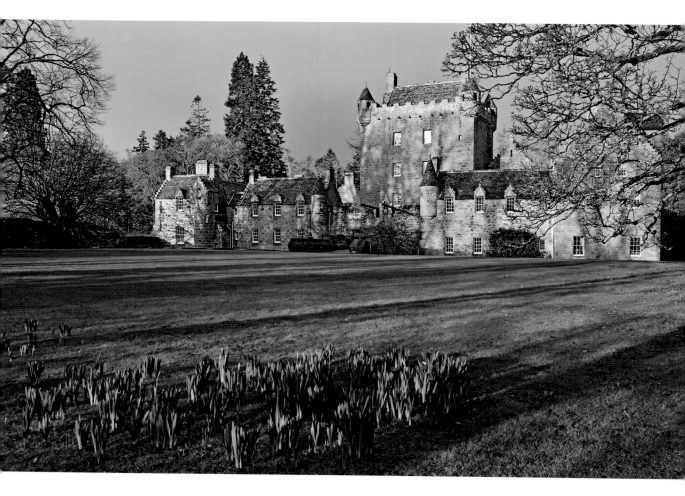

(of Scotland), whose land he holds in stewardship. This privileged personal connection to the king is important: the thane was the sovereign's representative, administrator, and proxy judge. Thanes had the right to exert high and low justice within their lands—in other words, they had the power to pass a sentence of death, and to spare the lives of those they chose. But they were not only high-ranking royal administrators. In a Scotland ruled by the clan system—loose federations of vast families claiming descent from a common ancestor—the thanes were above all powerful clan chiefs.

"The Thane of Cawdor lives, a prosperous gentleman." With these words, Shakespeare's Macbeth answers the witches' prophecy—that he will himself take the title as reward for his victories over the Norwegians. And before killing his cousin King Duncan of Scotland, near Elgin in 1040, the real-life Macbeth may have used the title Thane of Cawdor. In the eyes of the current Dowager Countess of Cawdor, Shakespeare's tragic antihero, a weak man consumed by guilt and manipulated by his wife, is an exaggerated portrait:

The castle's east façade, dominated by the powerful fourteenth century keep, includes numerous nineteenth century additions (above and following pages), notably the dormer windows, their pediments carved with the hunting arms of the Cawdor family (facing page, left). Here, everything is the product of centuries of care, including the surviving avenue of ash trees, near Auchindoune (pages 24–25).

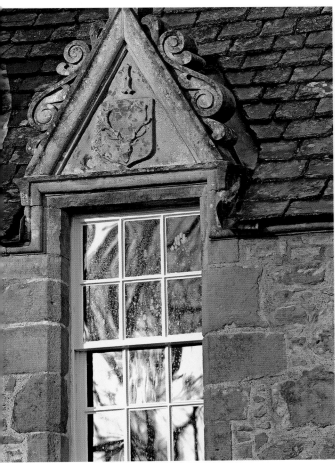
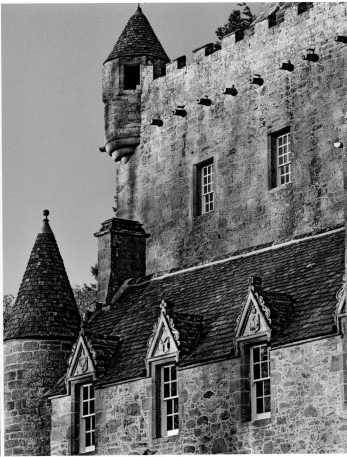

"I think Macbeth was one of the best kings that Scotland ever had. In reality, Macbeth reigned for seventeen years—seventeen years that were, to my mind, a golden age for Scotland. When Duncan's son Malcolm returned home from England to take his revenge on Macbeth and kill him, the Scottish people suffered enormous grief. It was only later that his reputation was ruined by this otherwise extraordinary playwright!" Not everyone can claim the Bard of Avon as their chief copywriter.

Lady Cawdor remembers her honeymoon in Burma with Hugh, the 6th Earl and 24th Thane of Cawdor, in 1979. "We arrived at 2 a.m. in the reception area of a hotel in Rangoon. A little man leaped out from behind the desk, thoroughly excited, and asked my husband: 'Are you the Thane of Cawdor?' The poor man was an ardent reader of Shakespeare. He had been waiting for us all evening and half the night."

Macbeth's descendant had met Angelika three years earlier. "In 1976, I was on a tour of Scotland with a Spanish friend, and we planned to visit our friend Sheila de Rochambeau who rents Drynachan, Cawdor's hunting lodge, every year. That year, she had broken with tradition and rented the little castle of Dalcross, where we arrived late in the evening. The courtyard was filled with people, including a priest—I thought it was a funeral party. 'Is someone

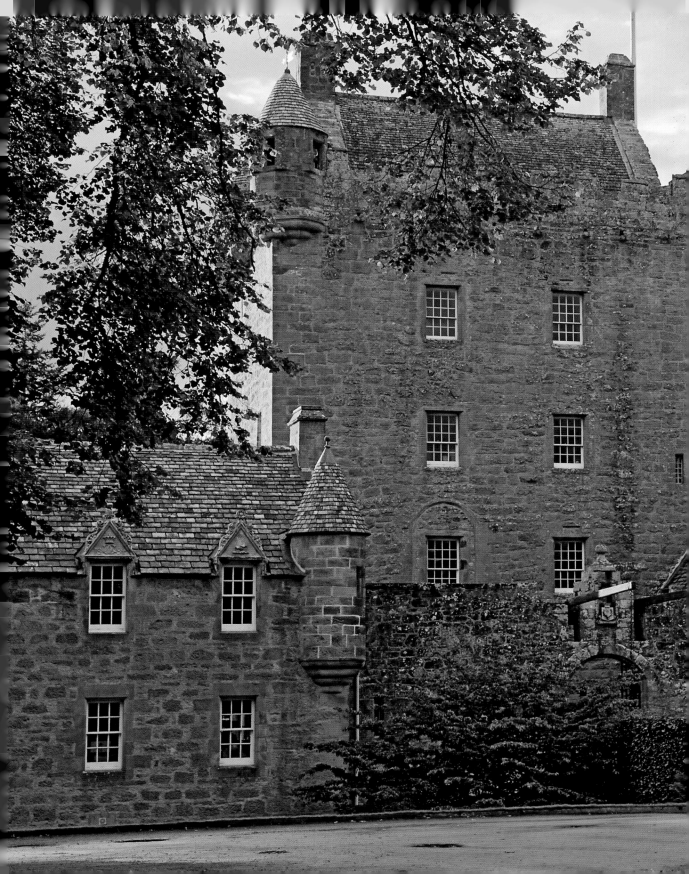

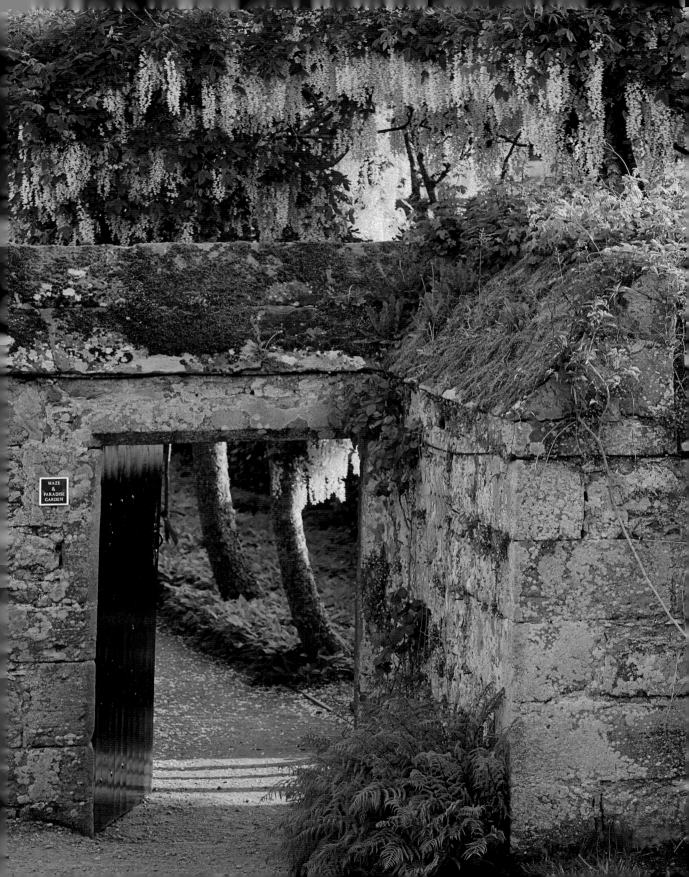

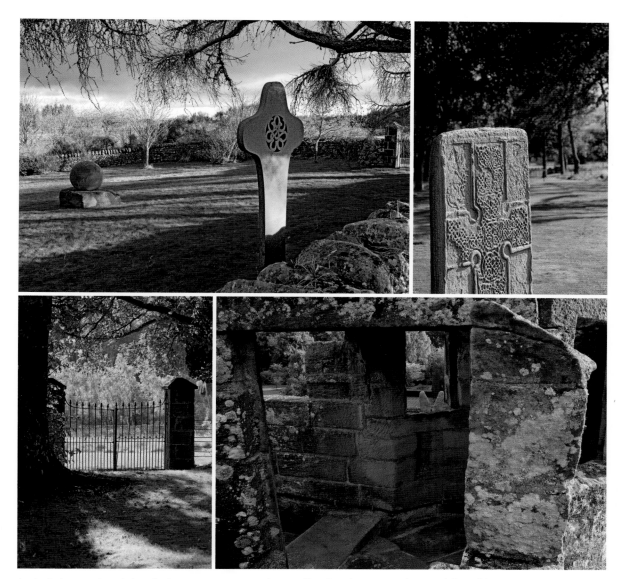

Ancient stonework and abundant greenery are everywhere at Cawdor; the contrast is especially striking at the approach to the old Walled Garden (facing page), and in the old and new cemeteries at Berivan, on the estate. The modern Celtic cross (above) is in Welsh slate—recalling the family's other property, in Pembrokeshire. Its inscription, "God is Love," is a tribute from Lady Cawdor to her husband. Medicinal plants and aromatic herbs used in the fifteenth century flourish in a formal framework of ancient box hedges, planted in Elizabethan times (pages 32–33).

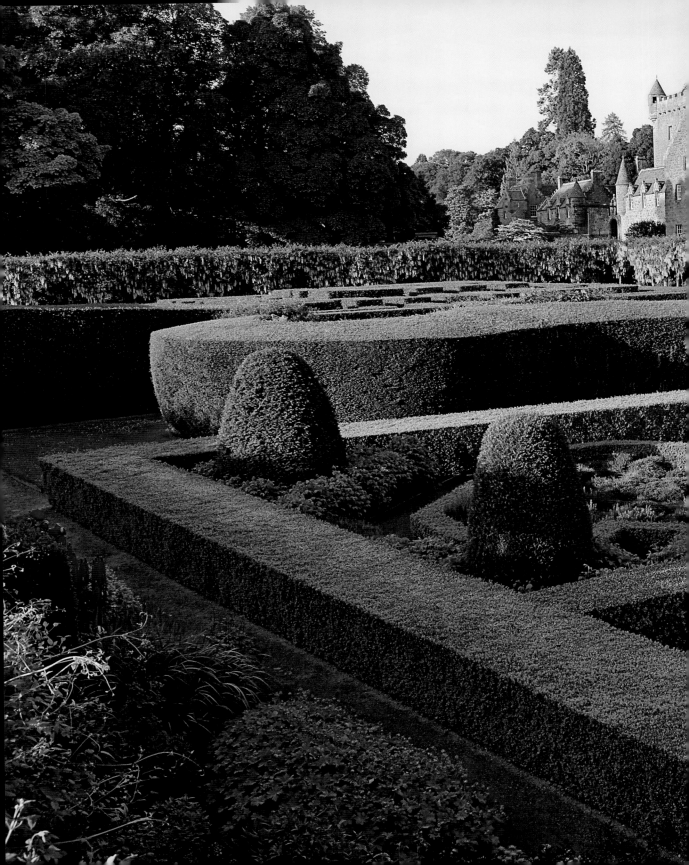

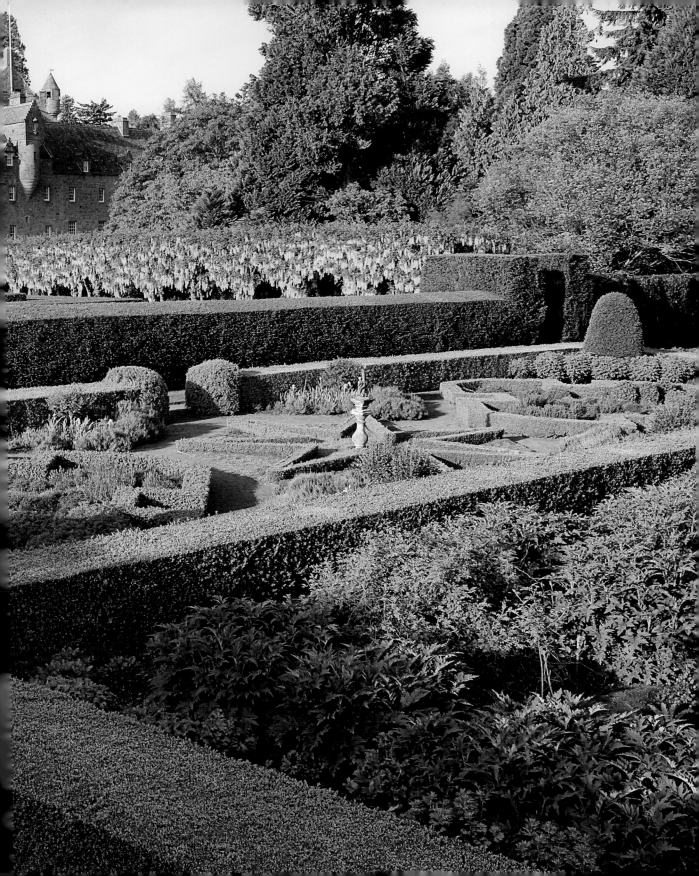

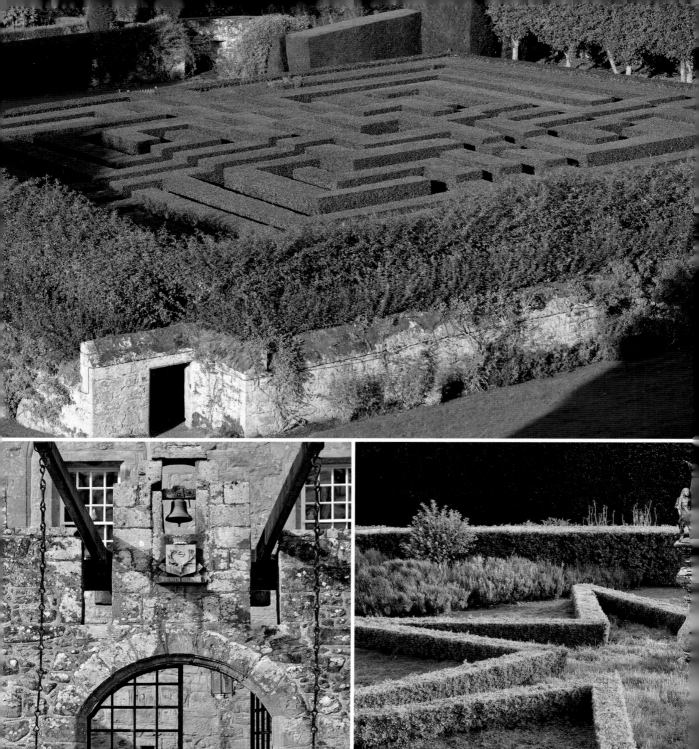
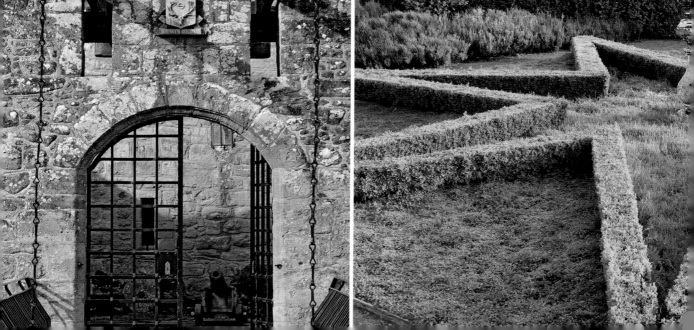

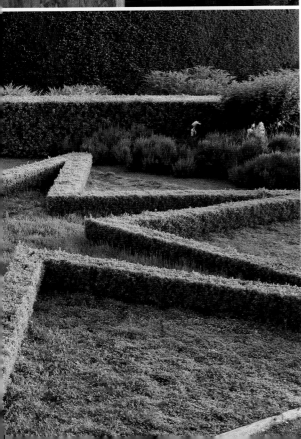

dead?' I asked. 'Worse,' came the reply, 'a ghost has sat on the bed in the Blue Bedroom.' The room that just been assigned to me...."

"That night, at dinner, I was seated next to a certain Hugh Cawdor." Two years later, at London's Heathrow Airport, Angelika was approached by her erstwhile dinner companion, whom she had almost forgotten. His opening line was hardly original:

"I think we have met before."

"If you don't have something more interesting to say...."

"No really, it was at Dalcross Castle. My name is Hugh Cawdor."

The couple dined together that night in London and met again in Paris two days later.

"Hugh might not have fallen in love with me, or with Paris, if I hadn't been living in paradise. My friends Hélène and Michel David-Weil had very generously offered me the ground-floor apartment of their town house. My last years in Paris were serenaded by the nightingales in their garden."

One year later, on December 28, 1979, they were married in Deauville, at the home of Anne d'Ornano.

"My girlfriends warned me," says Angelika: "'You must be mad to marry a man who already has five children and more mistresses than the roses in his garden!' But I was in love, and I knew that if I didn't take the plunge this time, I would regret it for the rest of my life. I had waited too long, afraid to commit myself. I had always lived so freely!"

Cawdor's gardens appeal to the intellect and senses alike. The seven points of the star at the heart of the symbolic gardens (left) evoke the seven days of Creation, or the "seven kingdoms": earth, air, fire, water, plants, animals, and humans. The holly labyrinth (facing page, top)—holly is omnipresent at Cawdor—was inspired by a Roman mosaic floor found at Conimbriga in Portugal, based on the labyrinth at Knossos. The motif is said to have been devised by Daedalus.

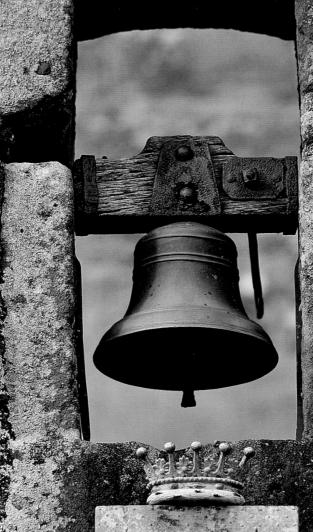

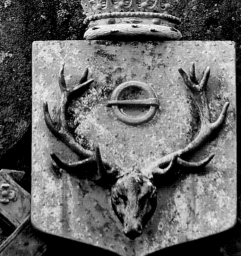

BE MINDFUL.

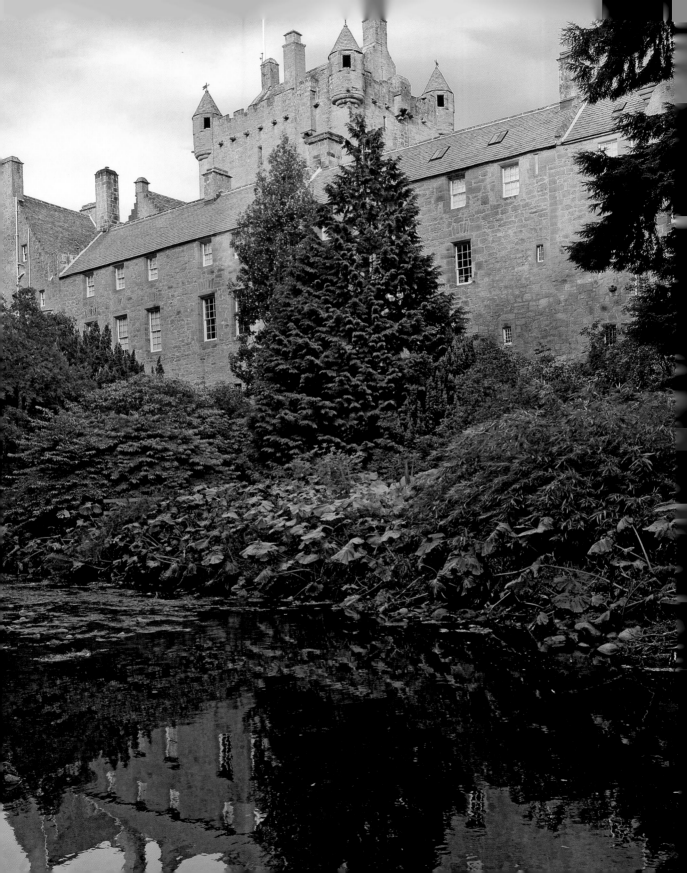

Living at Cawdor

One of the new Countess Cawdor's great strengths was her ability to live from day to day, seizing every opportunity that came her way—something she attributes to her African upbringing. She was just six years old when she followed her parents and sister to what was then Rhodesia, where her father—who lost everything when the Iron Curtain fell—went to seek his fortune as a tobacco planter.

"On the bridge of our ship, off the coast of Aden, I remember 'smelling' the spice of Africa for the very first time. I was amazed. And the continent never disappointed me. Even our precarious lifestyle had something fascinating about it, from the moment we disembarked in Mozambique. I can still see the vermin scurrying over the walls of my bedroom on the first night. It took us several long days to reach Salisbury."

❧ ANGELIKA'S STORY

The young Angelika divided her time between a Dominican convent school, where she received a strict education, and her parents' farm, where she enjoyed huge freedom. "Two Bushmen, skilled trackers, accompanied me on my hikes. I owe my discovery of nature to them. They taught me how to 'read the bush.' When I was hungry, they would give me a piece of cactus to nibble. And they communicated their passion for animals, too: they entered into a kind of telepathy with the kudus, leopards, antelopes, and cheetahs."

Angelika's intrepid, strong-willed character was forged in the vicissitudes of a life turned upside down by the changing fortunes of European history. Countess Angelika Lazansky von Bukowa was born in Prague in February 1944, in the throes of the Soviet advance on the city. Her first days were lived in a state of constant alert. The family castle at Chiesch, in Bohemia, was occupied by Russian officers who spent their time drinking. One of the generals, obsessed by her mother's beauty, even took the newborn baby hostage and threatened to throw her into the moat from the third floor if the superb chatelaine refused his advances. Later, in fear of the new Communist regime in Prague, the family was saved by the Americans.

"One night in 1947, my father was dining at the American embassy when our head forester came to warn him that the Communists had come to the house to arrest him. The Americans organized a secret expedition to evacuate us, my sister and me,

A portrait miniature painted in 1819 depicting the wife of John Frederick, 19th Thane of Cawdor, née Lady Elizabeth Thynne, daughter of the Marquess of Bath (page 38). In the early eighteenth century, Sir Archibald Campbell sent a sketch of the layout for the Flower Garden from France, where he was studying. The design is based on a garden at the Château de Loches. The monumental yew trees and smaller, lime-green Irish yews were added during the Victorian era (pages 41–43).

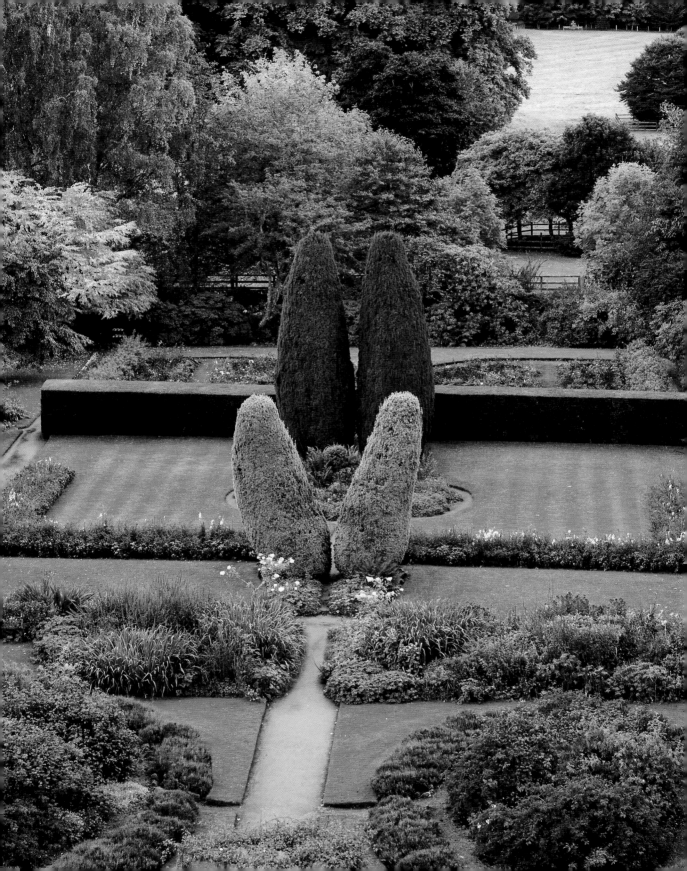

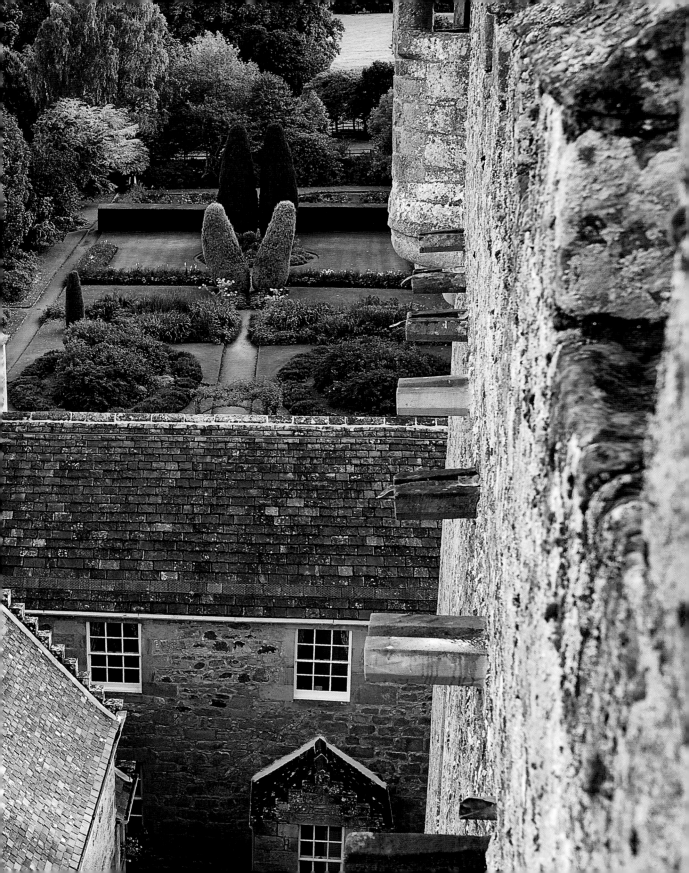

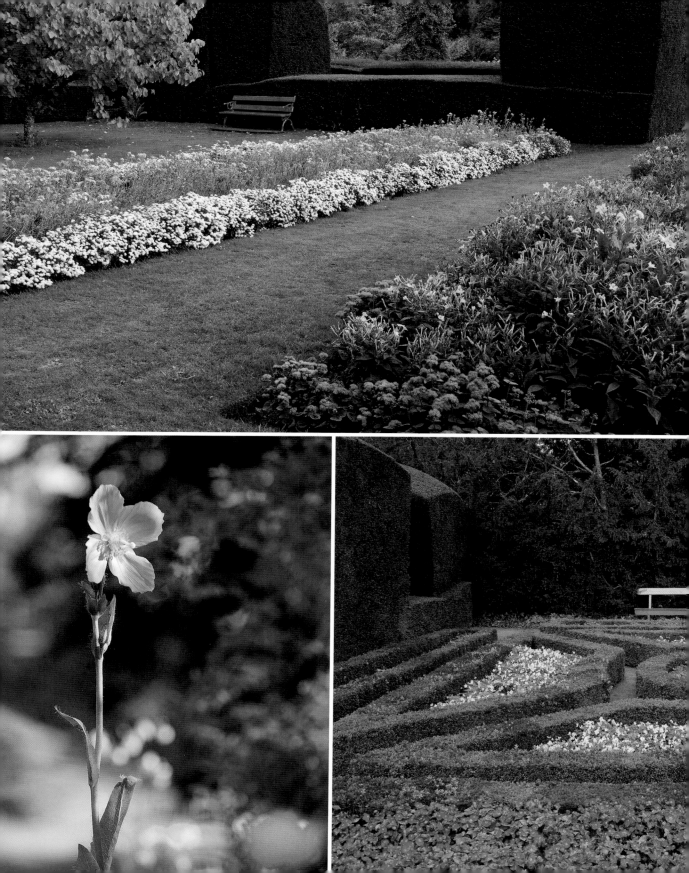

with our governess and our two dogs, aboard a Jeep! All we saved was a chest of toys, and a few pieces of jewelry."

The family took refuge at first with cousins in Grabenstätt on the shores of the Chiemsee in Bavaria. Here, Angelika lived an impoverished life until their departure for Africa. "I know what it is to be hungry. It's a sensation that never leaves you."

Some families experience great trials as challenges to be overcome. And the Lazansky von Bukowas—Mittel-European aristocrats and polyglots with an extensive network of international relations—were not easily defeated. On her return from Africa in May 1962, the young Angelika had secured a place at Cambridge University. "In our family, everyone learned French as their second language. And so, before sending me to England, my father decided I should spend three months in Paris, perfecting my command of the language."

But the young girl fell in love with the French capital. She settled in Paris, and was greeted everywhere with open arms: the Rothschilds, the Hottinguers, the Vernes, the Polignacs, the Mouchys.

"I was the well-brought-up girl you invited when you needed an extra, elegant, polyglot guest." The Bories introduced her to the Duke and Duchess of Windsor.

"Wallis was forced to put up with me because her husband adored me. In fact, more than anything, the former King Edward VIII liked speaking to me in German. But we did it in secret because the Duchess hated it. She would say: 'Angelika you have such a bad influence on him!' Fundamentally, and despite his great kindness, I thought the Duke of Windsor a very weak man. I remember one evening

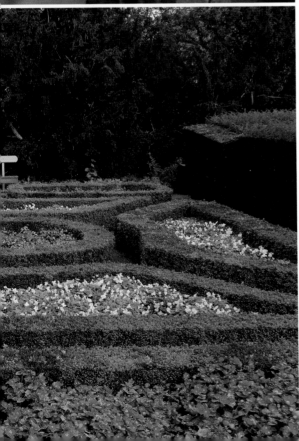

Red benches installed by Sir Hugh (inspired by the moss garden in Kyoto) stand in striking contrast to the greenery of the Victorian garden. Their color harmonizes with the red Flamboyant begonias, yellow Helen Harnes, and rare Tibetan flowers from the Meconopsis family (left and facing page). The garden inspires a mood of watchful reflection, echoing the Cawdor family device on the coat of arms above the drawbridge (page 36).

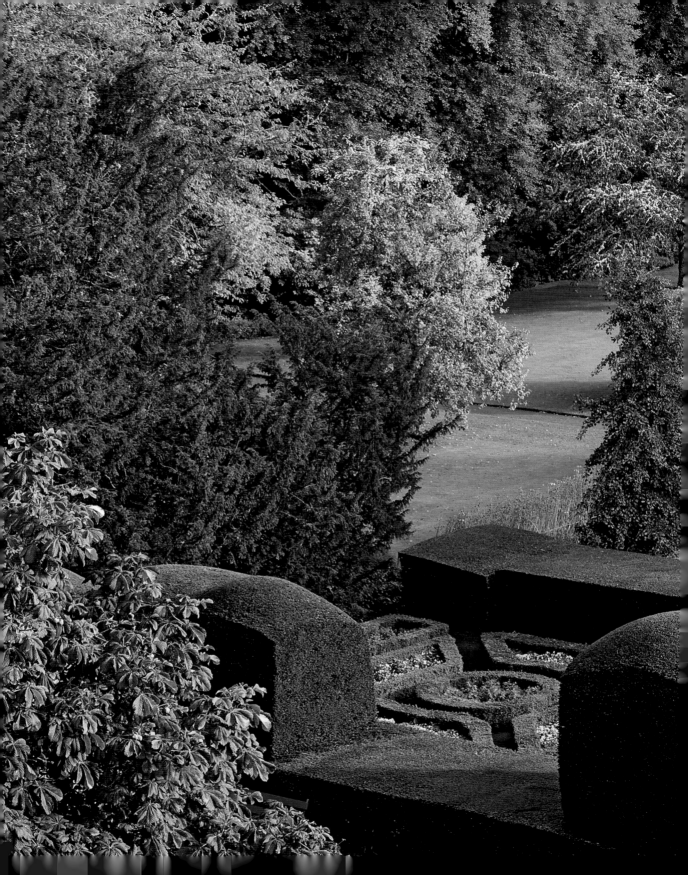

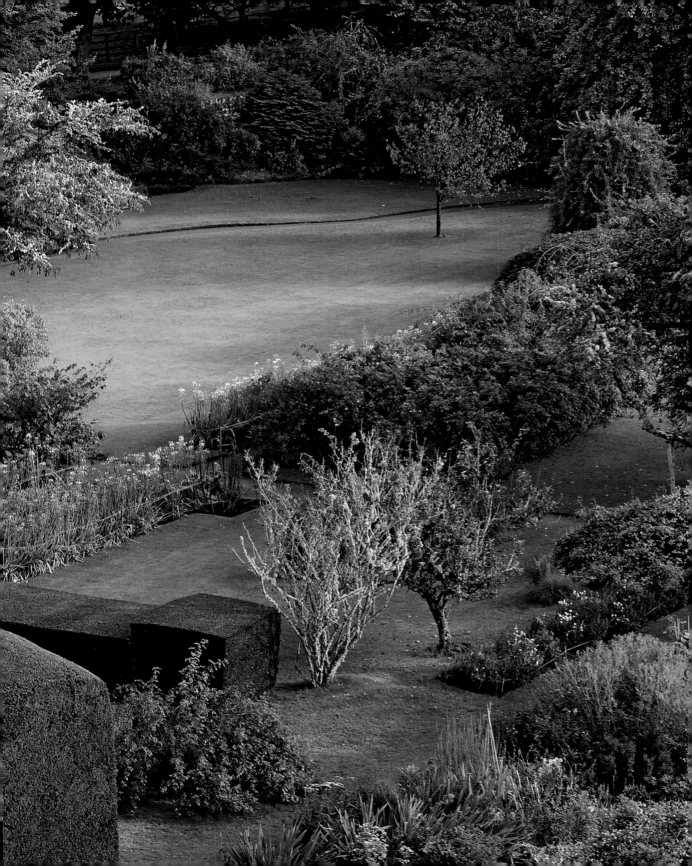

we were at the Palais Chaillot, for the première of a film about his life. To my surprise, he was so moved he began sobbing into his handkerchief. Wallis was exasperated, poking him with her elbow. And in the darkness, he took my hand, clutched it, and kept it within his."

Through the Margeries, old family friends, Angelika met Cristóbal Balenciaga who dressed her for her society outings, delivering his pretty navy blue and white striped boxes to her lodgings at the Irish convent on rue de Lübeck. Graced with a slender, almost feline silhouette, a high forehead topped with a mane of auburn hair, and mysterious, pale turquoise eyes, her natural elegance and magisterial carriage naturally singled her out—briefly—for a career as a model. After a meeting with the high priestess of fashion, Diana Vreeland, Angelika was the heroine of a series of fashion stories for *Vogue* and *Life* magazine.

But this dazzling, seemingly effortless existence didn't exempt her from the need for hard work. She had to earn a living. And so, with the help of Olivier Bizot, she created a marketing and public relations agency, the IPRA. The successful business moved to offices on avenue George V, and its focus on travel and tourism attracted a string of clients including American Express, Time-Life, the Canadian Tourist Office, and the World Bank.

"The actor Mel Ferrer and the director Terence Young had persuaded me to get involved in film promotions. And so I began acting as a guide for the cast of the film *Mayerling*, including the legendary Ava Gardner. Her contract stipulated that no photographer was to be allowed near her, which

In the Flower Garden, in the heart of Scotland, a gingko flourishes alongside a Tibetan cherry and a handful of indigenous species (pages 46–47). Other exotic *species—Rhododendron williamsianum* and a Vilmorin mountain ash—stand alongside the impressionistic laburnums, so characteristic of the Scottish spring (facing page and right), in perfect harmony with the vast, ancient sycamore (pages 50–51).

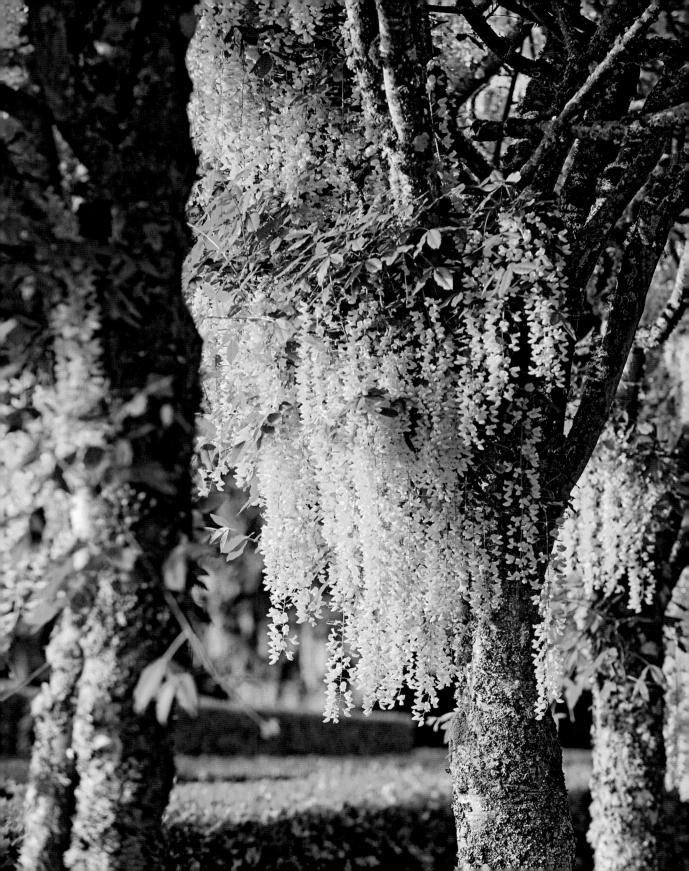

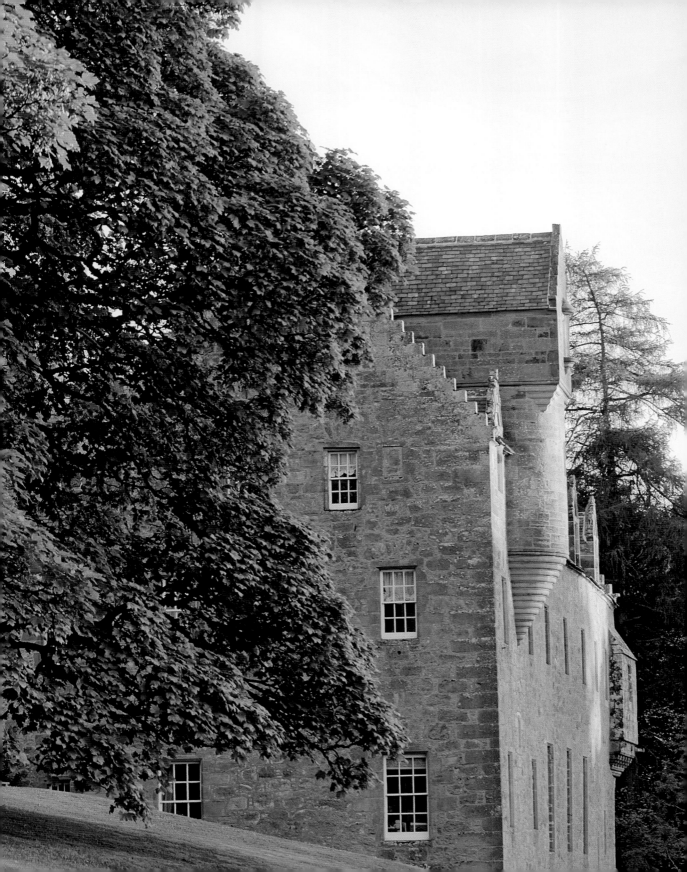

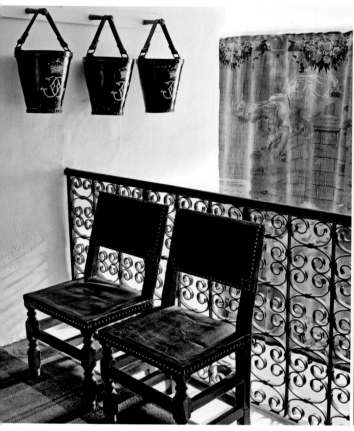
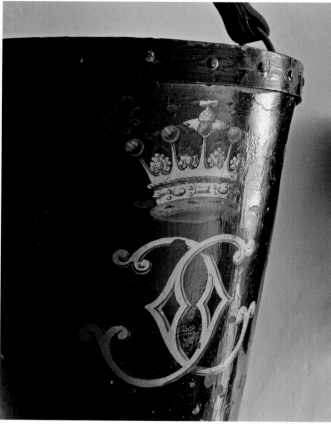

made my job almost impossible," remembers Angelika. "One night, to keep her entertained, I took her to dinner at Charles de Lubersac's house, in my little Volkswagen; she was enchanted, and seemed to have great fun." Another illustrious passenger in the tiny vehicle was Greta Garbo (introduced to Angelika by Cécile de Rothschild), with whom she spent hours walking incognito in the Marais. But of all Angelika's new friends from the world of film, it was Yul Brynner who made the deepest impression. One evening, the pair toured Paris's Russian cabarets. When they arrived at the Kalinka, the owner politely ushered the other clients out, opened bottles of vodka and tins of caviar, and played the balalaika. Through Brynner, she met his former lover Marlene Dietrich.

"I have always tried to keep my society life and my professional life separate," she says. "Although it hasn't always been easy. But everything changed when I met Hugh. I left my business, and this rather frenetic existence. I left my Parisian life behind."

There could have been no finer training for the new hostess of Cawdor, although society was scarce, if not completely nonexistent, in this remote corner of Scotland.

"You would only come here for love or friendship," jokes Angelika. "And straightaway, I fell in love with Cawdor—perhaps it was a kind of transference of my love for Hugh. In any event, the place opened its arms to me and, now that my husband has died, I feel—I'm certain—that Cawdor is protecting me. When I arrived here, I was very careful at first

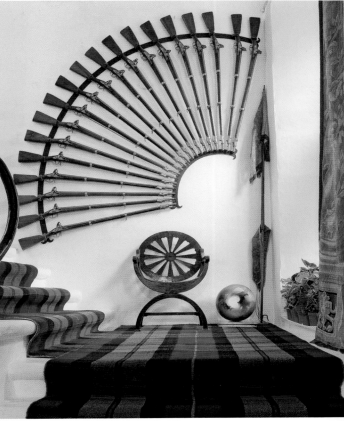

not to impose myself. Everything here had existed before me, I would have to adapt to it, and not the reverse. Little by little, with discreet touches here and there, and with Hugh's assent, I nonetheless managed to make the house comfortable. When I got here, the guest rooms were used to store all the furniture from the family's Welsh properties. Everything had to be rethought. And now, thirty years later, I am redecorating the very last room, uninhabited since the 1920s."

In 1979 the castle had been open to visitors for three years, and the business was losing money.

"I had thought that with marriage I would be able to give up work; instead, I discovered the most demanding business of all." Paris friends who smiled at the idea of this elegant, sophisticated, lively woman lost in the mist and peat bogs of Scotland soon found themselves confronting a quite different reality. Angelika bloomed where she had been planted

"It was one of the most fulfilling, wonderful periods in my life," she says today. To her own surprise, no doubt, but responding to some private longing buried deep within her since childhood, Angelika set about tackling the seemingly impossible

Today, the seventeenth-century main staircase—built by the 14th Thane—is laid with carpet in the Campbell of Cawdor tartan. The white walls are hung with a group of monogrammed leather fire buckets, and an arrangement of firearms taken from the defeated French invasion force that came ashore on the Cawdors' Welsh estate on February 22, 1797, hence their provenance—from the Manufacture d'Armes de Saint-Étienne (above and facing page).

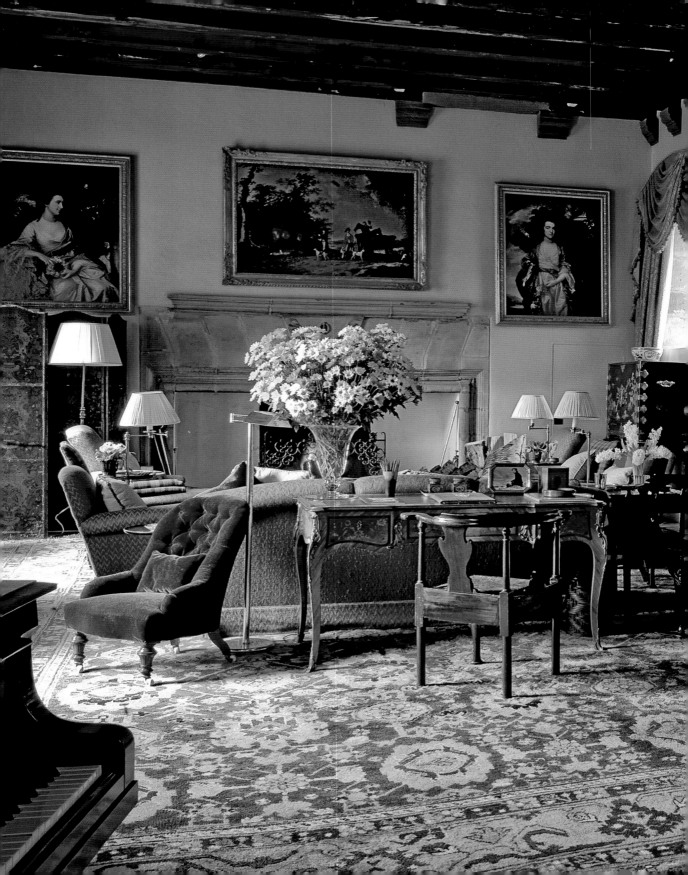

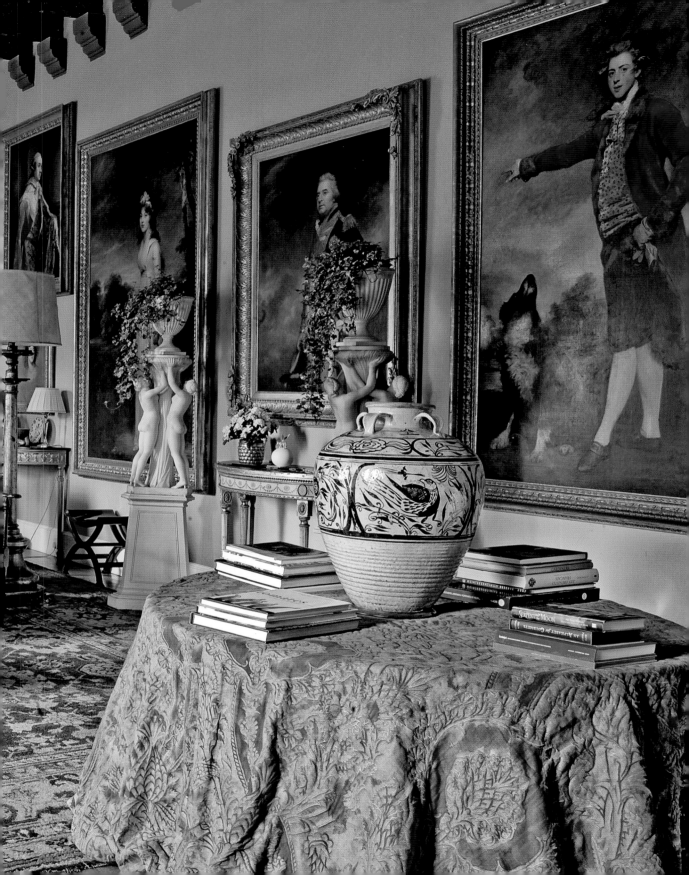

task of transforming an austere, quite unapproachable house into an unmissable stop on the tourist circuit. Angelika summoned all her courage, dedication, and unfailing tenacity, coupled with acute organizational skills, to marshal a diverse band of colleagues and establish—ten, fifteen years later—a respected cultural and heritage enterprise.

She inherited the castle upon the death of her husband Hugh, 6th Earl Cawdor, in 1993. Most unusually in this determinedly patriarchal, misogynistic land, the property was left to the laird's widow, and not to the heir to the title, Colin, 7th Earl Cawdor and the 25th Thane.

₰ OF GHOSTS AND RITES

Some visitors entering Cawdor Castle for the first time are often justifiably anxious about its ghosts. Is the house haunted, like every old house in Scotland (as tradition would have us believe)? We should tread carefully here—the last witch in Scotland was persecuted not so very long ago in the village of Forres, just a few miles away.

Rather than fully fledged ghosts, some guests—more sensitive than most to the world of the occult—have reported powerful presences, especially in certain parts of the castle. In the main Drawing Room, some claim to have seen a sorrowful woman in a blue dress, her face streaked with tears. Could this be the daughter of Sir Archibald, brother of

Pages 54–57: The Drawing Room typifies the generous volumes of seventeenth-century architecture; the room is an impressive gallery of Cawdor portraits, by Francis Cotes, Sir Thomas Lawrence, and William Beechey. To the right, the striking full-length portrait of John ("Jolly Jack") Campbell is by Sir Joshua Reynolds. The twin Athenian urns supported by figures of the Three Graces are all that survives of Jack's collection of marble sculptures by Canova. The contemporary Sèvres vase was a gift to Angelika from the artist Marina Karella. Photographs of a kilted Hugh, 6th Earl Cawdor, and his wife Lady Angelika, immortalized in 2002 by John Swannell, on the mahogany console (left).

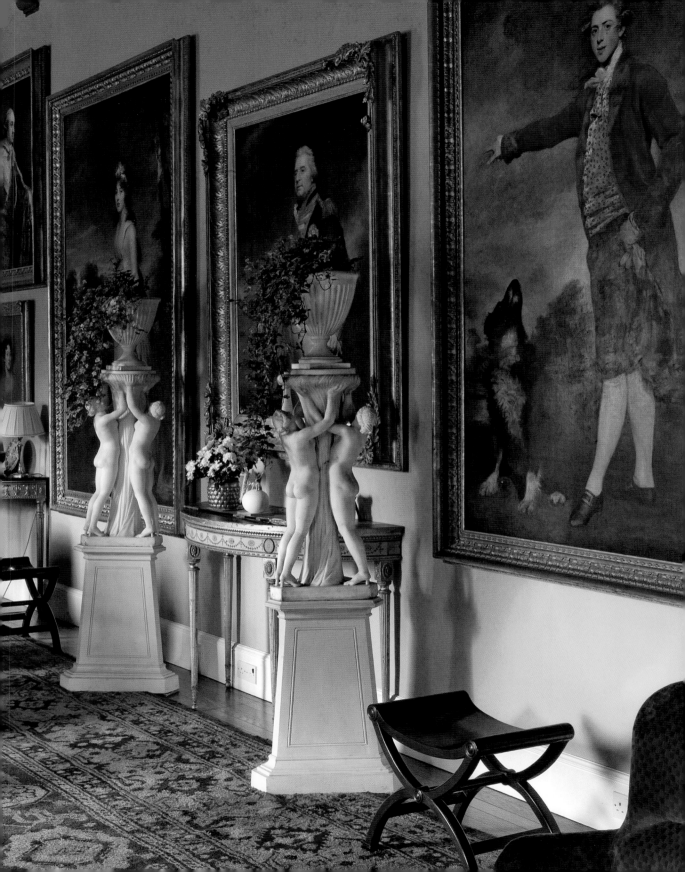

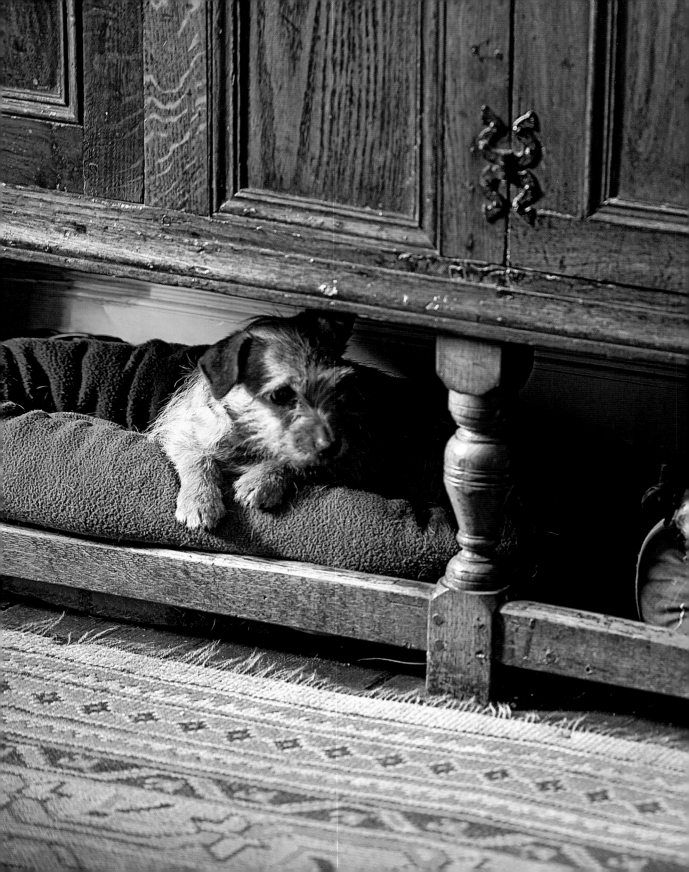

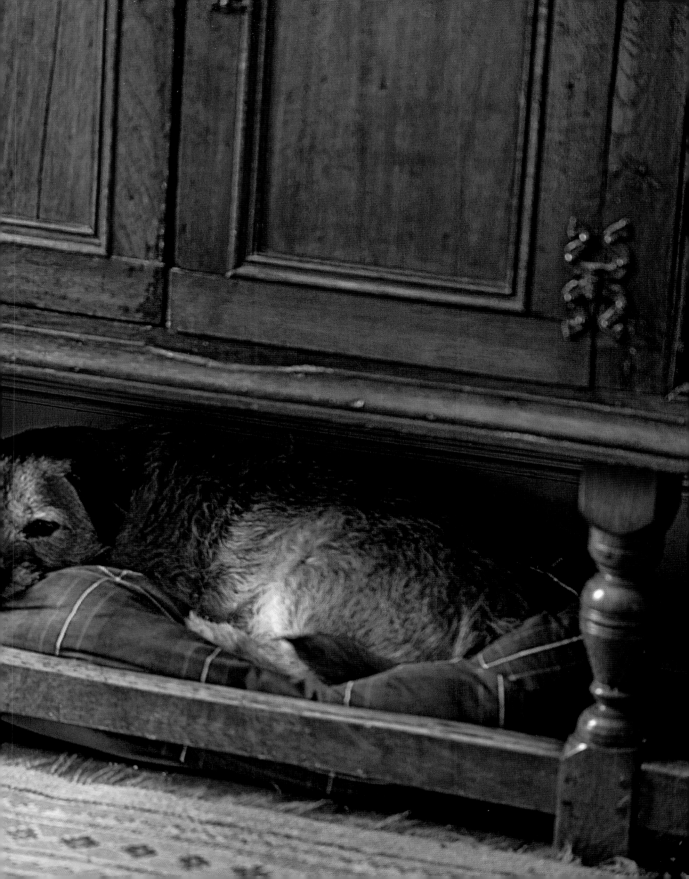

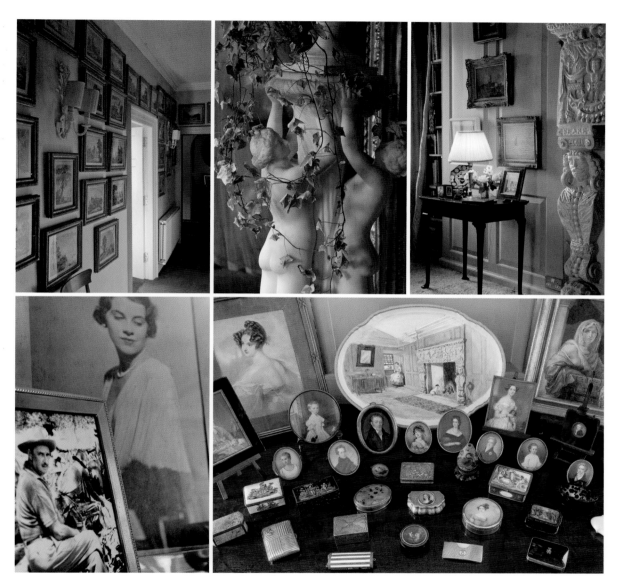

Cawdor is above all a living home, bustling with activity, to the delight of the dogs, Bessie and Kim. Both are a Border terrier, Norfolk terrier, and Jack Russell cross (pages 58–59). An array of watercolors, miniatures of the Lazansky von Bukowa family, and black-and-white photographs of Angelika's parents create a warm, nostalgic atmosphere in the Blue Sitting Room (above and facing page).

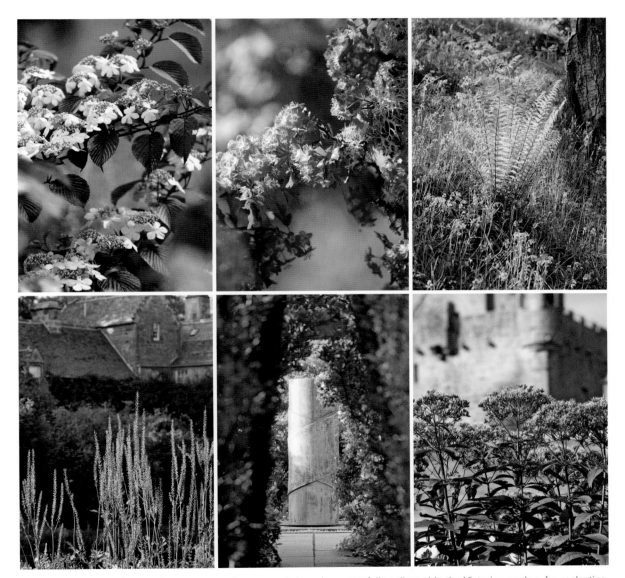

Every year since the nineteenth century, snapdragon seeds have been carefully collected in the Victorian garden, for replanting. In spring, the flowering beds complement the blossom of the old fruit trees, and an immense *Eucryphia nymansensis* (pages 62–63). Flowers reign supreme here: the dwarf rhododendrons (facing page), *Viburnum plicatum* "Mariesii", Hawthorn, bluebells, *Eupatorium purpureum*, sculpture by Xavier Corberó commissioned by Angelika Cawdor, and *Cimicifuga racemosa* (above, clockwise from top left).

John, who suffered a broken heart when she lost her fiancé at the Battle of Culloden? Some members of the household think so. There have been similar reports of a presence in the Tapestry Bedroom: a pleasant-looking, well-built young man dressed in a frilled shirt, black silk knickerbockers and a red doublet—the very image of the portrait of Jolly Jack Campbell (whose exploits are described in Chapter III), as painted by Reynolds in 1778. Another curious phenomenon: the castle dogs obstinately refuse to enter the Blue Drawing Room, as if something, or someone, was preventing them in the doorway. Beyond superstition, there may well be some reason as yet unknown for these strange manifestations. Scotland—that land of peat and clay—may indeed be permeable in some way, as if past lives were able to leave a clearer imprint here than elsewhere. The celebrated medium Yaguel Didier confirms that she has felt the presence of a least twenty different specters at Cawdor. And Prince Michael of Greece experienced a striking occurrence on his first visit to the castle: walking down a corridor past a closed door, he distinctly heard an angry telephone conversation conducted by a man who, it turned out, had been dead for several decades.

"Old houses shouldn't be disturbed; they accept our presence, and we should accept theirs," says Lady Cawdor. "I never feel completely alone here. These presences—which some people call ghosts—seem to me to be mostly friendly. We understand each other very well."

Cawdor's invisible residents have, perhaps, been disturbed by the opening of the castle to the public. Each year, from May 1 to the second Sunday in October, thousands of visitors pass through the main

Georges Jeanclos's, *Adam and Eve driven from Paradise* (facing page) is one of the treasures of the symbolic gardens. But the works of man struggle to rival the breathtaking *Nemophila maculata* and ancient, lichen-covered plum trees (left).

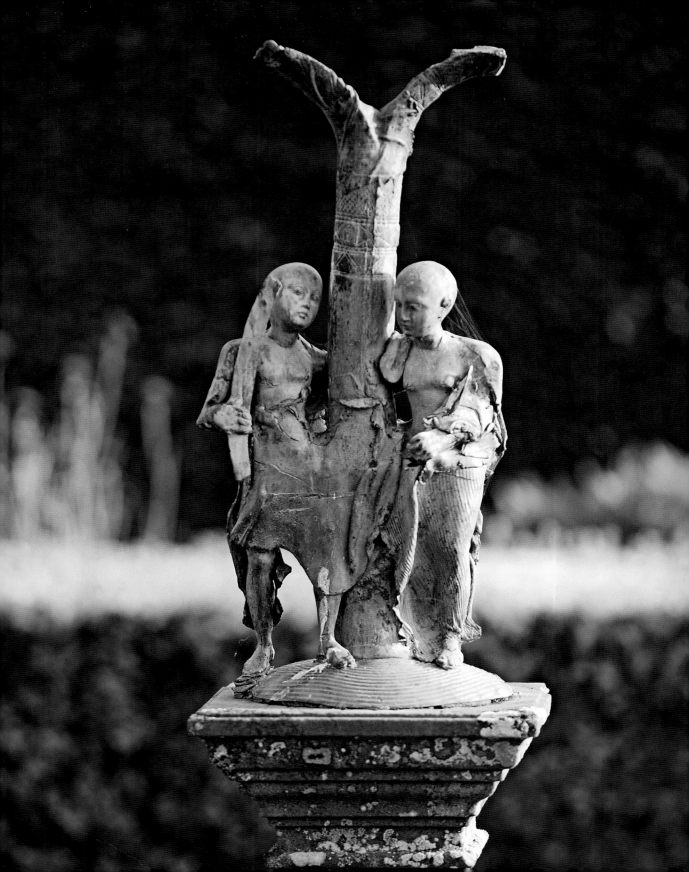

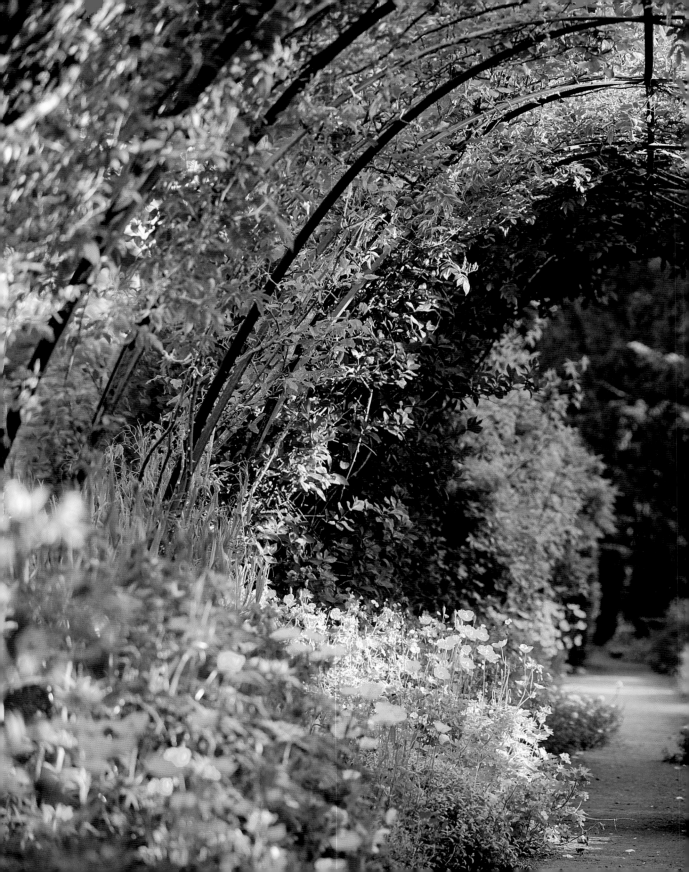

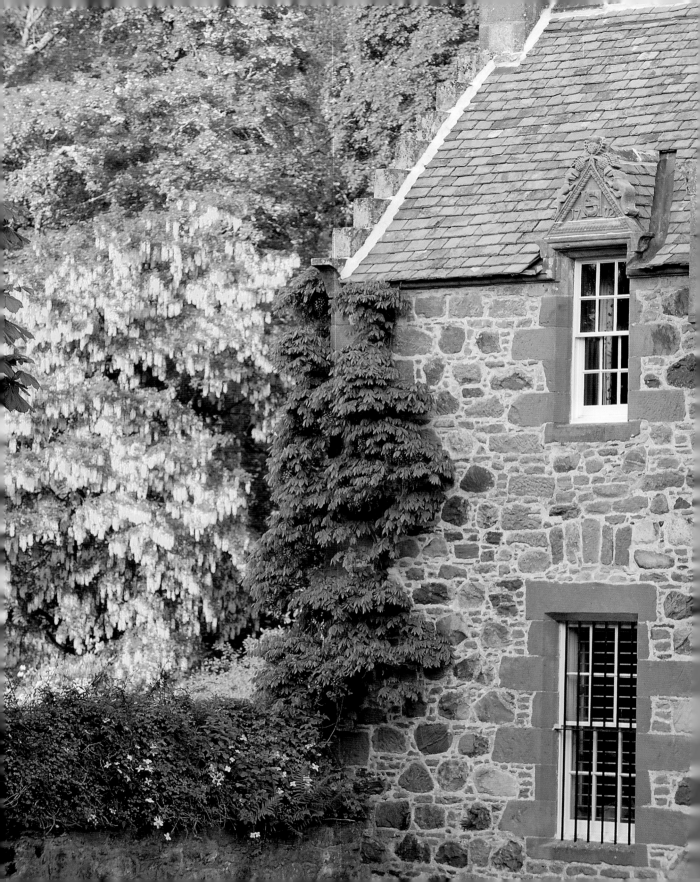

Drawing Room, the corridors, the Tapestry Bedroom, and the Pink Bedroom, climbing the staircase lined with French firearms from the Manufacture de Saint-Étienne, taken from a defeated French landing force that came ashore in the Welsh county of Pembrokeshire in 1797 (the last land invasion of mainland Britain). Inevitably, visitors are impressed by the consummate art of a hostess who has succeeded in transforming this medieval fortress, with walls over fifteen feet thick, into a welcoming, comfortable home. A less doughty spirit would doubtless have preferred to make their home in the pleasing spaces and light-filled rooms of the Cawdor summer residence and dower house at Auchindoune, rather than holding out in this ancient fortress.

Visitors apart, the castle truly comes into its own during the dark days of the Scottish winter, when great trunks burn in the fireplaces. The famous Noah tapestry (woven at Oudenaarde in 1682) is prized less for its artistic importance than for its ability to retain the heat from the hearth; crimson velvet curtains surround the great four-poster bed used by the mistress of the house—this was the marriage bed of Sir Hugh Campbell and Lady Henrietta Stuart in the seventeenth century.

The Dowager Countess is an early riser who takes her breakfast alone, seated at the great mahogany dining table, gleaming with the reflected sparkle of the Cawdor silver. She keeps an eye on her dogs, which have slept close by in the scullery; she will shortly serve them a meal of cereals, garden vegetables, and venison shot on the estate. She opens the tall windows to feed red squirrels from the nearby wood; the room is filled with the song of the torrent,

Monet would have felt at home in the gardens at Cawdor with their jasmine and rose arbors, carpeted with bluebells (pages 68–69). Clematis climbs the walls of the eighteenth-century apartments; a bouquet of *Mecanopsis cambrica* is surrounded by lupins; the delicate carmine red of *Papaver orientalus* harmonizes with the soft dusky pink of a rhododendron: Cawdor's gardens are truly "picture perfect" (facing page and right).

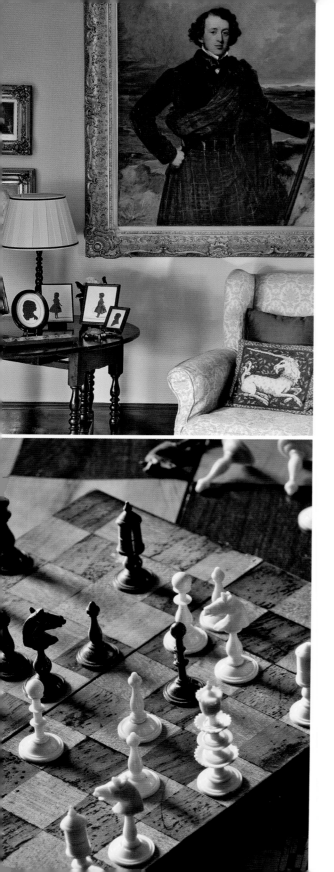

the Cawdor Burn, rushing below. The pale, watery morning light filters through the tops of the trees on the grounds, touching the tapestry cycle illustrating episodes from the story of Don Quixote, woven in London, in the workshops of Francis Poyntz.

Retreating upstairs to the cozy, impeccable Blue Bedroom—a bright corner room filled with memorabilia, family photos, gifts from friends, and souvenirs of her travels—Lady Cawdor carefully compiles her menus for the week, inspired by the recipe books scattered all around her.

Every day she crosses the Flower Garden and the Wild Garden—planted with often rare, exotic species—before pushing on to the heart of the dense, ancient Caledonian forest known here as the Big Wood. "Since my childhood with the Bushmen, I have lived in communion with trees," explains Angelika. "I feel the current of energy that courses through nature—its vital force. The trees give me strength. The Big Wood is the true seat of Cawdor's magic."

Back at the castle, Lady Cawdor assumes her role as the chief executive of a thriving business, piloting and managing everything down to the last detail from her offices on the edge of the North Courtyard. This is her vocation and her raison d'être.

With fierce energy, Angelika makes it a point of honor to keep every room in her ancient home alive. Tea is always served at five o'clock in the afternoon, in the small Dining Room. And guests always gather for aperitifs before dinner in the main Drawing Room, built in the sixteenth century on the site of the former Great Hall and decorated with portraits of illustrious Cawdors and Campbells. To outside eyes, these family souvenirs are above all masterpieces by Francis Cotes, Sir Joshua Reynolds, and

"Inanimate objects, do you have a soul?" asked the nineteenth-century French poet Lamartine. From an eighteenth-century chess set to the Richard Ginori Fiesole tea service, ornaments in the Yellow Room are the repositories of a host of memories, beneath the distant gaze of a kilted ancestor, painted by Frederick Say (left and facing page).

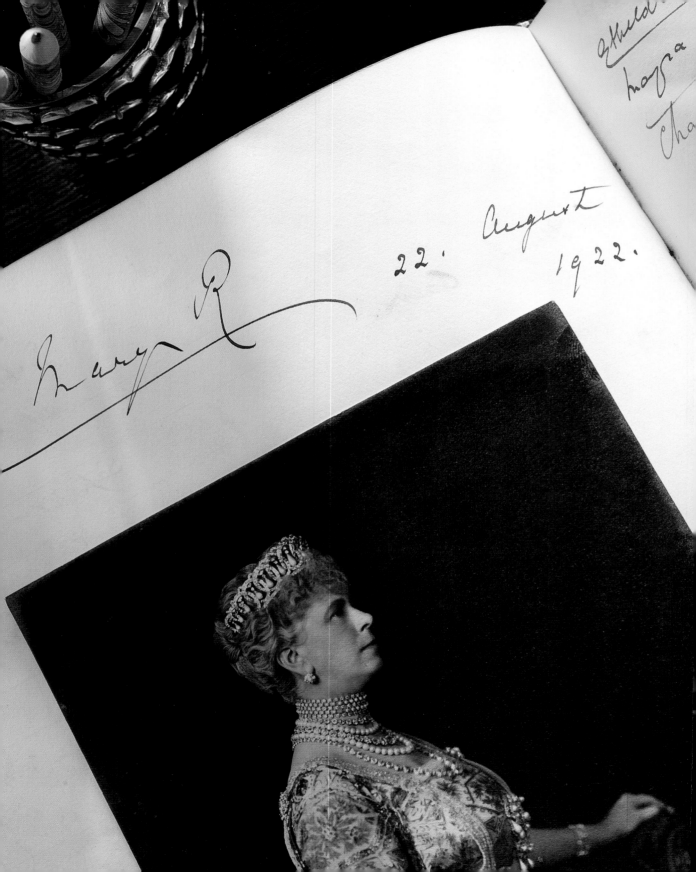

Mary R

22. August 1922.

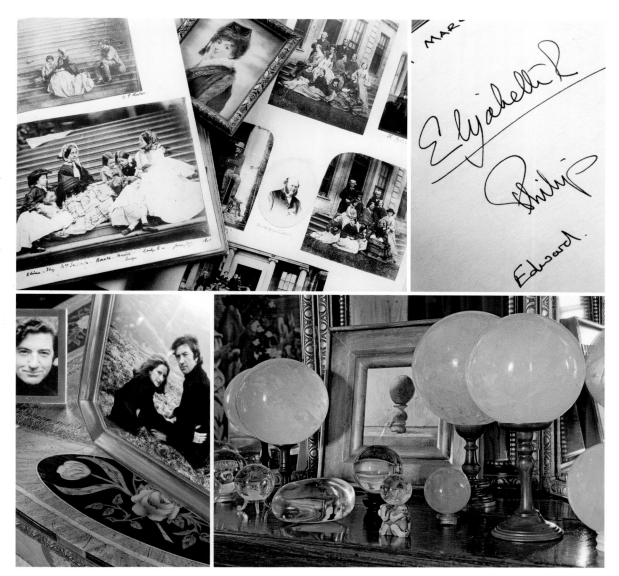

Facing page and above: The famous guest book is graced by the signatures of Queen Mary, in 1922, and her granddaughter Queen Elizabeth II, in 1980. The book is a treasured part of the house's memorabilia, along with photographs of Hugh and Angelika, and Angelika's collection of rock crystal spheres (facing page and above). Echoes and harmonies, from the Dining Room of Cawdor Castle to the summer dower house at Auchindoune: the rich vermilion of an eighteenth-century Qianlong service bearing the family crest echoes the border motifs of a large tapestry woven by Francis Poyntz's royal workshops at Hatton Garden (page 78). Neapolitan watercolors by Xavier della Gatta (page 79) contrast strikingly with surviving works of sculpture from the collection of "Jolly Jack".

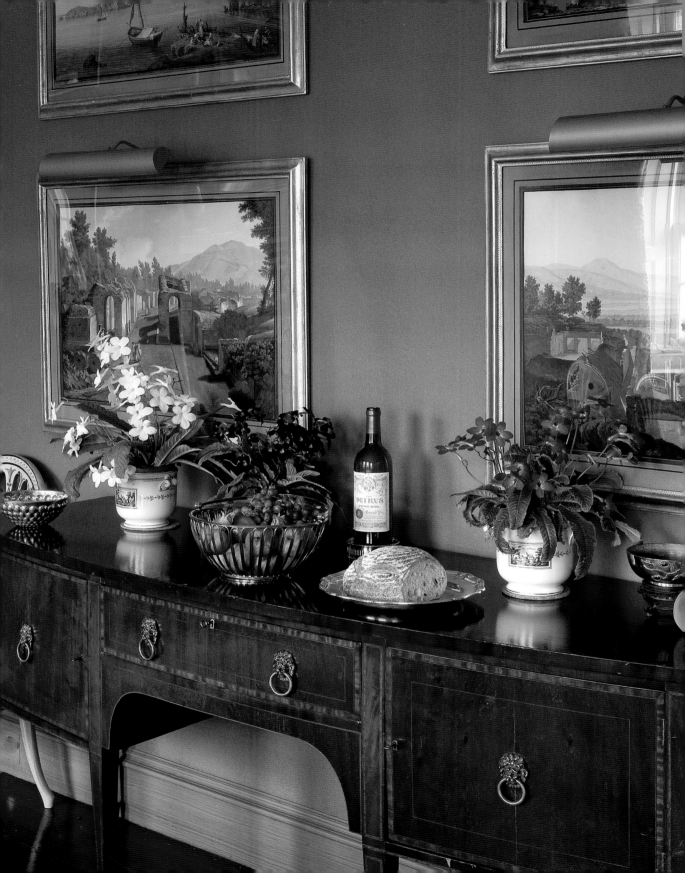

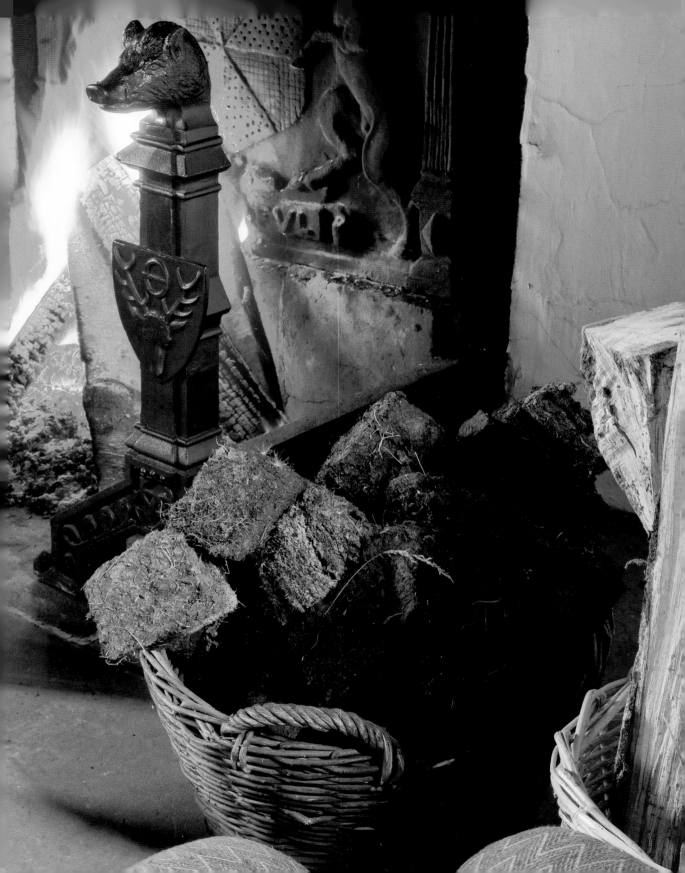

Sir Thomas Lawrence. And coffee is always available in the Tower Sitting Room, originally the vestibule to the Keep, decorated with Flemish tapestries dating from the early seventeenth century, based on cartoons by Rubens and featuring allegories of Rhetoric, Geography, and Astronomy.

The house is never livelier than at Hogmanay—the Scottish New Year celebrations. Each of the fourteen guest rooms is equipped to reflect its occupants' personalities. Most of the bedrooms open off a long corridor laid, like the main staircase, with a carpet woven in the tartan of the Campbells of Cawdor.

An invisible population of servants—almost ghostly in their discretion—adds a further touch of mystery to this Scottish country house: the hearths are lit and extinguished as if by magic as the company moves from room to room; clothes are put away in wardrobes and drawers even before one has had time to fold them; at mealtimes, dishes appear and disappear magically into and out of the servery, in an apparent sleight of hand by Martin, the chef.

Three hundred and sixty-five days a year, Cawdor's estate supplies food for the castle table, as if the gigantic fortress was prepared for a siege, holding out against some unseen assailant. Another sign of Scottish pride: a proper awareness that one is able, thanks to the infinite riches of the land, to live self-sufficiently on an estate where everyone is free to carry on as if London didn't exist.

Dried peat and logs from the Big Wood burn in the Drawing Room fireplace (facing page), casting their glow on the fine bronzes—one of Angelika's left hand by the Catalan sculptor Xavier Corbero (right, top), and a statuette by Agura, a favorite pupil of the Japanese artist Churyo Sato—under the watchful gaze of Lady Caroline Howard, by William Beechey (right). Pages 82–83: The soft, vegetable-dyed colors of the old Campbell of Cawdor tartan are seen on a cashmere throw, a rug, and a covered armchair in the Drawing Room.

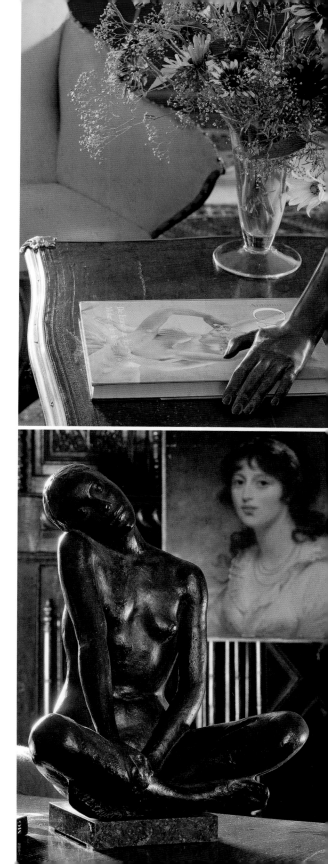

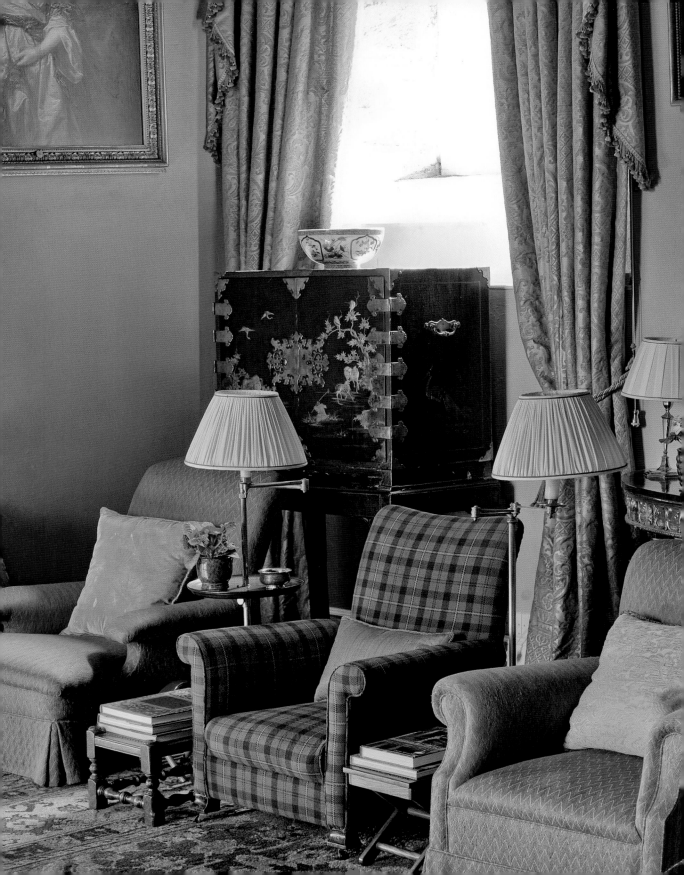

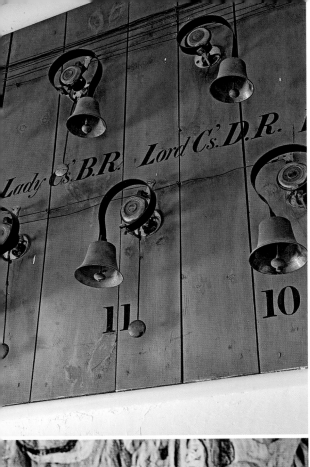

✤ PROPERTY OF THANES

Historians find no written trace of Cawdor before 1454, when King James II of Scotland (1430–1460) authorized his faithful vassal William, Thane of Cawdor, to add turrets and battlements to his castle, "situated in our prevostship of Invernairn, and to complete the said castle." Standing on the great lawn, visitors can trace these defensive additions: the crenellated parapet and pepperbox turrets are in a different, darker stone than the rest of the building. Proof that the bulk of the castle is much older.

The tall, majestic silhouette of Cawdor Castle rises against the often stormy sky a few leagues from Inverness and the beaches at Nairn. A sentinel of the Highlands, standing on a vast estate, the castle flies the gold standard bearing the arms of the Campbells of Cawdor. Defined by its imposing central Keep and corner turrets, its tall chimneys, crowstepped gables, and sloping roofs of old slate, the details of this imposing building blend into a harmonious ensemble of ocher sandstone and ash-gray granite—elaborate and austere, massive and ethereal. From the drawbridge—welcoming today's visitors, rather than keeping them at bay—it is still possible to see the position of the first entrance to the Keep, walled up now and suspended in midair, at first-floor level: originally, the doorway was reached by an external wooden staircase. The building conforms to a traditional plan, often seen in Scotland: a robust Keep surrounded by a quadrangular arrangement of lower wings, flanked by more decorative, nineteenth-century additions. With the exception of the later sections, the sheer walls—which are extremely thick—are pierced only by a handful of narrow windows.

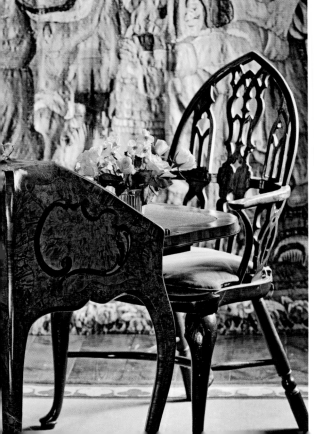

For many years Cawdor was a family home and hunting lodge, occupied primarily during the hunting season. A team of thirty servants was on hand to answer the tinkling calls of the service bells in the scullery (left, top). Nevertheless, the casual atmosphere survives: a cheerful neo-Gothic Windsor chair stands informally at a writing desk bearing the stamp of the Grenoble cabinet maker Hache (left). The dining-room doorway is an invitation to relaxation and enjoyment (facing page).

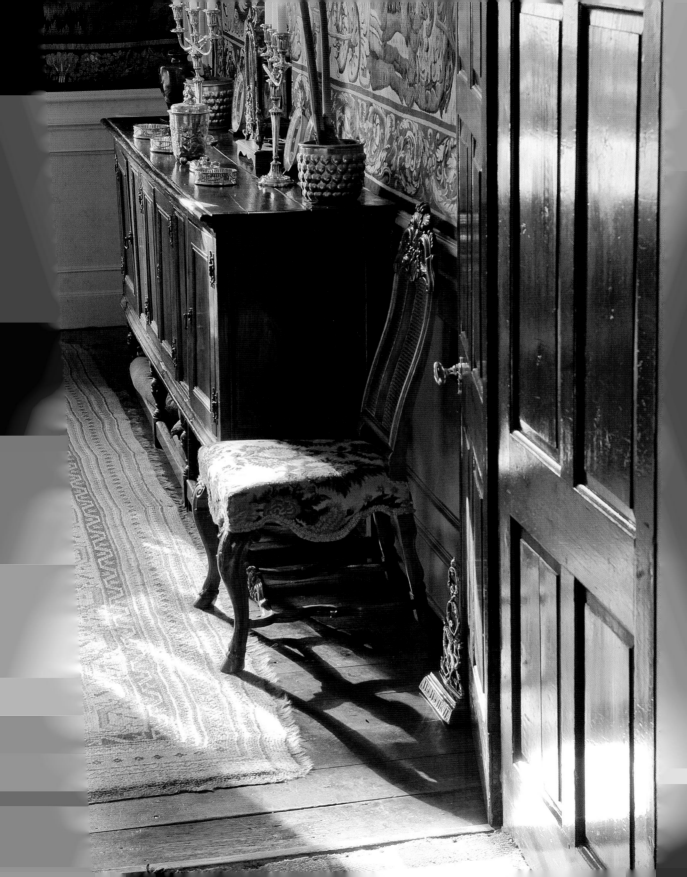

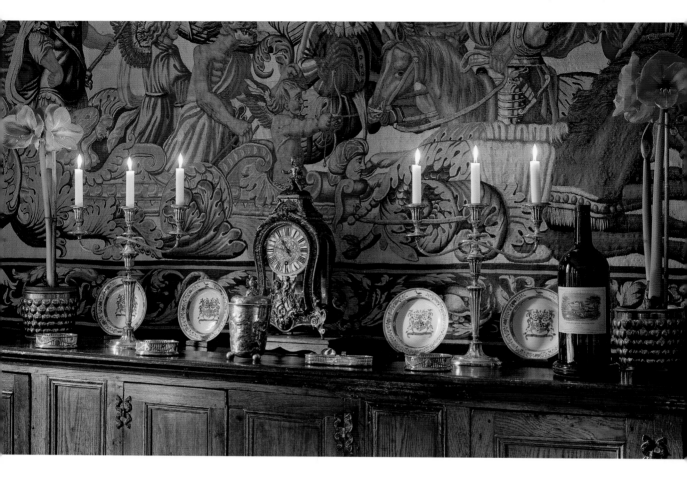

Like a fine gem in a rich, green setting, the great stone edifice contrasts superbly with its luxuriant surroundings. The gardens at Cawdor offer an array of species unique in Scotland: successive generations of the castle's owners have embellished, transformed, and extended them, providing visitors with endless, delightful viewpoints and perspectives.

The oldest surviving plan of the castle is in fact relatively recent, dating from the eighteenth century, making it difficult to gain a detailed knowledge of the various extensions, additions, alterations, and whims of its earlier architects. Cawdor has narrowly escaped destruction on several occasions, notably in 1645, during the Scottish civil war between the Covenanters (a force of Presbyterians who had allied themselves with Cromwell and the English Parliamentarians) and the Royalists, supporters of King Charles I.

Following the 1707 Act of Union (the merger of the English and Scottish parliaments, a move that enjoyed very little popular support in Scotland), violent confrontations laid waste to the Highlands, destroying many fine houses in the region. How, then, has Cawdor survived the reversals of history unscathed? Some would point to the magic power of the ancient holly tree. It was in these difficult times, fraught with wars and danger, that the Thanes' seat was transformed from an ancient fortress to a more welcoming residence. Sir Hugh Campbell, the laird of the day, made the renovations his life's work. With the support of his wife, Lady Henrietta, Sir Hugh

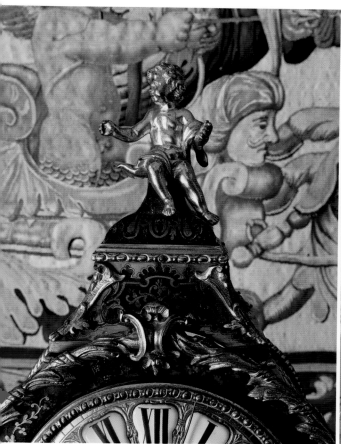
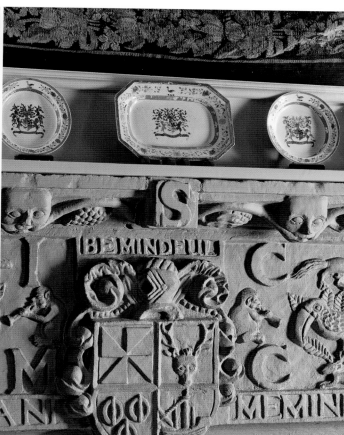

added an extra story to the living quarters, repaired the fireplaces, enlarged the windows, and added a great dovecote. He transformed Cawdor into a gentleman's country home. Hugh and Henrietta signed their work with a cipher of intertwined hearts on the "marriage stone" at Auchindoune (the castle's summer residence and dower house) and with their respective coats of arms, carved in sandstone in the castle's North Courtyard.

Sadly, after their deaths, the family left its Scottish estates in the hands of a string of managers, abandoning the misty moors for the gentler climes of Pembrokeshire, southwest Wales, and a livelier social life in London. Cawdor sank into oblivion. It took the great fire of 1819, and the gentry's pre-Romantic fascination with Scotland, to wake the sleeping beauty and attract Sir Hugh's great-grandson, Sir Archibald, the 1st Earl Cawdor, to the Nairn coastline. It was Sir Archibald who—with a feeling for the picturesque worthy of Sir Walter Scott himself—added the decorative flourishes and neo-Gothic ornamentation that are so much a part of the castle's charm today.

A concentrated dose of the finer things in life, beneath a tapestry illustrating the *Story of Don Quixote* (woven in London after cartoons by Francis Ponytz): the castle's superb Qianlong service, a group of Qing vases, a Boulle clock, and a magnum of Château Lafite (above and facing page). The chimneypiece (above right) commemorates the marriage of Muriel Cawdor to Sir John Campbell of Argyll in 1510. When it was installed in 1671, twenty-four men carried the immense stone over the drawbridge, which collapsed under the weight.

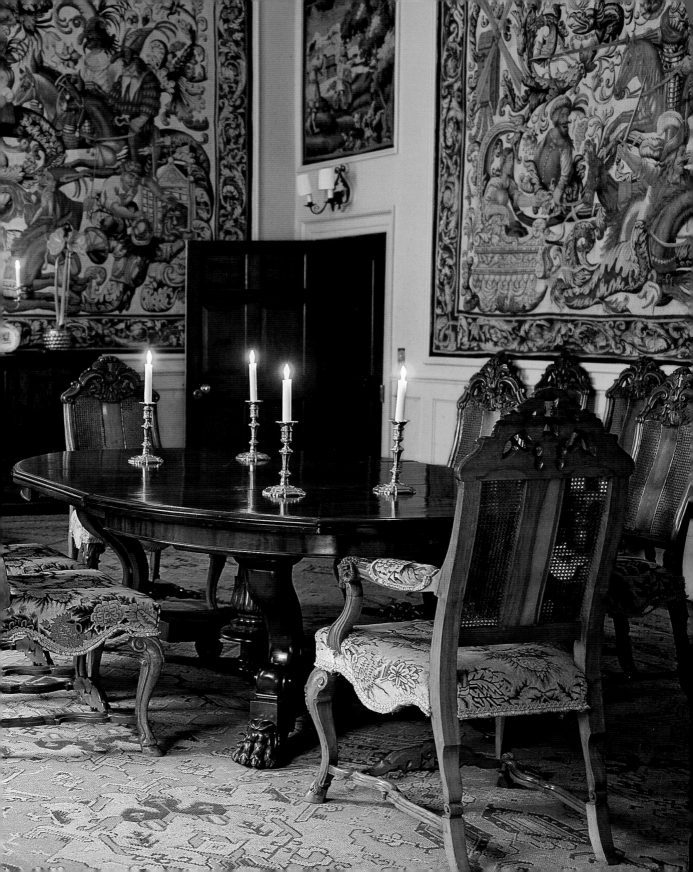

❧ "WITH AFFECTION, NOT AFFECTATION"

From the top of the Keep, and the corner turrets punctuating the Battlement Walk, the view extends over an endless, green patchwork. To one side, an expanse of smooth lawn extends up and away from the castle entrance, culminating in meadows grazed by Hebridean and Saint Kilda sheep. To the east, north, and west, the visitor is struck by the variety of planted tableaux. Uniquely for a Scottish castle, Cawdor boasts three very different gardens, each with its own history, carefully planned by successive generations of owners, all equally devoted to the castle's surrounding landscape. The oldest, dating back to the Renaissance (if not earlier), is the castle's kitchen garden, now the "charterhouse" Walled Garden. The Flower Garden is a tribute to the seventeenth-century taste for "harmonious contrasts." And the so-called Wild Garden is in fact very skillfully composed: a kind of antechamber to the transcendant, consummate centerpiece of the park at Cawdor, the celebrated Big Wood, a remnant of ancient Caledonian forest, and a botanists' paradise.

The family archives indicate the presence of orchards on the site of the current Walled Garden, planted with indigenous species until the late seventeenth century, when they were joined, and sometimes replaced, by a host of exotic vegetables: Indian watercress, Turkish parsley, and Silesian lettuce.

"When I first came to Cawdor," remembers Angelika, "the old Walled Garden was a Victorian kitchen garden, one of the finest of its kind. But the public—visiting the castle in greater numbers every year—were helping themselves, quite shamelessly,

Exceptional elegance in attentive detail: the lions' feet of the George III mahogany table echo the rams' heads on the armrests of the fine Dutch chairs (facing page). The Louis XV marquetry writing chair, by Pelletier, is in fact a charming gondola seat decorated in Venetian lacquer (right).

Successive generations have added their eclectic treasures, great and small, to the collections at Cawdor. The Tower Sitting Room features a Chinese Coromandel cabinet from 1725, a pear– and lemonwood George III writing desk, a Henry Moore sculpture, and a watercolor painted in India by Edward Lear. In the Drawing Room, the group portrait of Charles Campbell and his brothers Alexander and George is the work of three artists: Philip Reinagle for the figures, Sawrey Gilpin for the horses, and George Barrett for the landscape (above). A view of the windows on the main staircase. The Dining Room at Auchindoune features a Neapolitan gouache by Xavier della Gatta (facing page).

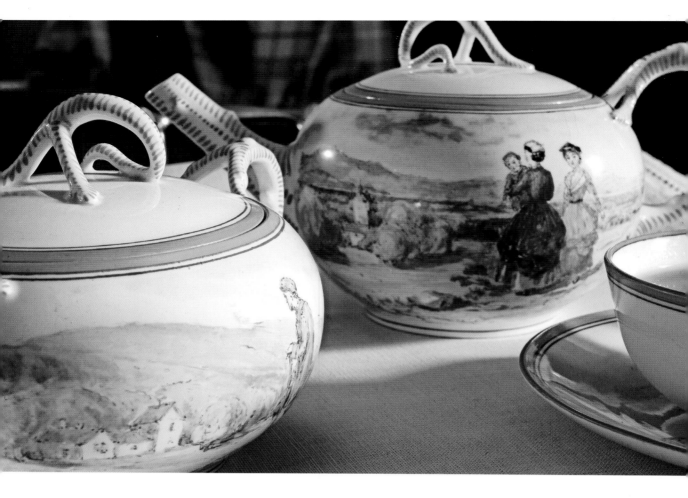

as if they were at the supermarket! I can still see Andy Wood, our head gardener of twenty-five years, running up to the castle to tell us, 'I've just found the vicar under the strawberry nets!' He was red with rage, poor man." As may well be imagined, after such an outrage, the kitchen garden was closed to visitors.

It was born again in the most enchanting way when, in 1981, the Earl Cawdor decided that the time had come to reinvent it.

"We had just been staying with the French ambassador in Madrid, where Hugh had found a book about Roman villas on the Iberian peninsula. He came across a photograph of a Roman mosaic floor from a villa in northern Portgual, called Conimbriga.

It was the last known representation of the labyrinth at Knossos, supposedly devised by Daedalus himself. Hugh fell in love with the picture and decided to recreate the labyrinth at Cawdor."

Today, visitors lose themselves at will in the vast maze of holly—a reference to the estate's guardian holly tree. And the labyrinth is only the beginning of a veritable journey of discovery through the gardens.

"Hugh gave me a free hand with the remaining half of the garden, to plant whatever I wished. After a great deal of thought, I decided to create a series of symbolic gardens, starting with a paradise garden full of the sound of running water, fragrant flowers, and peace. My idea of Eden is like sitting in a soap

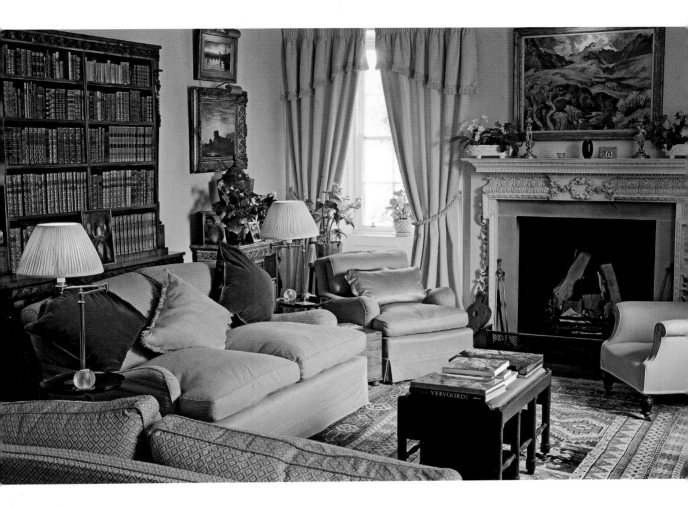

bubble, looking around at everything that is most beautiful in the world. That's why my earthly paradise is round, with a bronze fountain in the middle reproducing my personal star chart. There are plants in flower here throughout the year, and all of them are 'a whiter shade of pale.' For me, peace is monochrome, and colors are always a source of stimulation and excitement. For the space dedicated to Earth, I was inspired by a superb antiquarian book,

Paradisi in sole by John Parkinson, given to me by Hugh for my birthday in 1981. It is all about 'heaven on earth'—which still seemed possible when it was published in 1629. From it, I took all sorts of ideas for arrangements of herbs and medicinal plants. But I left nothing to chance. I was studying the kabbalah and its many symbols at the time, and I was careful to translate these years of reading, which had taught me so much, into the design of the gardens and their

Tea is served in the cozy Sitting Room at Auchindoune (above), on a nineteenth-century service painted by a relative of the Thane, Muriel Boyle. It features a variety of views of the estate: the castle itself to the right, and to the left, the hunting lodge at Drynachan (page 92). The bedroom known as the Tapestry Room was decorated as a bridal chamber in the seventeenth century. It features a canopied Venetian marriage bed and a cycle of tapestries commissioned and woven specially for the room in Oudenaarde, Flanders. The cost, in 1682, was £483, including £3 customs duty (pages 94–95).

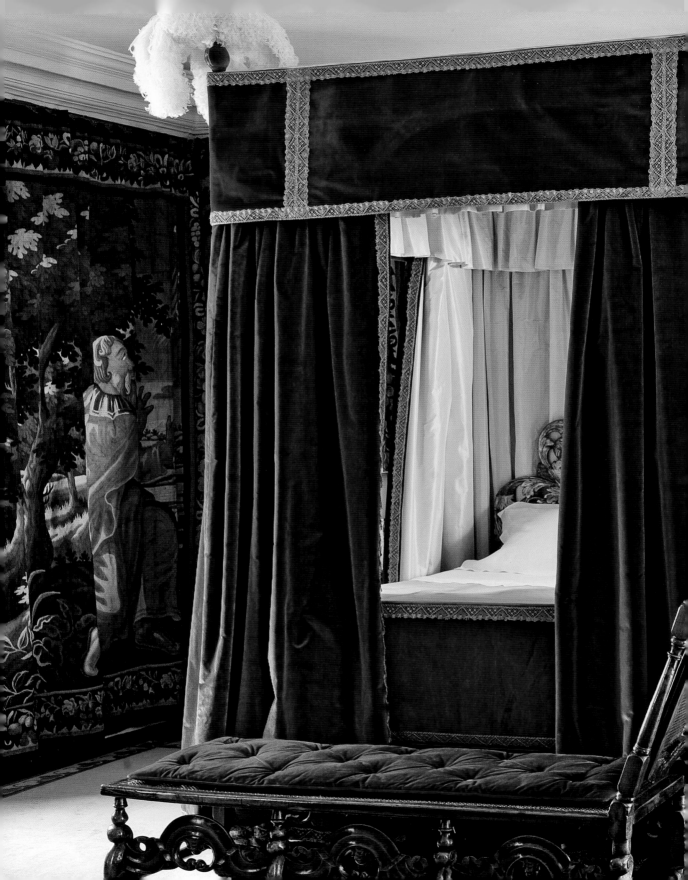

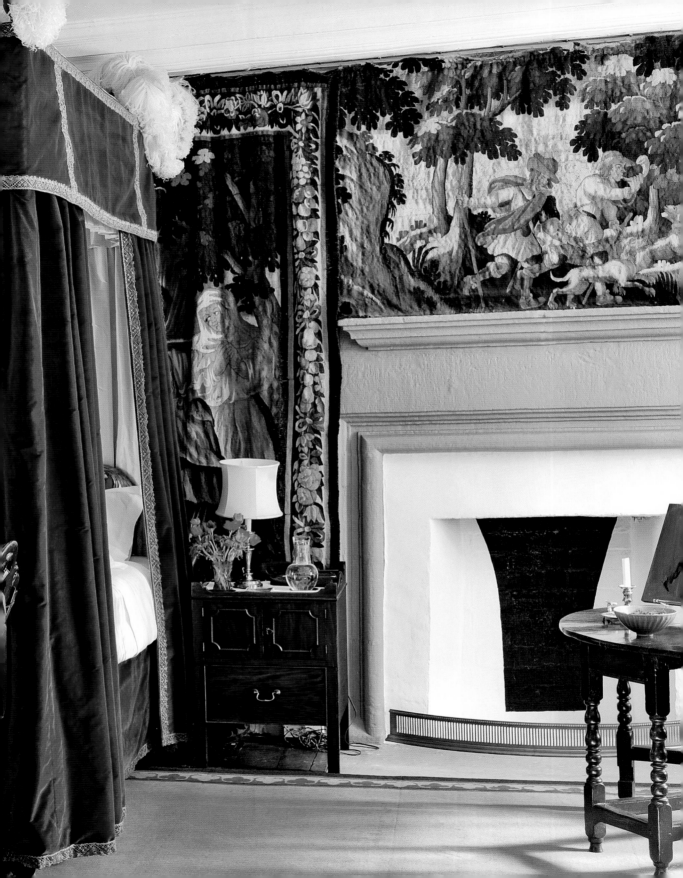

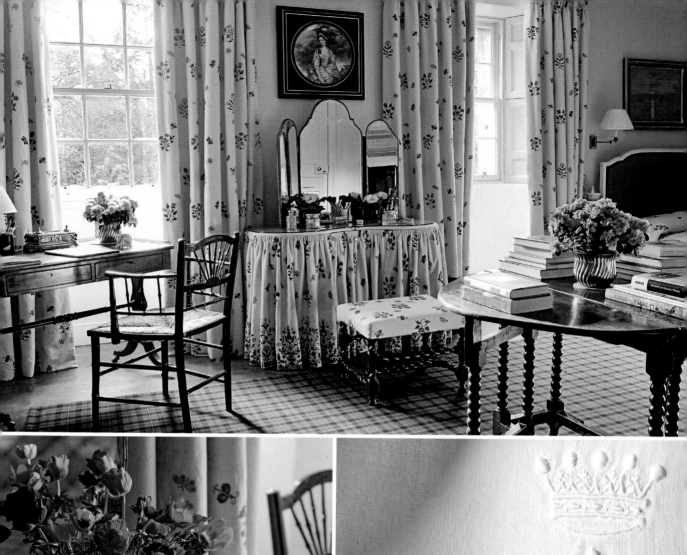

choice of plants." Goethe's theory of color was the starting point.

After Earth comes Purgatory, with a host of thorny plants from the Scots thistle (nineteen varieties) to a no less extensive and varied array of Scottish roses.

"I am convinced that everything has its place in the universe, and that all things are interconnected." Lady Cawdor's fascination with this holistic, round, all-embracing vision is further reflected in her collection of spheres, globes, and balls in crystal and onyx. A clue, perhaps, to the feeling of well-being and fulfillment experienced by every visitor to Cawdor? Paradise or not, one feels very much at the center of the universe here.

"The entrance to paradise is hard to find; I have hidden it quite deliberately. You have to walk toward the fountain created by the Spanish sculptor Xavier Corberó." The tall, delicately coiled column of bronze gleams with a rippling, purifying fall of water. And there can be no Eden without the Tree of the Knowledge of Good and Evil, with a selection of more or less forbidden fruit: old varieties of apples, quince, pears, and red currants predominate, together with wild strawberries and gleaming stalks of rhubarb.

The bedhead is silver and giltwood. The fine linen sheets, miraculously preserved since the nineteenth century, bear the Cawdor arms surmounted by the family coronet. The room's imposing elegance contrasts with the cheerful, comfortable atmosphere of the fourteen guest bedrooms, including the Green Room, with its embroidered Indian textiles and old Campbell of Cawdor tartan carpet (left and facing page).
Page 98–99: Guests staying in the Woodcock Room have only to call to enjoy a private tea. But at five o'clock, the fireside in the small Dining Room is the place to be. Scones, clotted cream, and homemade strawberry jam are served on a Meissen porcelain service.

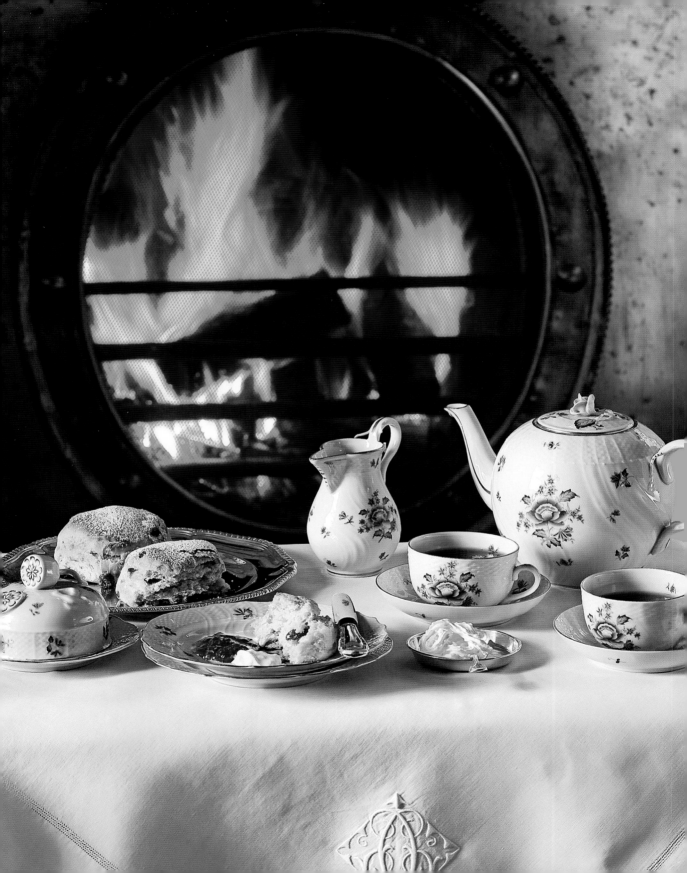

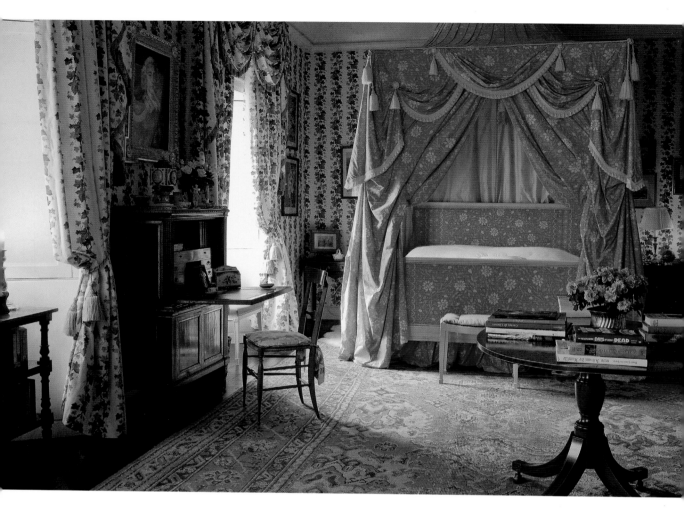

Adam and Eve Driven from Paradise, a sculpture by Georges Jeanclos stands at the center of a spiky, seven-pointed star of box hedges—a reminder that earthly paradise did not last forever. Facing these symbolic gardens, the Flower Garden was designed by Sir Archibald Campbell in 1720, during his time as manager of the Scottish estates of his nephew John, the 16th Thane of Cawdor. John spearheaded the advent of a distinctive French influence in Scottish gardens; he had crossed the Channel on official business in Poitiers, Blois, and Paris, and wrote to his uncle with a drawing of an oval rose bed bordered with lavender (the original is at the Château de Loches,

near Tours). The scheme was translated intact to Cawdor, and can still be seen today.

More generally, this section of the gardens, like most of the rest of the park at Cawdor, has remained faithful to the spirit of its creators. Here, almost the entire joyous profusion of plants dates back to the Victorian era. As a result, it may not always be to our modern taste. "The small beds of dahlias, filled with gravel, are not at all to my liking," Angelika admits. "But it would never occur to me to get rid of them. They are a part of the history of this place, and it would be all too easy to change things to conform to modern tastes. These borders were here long before

me; they will be here after I'm gone. You see these snapdragons? You can see them in a painting by Edgwood, done in 1905. Hugh, my husband, liked to point out that this garden was a product of 'affection, without affectation.' That's a wonderful definition of love, too, don't you think?"

Not the least spectacular of the ornamental features in the gardens at Cawdor are the old topiary trees, shaped like huge menhirs, bent and straightened by years of attentive, indulgent (rather than

directorial) trimming by the gardeners. Today, their forms stand like timeless sentinels reaching out to wild nature, and the world beyond.

A simple, almost hidden door leads to a log bridge over the Cawdor Burn, and what is proudly known at the castle as the Wild Garden. Azaleas, rhododendrons, bamboo, and other similarly untamable species compete for space in a riotous planting that dates back to the 1960s. The garden is also home to a number of very rare species, acclimatized

The Woodcock Room is a faithful recreation of the bedchamber used by Jolly Jack's wife Lady Caroline in Wales, in 1789. The furniture is by Sheridan and the small writing desk, by Stockel, is French (facing page and above).

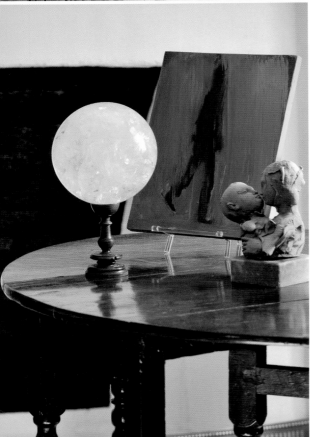

here since their introduction by Angelika's father-in-law, Jack Cawdor, who brought them home from his travels in Tibet. But the castle's main collection of Oriental plants is found nearby, in the gardens of Auchindoune, the summer dower house. Species such as *Meconopsis napaulensis*, *Arisaemas*, and *Xanthoxylum* flourish here, exotic but perfectly integrated with their surroundings.

And it was at Auchindoune that Angelika first began growing organic vegetables a quarter of a century ago—a pioneering project in its day—following methods and principles that have since been widely copied. There is a strange poetry in the desire to keep alive old—even historic—species in this place: Scorzonera, Chinese artichoke, fat garden peas "just like in the old days," and red and white Vienna cabbage.

Cawdor: the cheerful conservatory of a way of life, an art of living, a living heritage that has come down to us perfectly intact in the intimate knowledge of its fragrances and flavors. Cawdor, or the *sapientia* of the ancients; in Roland Barthes's definition: "a little wisdom, a little knowledge, and as much flavor as possible."

The bedrooms at Cawdor offer a rich variety of decorative styles: matching embroidered chintz furnishings in the Yellow Room, and twin Chippendale four-poster beds in the Pink Room. Paintings by Paul Sandy show Windsor Castle and Eton College. Here and there, crystal spheres add a distinctive touch, alongside contemporary artworks: *Man Walking toward Death* by Firmin Aguayo, and a *Kiss* by Georges Jeanclos (left and facing page). Pages 104–105: The main entrance to Cawdor Castle, with its austere, medieval drawbridge.

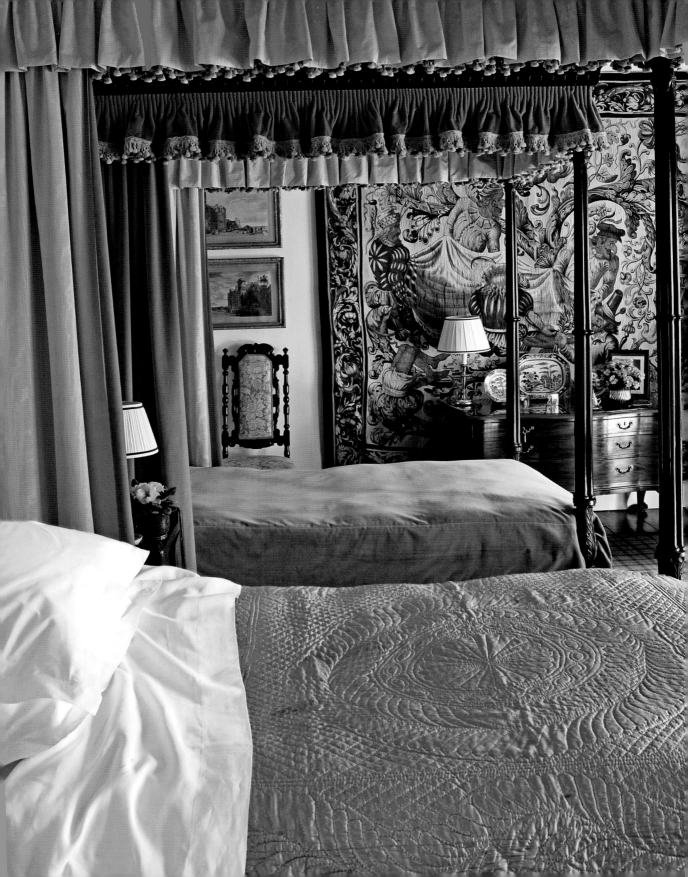

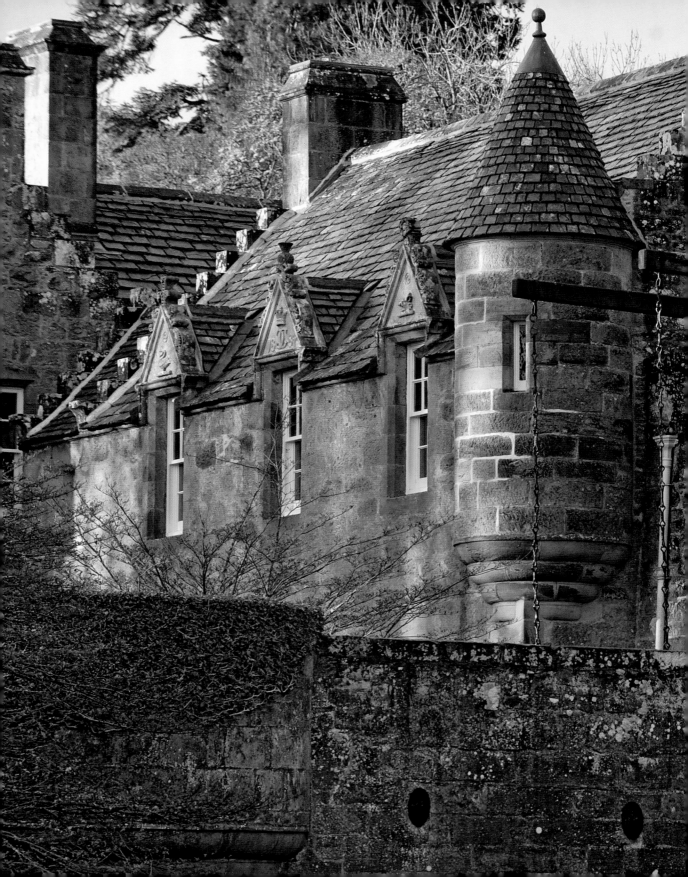

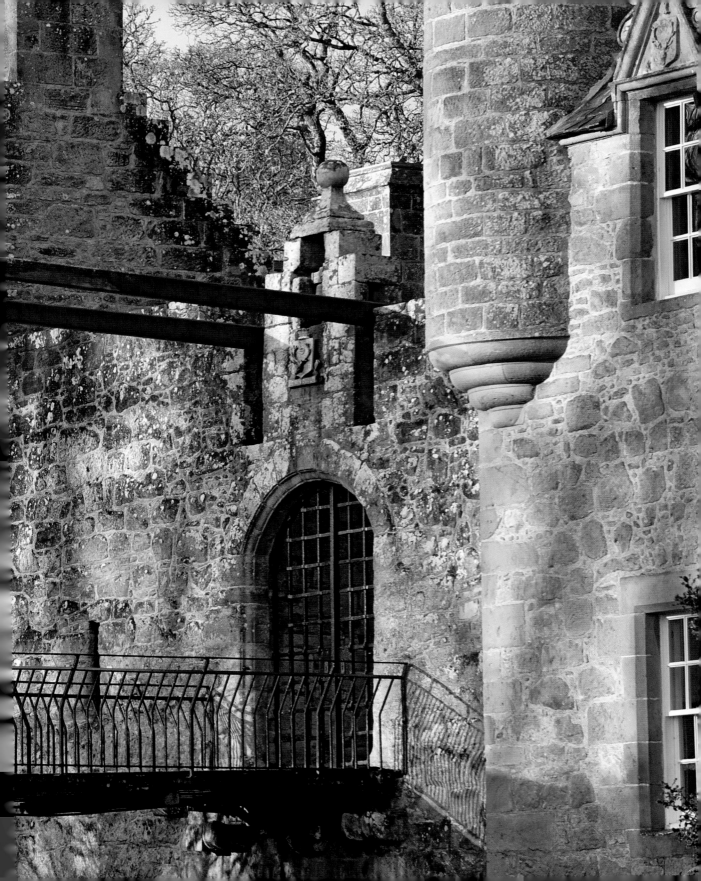

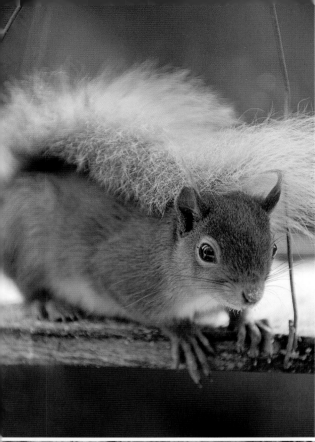

☙ THE BIG WOOD

The Cawdors have distinguished themselves down the generations by their love of trees, symbolic of the family's deep roots in the Scottish soil. At the very heart of the estate, 18,000 acres (7,284 hectares) of forest are managed with care and skill. The Cawdors have always taken a paternal interest in their trees, to the point of meting out often harsh punishment to anyone seeking to harm them.

"For us, each tree is a being in its own right. I recognize them. I speak to them as I was taught to by the Bushmen in Rhodesia. The energy currents radiating from them are amazingly real and powerful," explains Angelika, who firmly believes in the communion and interconnectedness of created nature.

Lady Cawdor's greatest joy is this fine forest of oaks, a short distance from the castle: "I prefer to think of myself as its guardian, rather than its owner." The so-called Big Wood is a vestige of ancient Caledonian forest that looks today almost exactly as it did after the end of the last ice age. Three species predominate, as they have done since the dawn of time: sessile oaks (*Quercus petraea*), notable for their tormented, twisting trunks and their knotted branches and roots, ash, and Scots pine. Alongside them, in a fragile but seemingly timeless balance, stand birches, aspens, mountain ash, white elm, and of course holly and juniper—a universal presence in these climes. The Big Wood is, then, a unique remnant—with no known equivalent—of primeval Scottish forest.

The centuries-old oaks and ash trees of the Big Wood. In this protected natural setting, the ancient stones are covered with abundant moss and lichens. The cheeky presence of the rare, protected red squirrel is another sign of the site's ecological well-being and preserved ecosystem (pages 106–09).

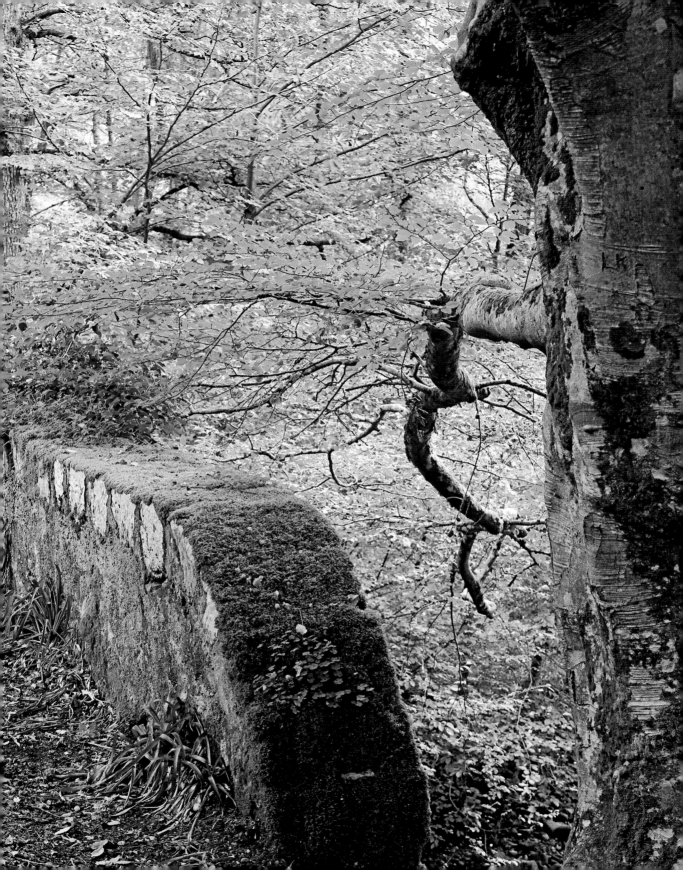

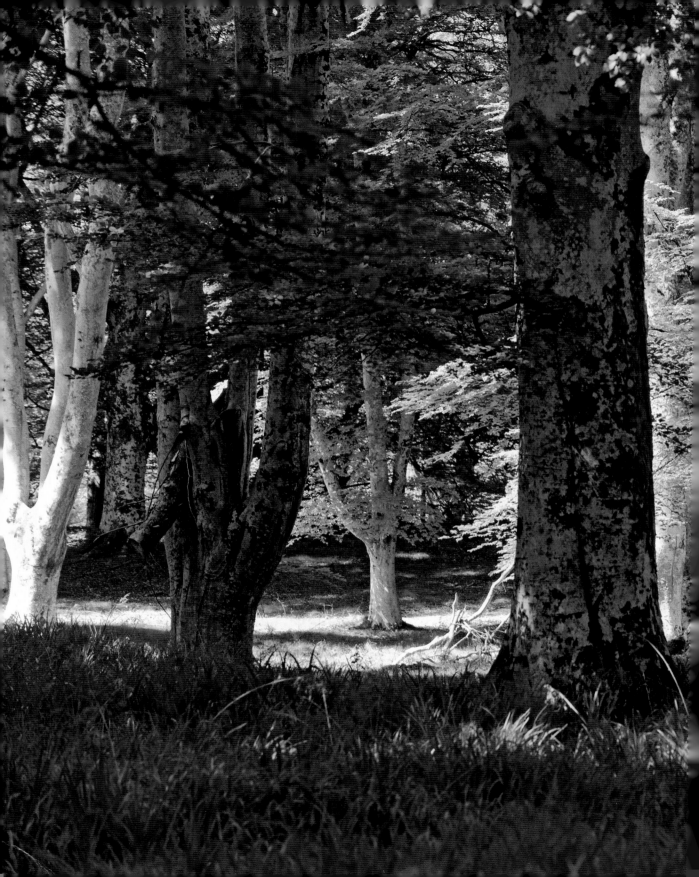

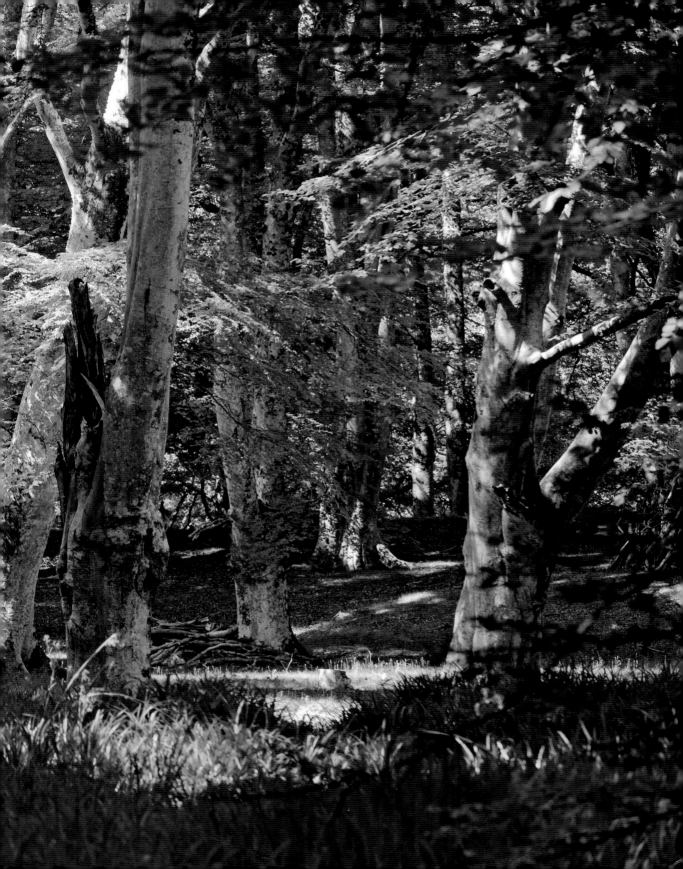

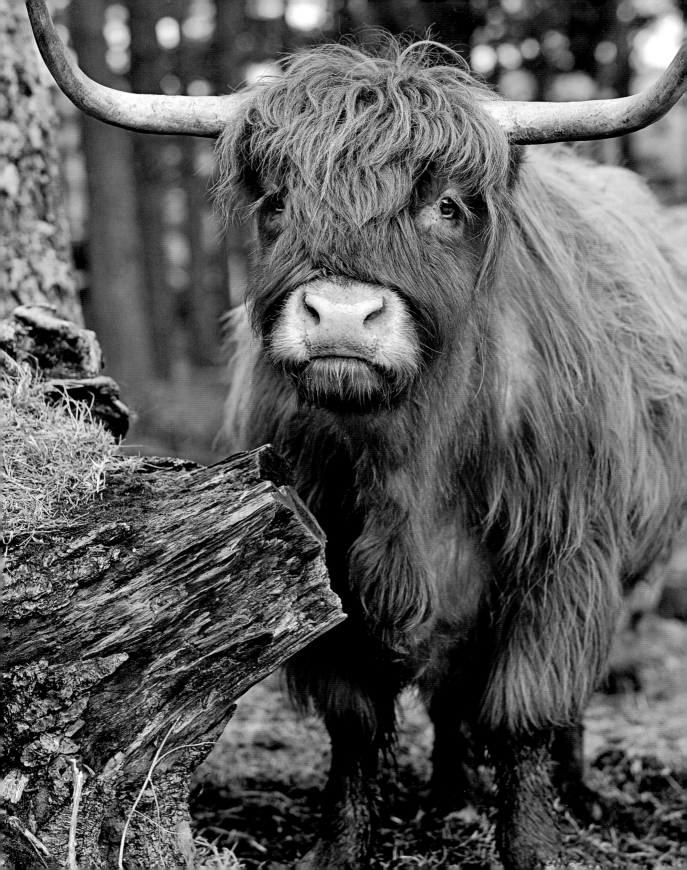

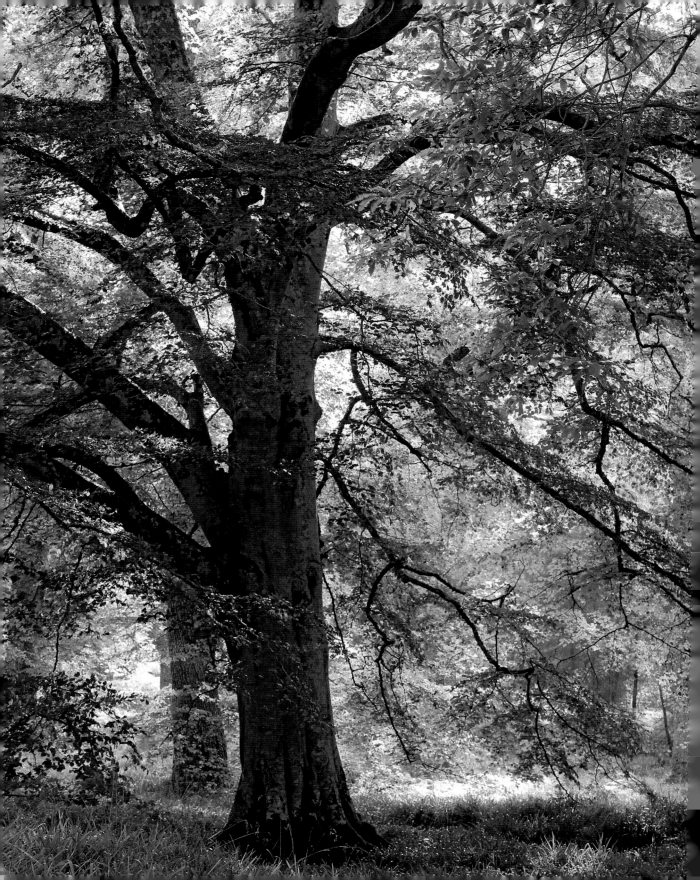

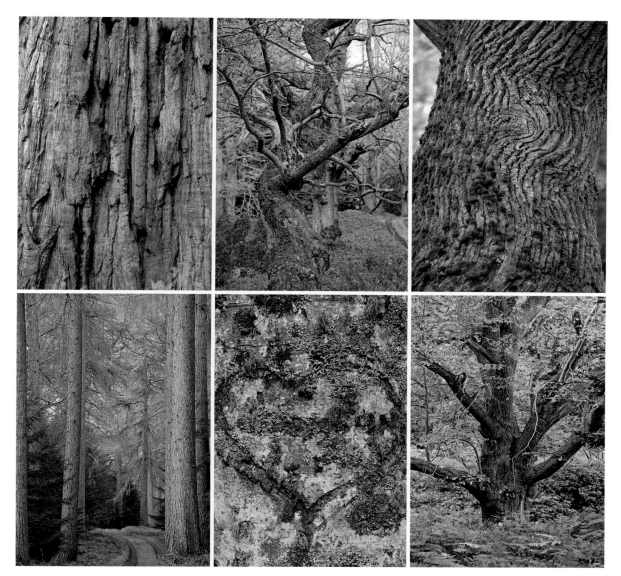

"The Big Wood is the true seat of Cawdor's magic," says Angelika Cawdor. The primeval Caledonian forest is a mix of sessile oaks, ancient beech, and rare species including a giant *Wellingtonia sequoia*, mountain oak, and larch, planted here in 1806 (facing page and above). Out on the estate, the bracken-covered hillsides and stands of lichen-encrusted Highland birches harmonize with the red-brown coats of the Highland cattle, an ancient breed whose marbled meat takes its superb flavor from the local pasture (pages 110–11).

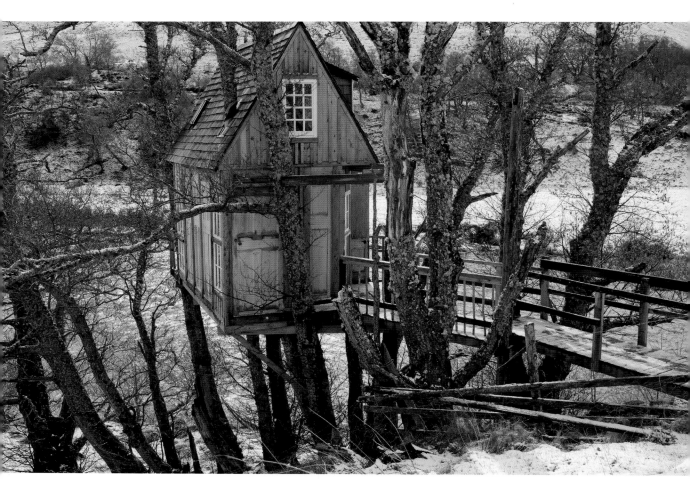

This archaic flora holds other surprises, not least over 130 species of lichens, including several found nowhere else in the world—a sign of the purity of the air and soil, and the region's curiously low rainfall.

"You can't imagine how many botanists and nature lovers one comes across on the footpaths," smiles Lady Cawdor. "Some of them sport salt-and-pepper beards, so that they almost blend in with the lichens, as if in empathy." Birdwatchers armed with binoculars and notebooks are equally dedicated, frequent visitors. And true enough, the shimmering, silvery canopy of this enchanted, age-old forest is home to a host of birds—the perfect, sylvan backdrop for a performance of *The Magic Flute*.

Zoologists are delighted to watch the courting antics of three mating pairs of buzzards, but anxious, too, for the fate of the local red squirrels, a protected species, and the buzzards' favorite delicacy.

For centuries, the Big Wood has been a source of oak, as witnessed by a royal command, issued by King James IV of Scotland to the Thane of Cawdor in 1505. This ultimate Renaissance monarch, fascinated by the sciences and seafaring, dreamed of equipping his kingdom with a fleet to match that of Spain or Portugal. To this end, James created two shipyards and launched almost forty ships. The greatest of them, the *Michael*, weighed a thousand tons and measured 240 feet (73 meters) in length. In its day, it was one of

the largest ships in the world. An entire small forest was felled to build this vessel alone.

From the mid-seventeenth century, the introduction of coal led to a drop in the demand for firewood, and it was perhaps this that enabled Sir Hugh Campbell to garner enough wooden bolts, balks, and beams to extend and comprehensively renovate the family home. Nonetheless, the archives record that, in 1720, some nine hundred oaks were harvested from the Big Wood, earning the sum of three hundred pounds sterling. The trees were replanted from

the mid-eighteenth century: a note dated 1742 records a scheme of systematic, planned replanting. During this period, the Big Wood increased in size, and acquired the multiplicity of species we see today.

Trees from the forest were logged for the last time just before 1806, to satisfy the British navy's demand for oak on the eve of Admiral Nelson's naval victory at Trafalgar. How far did wood from Cawdor contribute to the naval supremacy of His Most Gracious Majesty? Local tradition knows the answer. The forest's thriving population of larch

On the banks of the River Findhorn, the tree house is a delightful hideout for the children of Colin, the 7th Earl Cawdor, who often organizes picnics here. The Caledonian forest offers further surprises: *Pleurotus* mushrooms known as "tree ears," or this beech root covered in moss (pages 114–17).

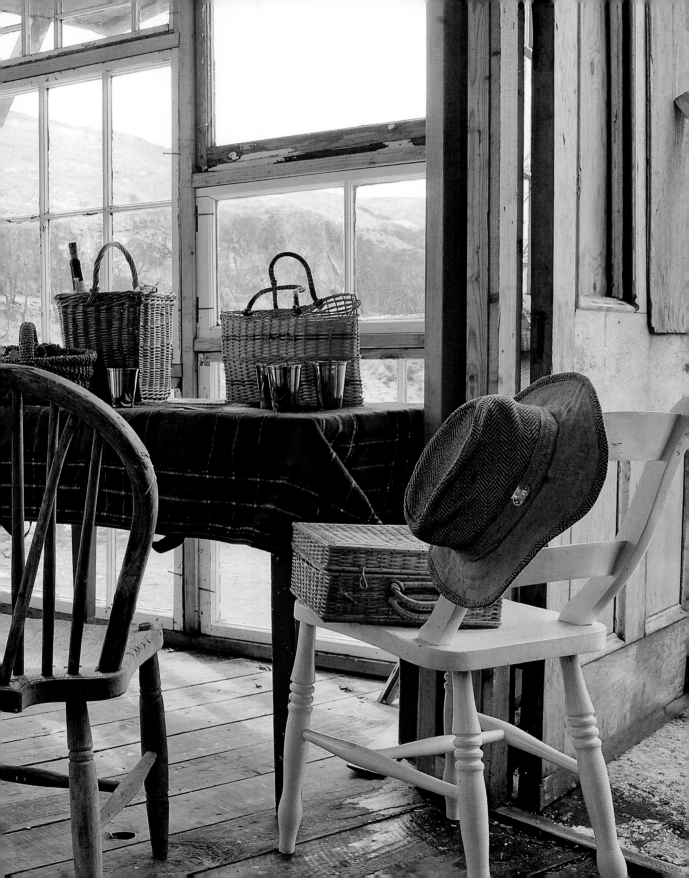

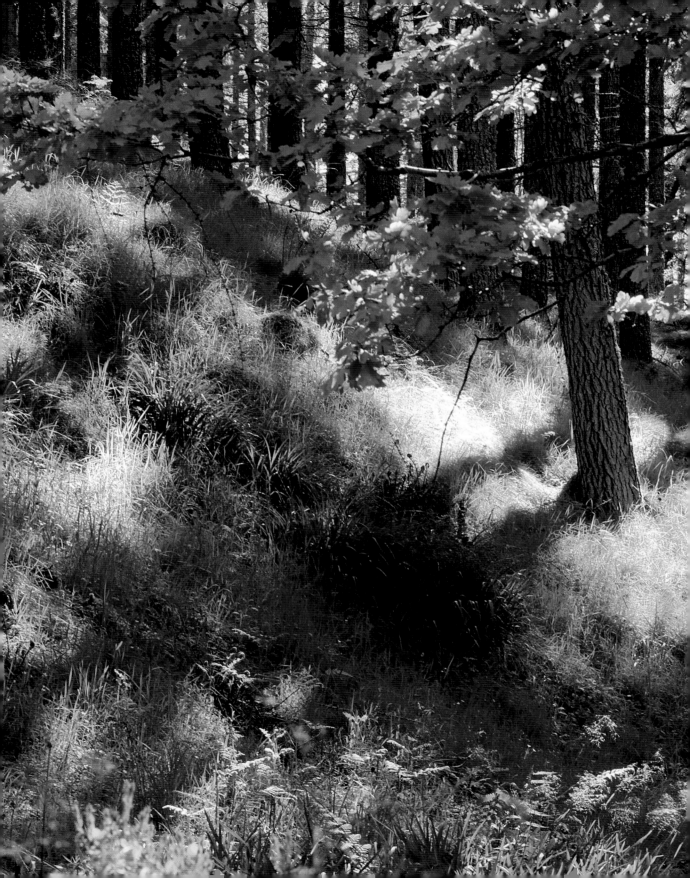

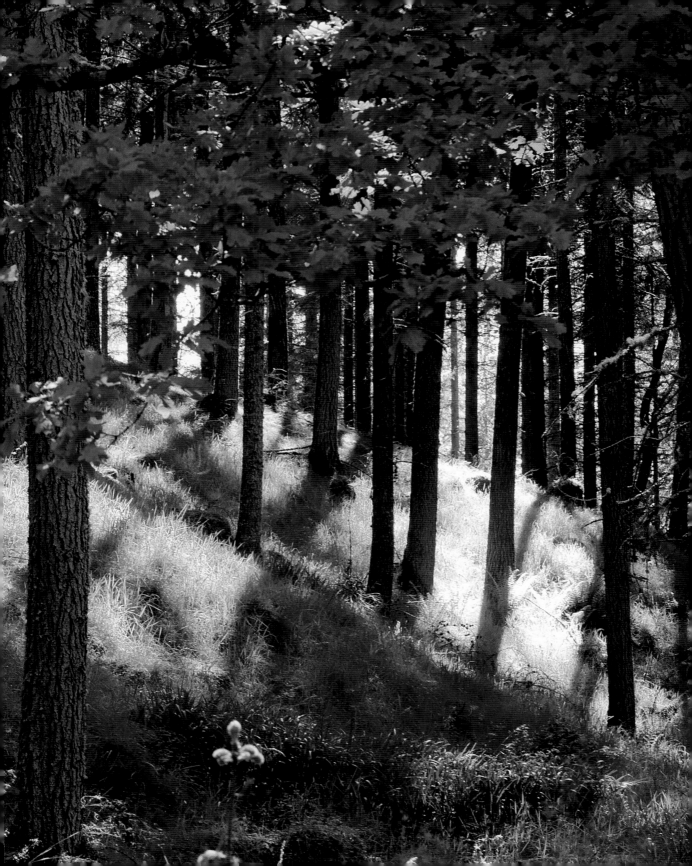

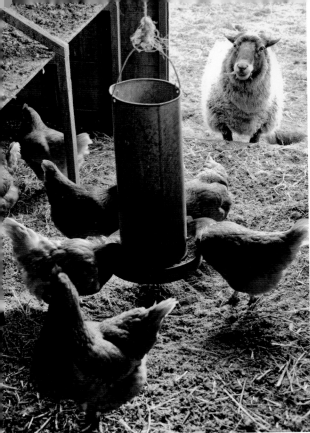

testifies to the last great logging program: the larch trees were originally planted as supports for great oaks that were subsequently felled.

In 1953 the so-called "great gale" damaged the canopy of this imposing forest. Modern stewardship of the Big Wood—controlling the number of saplings that are allowed to develop, and managing their subsequent growth—is a product of this disaster. Hence, for the past fifty years, what looks like a wholly natural forest is in fact the product of skilled, unobtrusive management, in perfect harmony with nature. Above all, it is essential to control the proliferation of certain species, which could harm the forest as a whole—in particular the rhododendrons, whose beautiful flowers belie their true nature as rampant invaders. Scarcely a year goes by without disease affecting some corner of this otherwise magical forest, to the concern of botanists, and Angelika.

Spring is the best time to discover the Big Wood, when the uneven ground, heaving with twisted roots, is covered with wild pea flowers, bluebells, ferns, moss, and honeysuckle. A splendid sight that should not blind us to the extraordinary efforts necessary to preserve this place.

The castle chickens, raised in the open air, are often visited by the Scottish Blackface sheep. The estate's organic produce is served at Lady Cawdor's table, and in the restaurant when the castle is open to the public. The estate also includes 80 cottages and 14,000 acres of managed woodland (pages 118–21). Pages 122–23: An American visitor once remarked: "Most people have a black sheep in the family. The Campbells have an entire herd!"

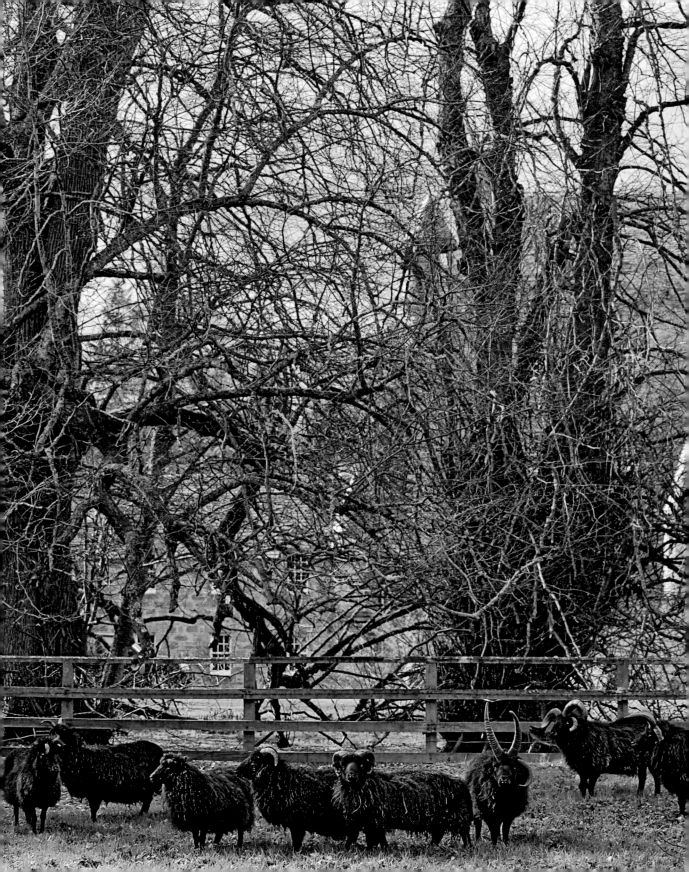

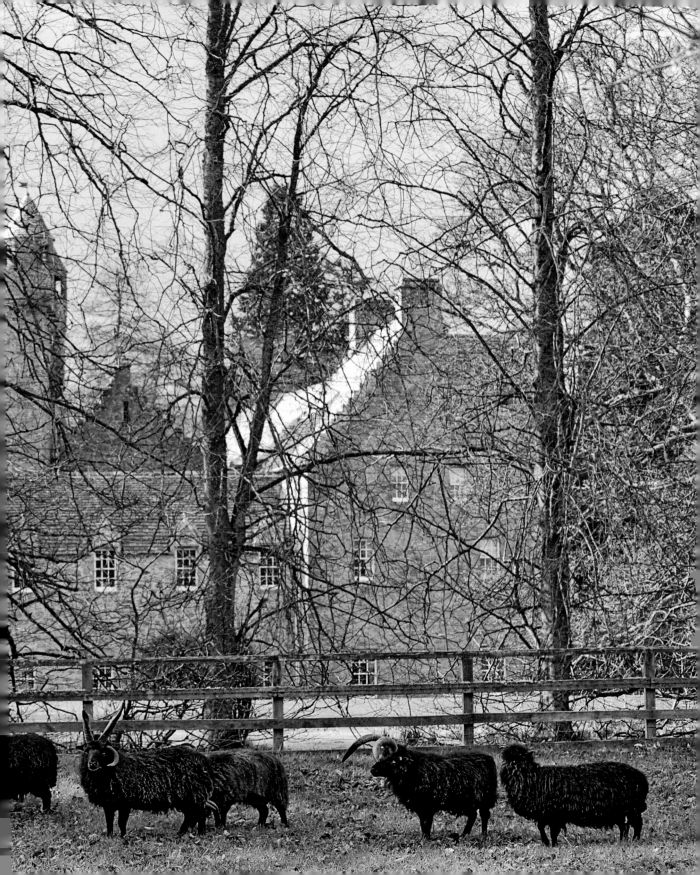

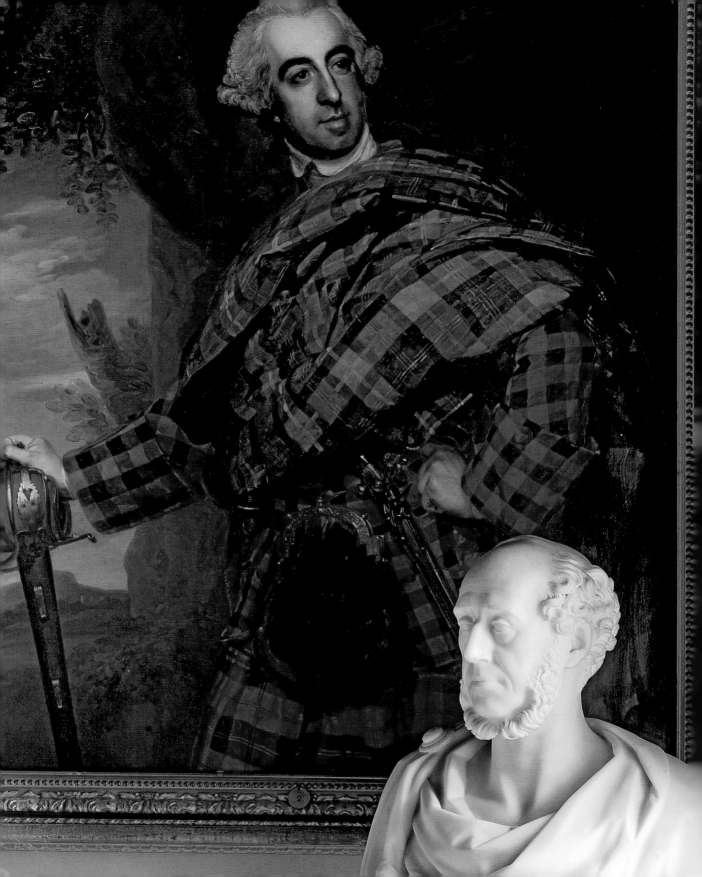

The Spirit of the Highlands

Our tale begins in the early sixteenth century: the modern fortunes of this prosperous family rest on the frail shoulders of a baby girl. The most powerful laird in Scotland, the 3rd Earl of Argyll, sought to secure Muriel's hand in marriage for his son, John Campbell. Rejected by the Cawdor family, but undeterred, John abducted the girl from Kilravock Castle, the home of her maternal grandmother. To guarantee her granddaughter's identity, and prevent her substitution, the poor woman had just enough time to brand her buttock with a red-hot key from the fire, while her nurse bit off the end of one of her fingers! The child's uncles set off in pursuit of her abductors, and even succeeded in killing half a dozen of their number. But to no avail: all they recovered was a decoy, a straw dolly bundled up in the little girl's clothing. And so Muriel, 9th Thaness of Cawdor, was raised at Inveraray, where she was finally married, upon coming of age, in 1510, to Sir John Campbell of Argyll. Contrary to all expectations, the story had a fairy-tale ending: the marriage was a happy one, blessed with thirteen children, all of whom lived at Cawdor, and from whom the Campbells of Cawdor are descended.

And so the Campbell boar joined the stag's head and shield of the Cawdors on the family crest. The Argylls' reputation for violence remained undimmed, nonetheless; in Scotland, a piece of bad news is traditionally prefaced by the expression "The Campbells are coming!"

Above the ancient Drawbridge, visitors are greeted by a motto: "Be mindful." This is probably a variation on the old motto of the Campbells of Argyll, *Ne Obliviscaris*, "Do not forget." And yet, down the centuries, mindfulness has not been a notable virtue of the Campbells of Cawdor. In the middle of the seventeenth century, John Cawdor went mad under the influence of potions administered to him by his wife; his son Colin died from plague contracted at the University of Glasgow. And a century later, John Cawdor, known as "the Welshman"—an ardent supporter of Charles Edward Stuart—very unmindfully urged his countrymen to sport the tartan when the English had forbidden it, after the defeat of the Highland lairds at Culloden in 1746.

Angelika's favorite character is the latter's grandson, also named John, but nicknamed Jack or, more precisely, "Jolly Jack."

The Campbells are not known for leaving their convictions at the door, with the boots and flower baskets (facing page). Pryse Campbell, 17th Thane of Cawdor—painted here by Francis Cotes in 1762 (page 124)—defied the English ban on emblems of Scottish culture and nationhood by proudly wearing his clan tartan. Pages 128–29: Scottish Blackface sheep graze peacefully on the moors at Drynachan, amid the late-flowering heather.

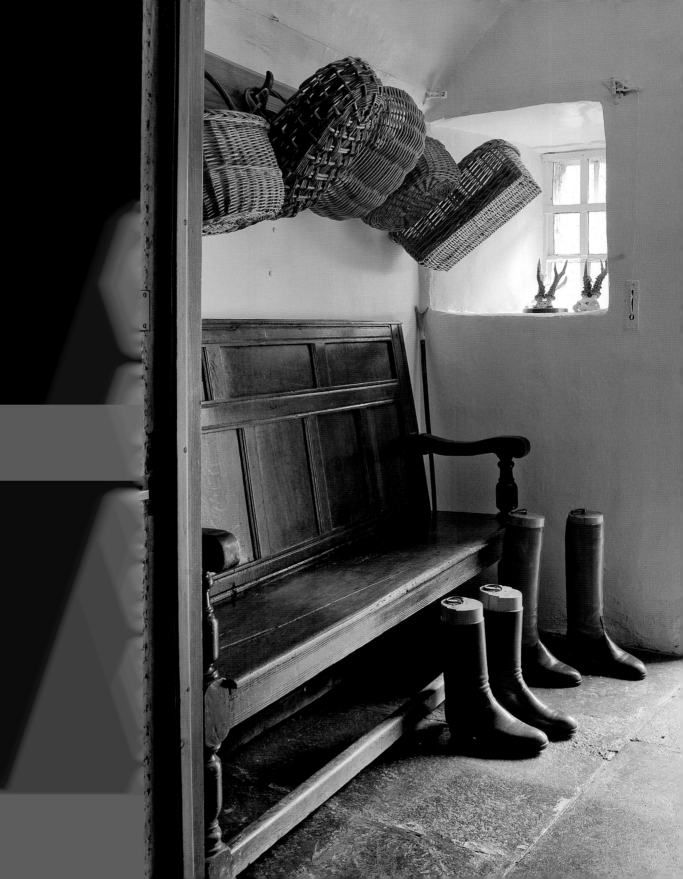

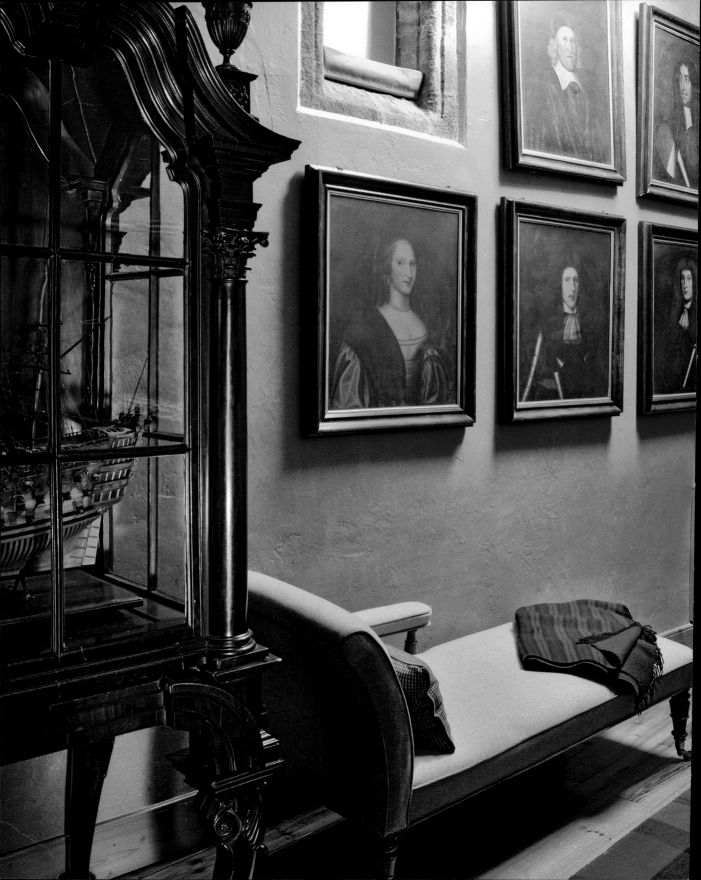

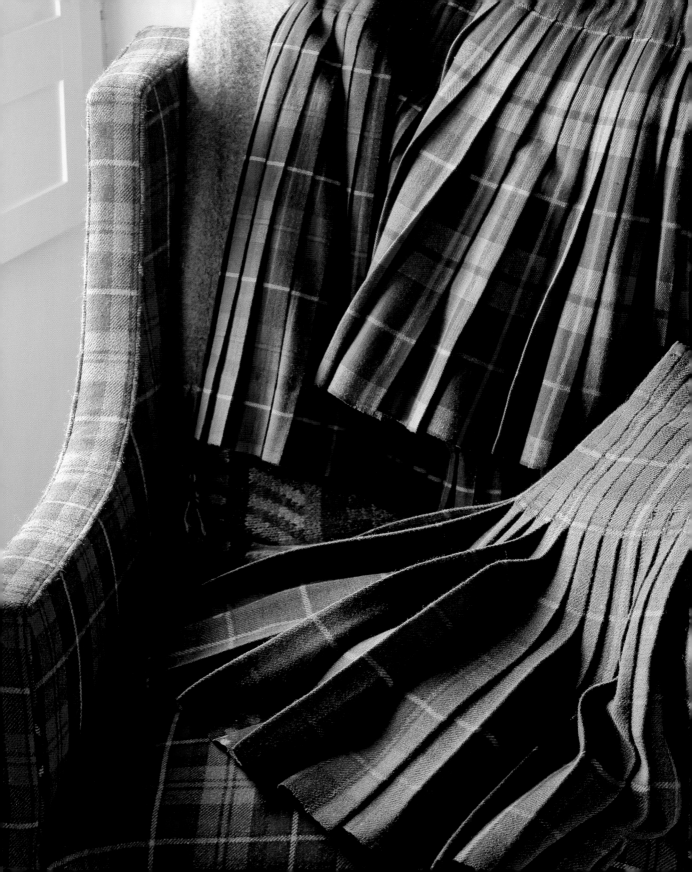

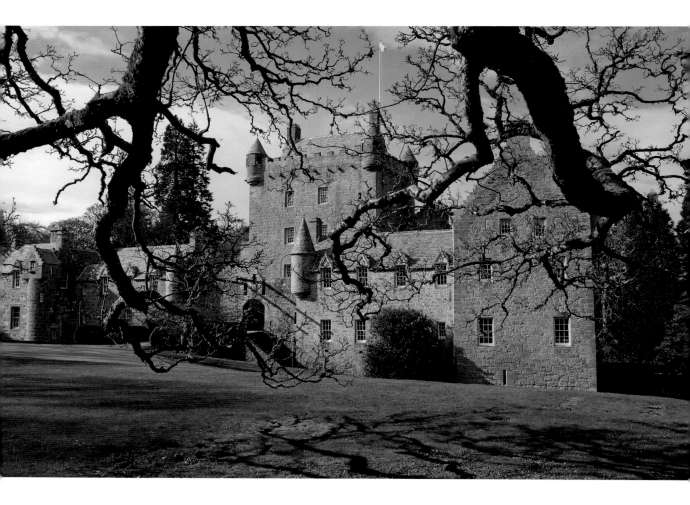

"Jack Campbell was a true eighteenth-century 'dilettante': an enlightened collector, art lover, landscape gardener, and traveler. In other words, an out-and-out charmer."

Jack was indeed the embodiment of the ultra-refined top rank of British society, many of whom seem to have decamped en masse to Italy during this period. It should be noted that Jack's cousin, Charles Greville, was the man who introduced Emma Hart to Lord Hamilton, the British ambassador to Naples, whom she married before becoming the notorious mistress and love of Admiral Lord Nelson.

Jack's museum, his antiques, his collection of Canova sculptures, sapped his fortune to such an extent that his cousin—one of the founders of Coutts, the bank of the British royal family—urged him to adopt a less extravagant lifestyle, even recommending that Jack should sell his London house and move to

On kilts and throws, soft furnishings, even the carpet: the Cawdor tartan has been revived in recent decades (pages 130–31). The tartan is worn proudly by piper Roddy Ross, exciting the interest of visitors and playing an early morning wake-up call for Lady Cawdor (facing page). Pages 134–35: For thousands of years, Highland peat has gathered its lambent energy from the pure water, mosses, lichens, and heather roots.

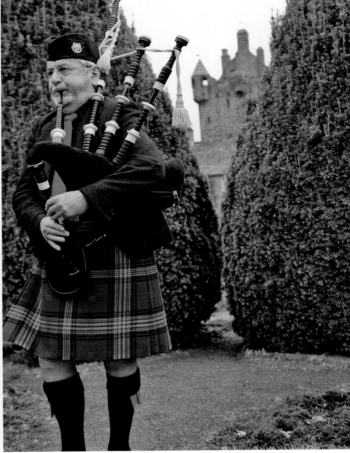

the country. And so Jack came back to Cawdor, where he set about embellishing the castle in his own style, in particular planting a host of trees. His art collection was dispersed in around 1800, to the great regret of his descendants today: one of the very few surviving pieces at Cawdor is a painting of the genial spendthrift, by the studio of Canova. Jack is shown admiring one of the sculptor's greatest works, *Cupid Awakening Psyche with a Kiss*, a work he commissioned, but which was captured by Napoleon's General Murat when French troops entered the city of Naples. The statue was subsequently presented to Napoleon as a gift from his sister Pauline Borghese, and is now one of the highlights of the Louvre collection. "Jolly Jack"

is still fêted by art historians as one of Canova's first and greatest patrons. Canova's *Fountain Nymph*, one of the masterpieces of the British royal collection, was carved for Jack but subsequently demanded by the Prince Regent, the future George IV. Despite this, the Campbells only truly secured their place at court three generations later: the 3rd Earl Cawdor, Frederick Archibald, was Queen Victoria's aide-de-camp and subsequently held the same position under Edward VII and George V. His wife, Edith Turner—a notorious beauty and troublemaker—is remembered as the great renovator of Cawdor Castle; the striking neo-Gothic touches that give the castle its immediate, inimitable charm were her additions.

At the time, the Cawdors only occupied their ancient Scottish home in summer, and during the grouse season. But they remained attached to the immense estate and, little by little, it was brought back to life. The census of 1883 records the Cawdors (in last place) on the list of twenty-eight British families owning over 100,000 acres of land.

The family's definitive return to the Highlands came in 1934 when Jack, unable to bear married life in Wales, left his wife and children there and returned to Scotland to live alone at Cawdor. He was an introverted, meditative character who seemed to spend his life fleeing some inner malaise. In 1919—when he was not yet twenty—he enlisted in the Royal Navy and traveled around the world. Jack was a great adventurer who discovered an abiding passion for Tibet, taking part in expeditions from which he brought back the abundant exotic species that still thrive in the woods at Cawdor today.

In 1923 he accompanied the great explorer Frank Kingdon-Ward on an expedition to the Tsangpo gorges in search of one of the sacred high places of Tibet, a waterfall described in a handful of ancient texts. Sadly, their quest was fruitless. The Royal Geographical Society in London concluded that the celebrated site was in fact mythical. Five subsequent expeditions failed to find this Holy Grail of Tibetan Buddhism, and it was not until 1998 that Ian Baker finally succeeded in proving its existence, based on a detailed reexamination of Jack Cawdor's travel notebooks. "My father-in-law would so love to have seen his achievement confirmed!" says Angelika. "For him, the waterfall was more than a sacred place: it was a key to spiritual transformation, an open door to another dimension." Be mindful. . . .

Small Scottish pleasures: watercress, an indispensable ingredient for sandwiches and salad; *pied de mouton* mushrooms ("sheep's feet"), an autumn delicacy at Drynachan; and a walking stick based on a traditional type used by shepherds in the French region of Gers, decorated for Angelika by Jean-Charles de Castelbajac (left and facing page). Pages 138–39: A typical Highland skyscape: it's not unusual to see four seasons pass by in a single day.

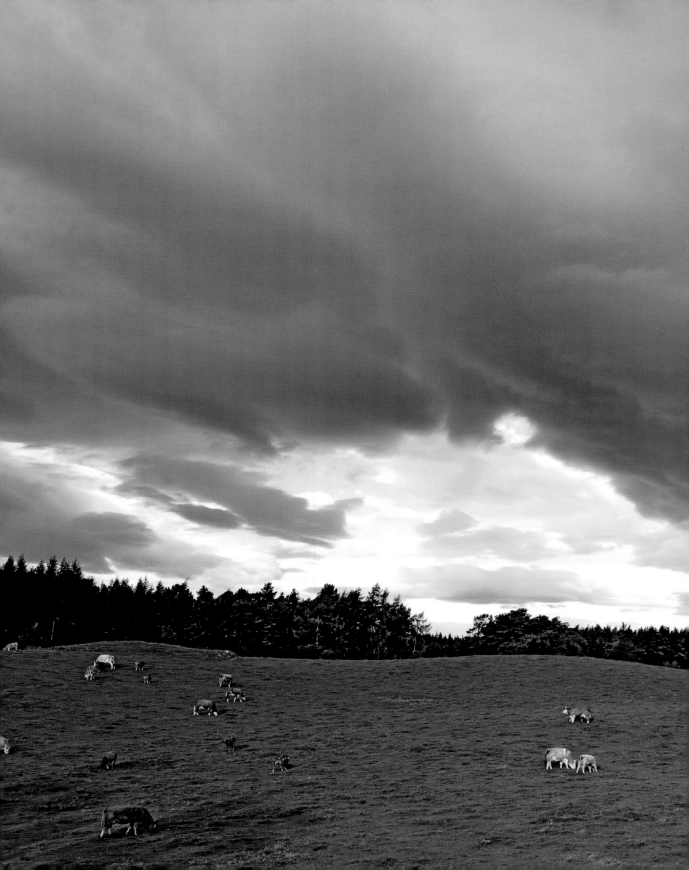

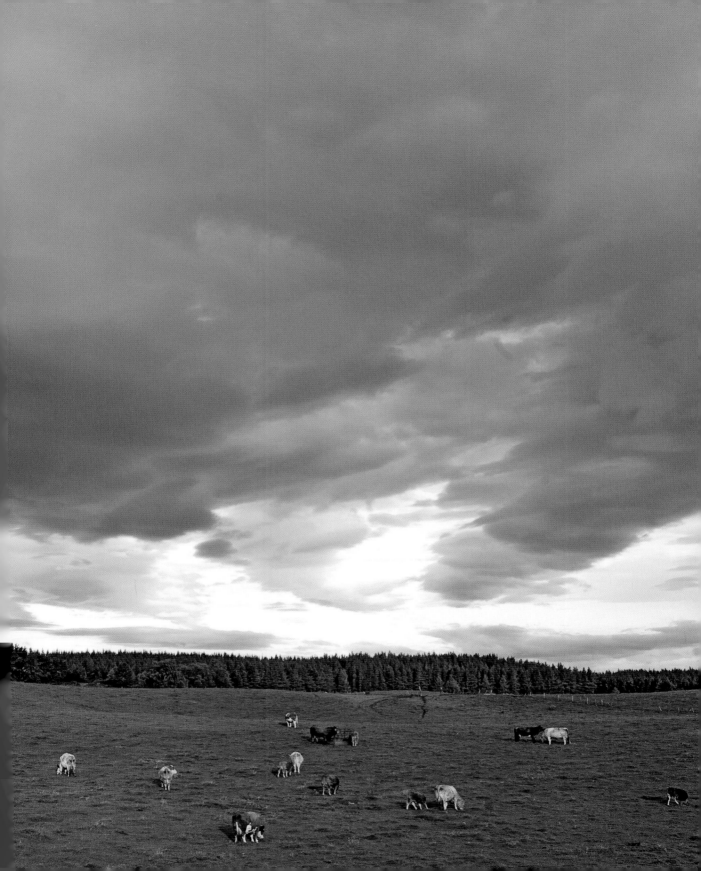

❧ FAMILY HOMELAND

Cawdor is not only a castle: it's also a vast estate. Close to the town of Nairn, 14 miles (22 kilometers) east of Inverness on the east coast of Scotland, the property covers some 58,000 acres (23,470 hectares) between the Moray Firth and Carrbridge in the Cairngorm mountains—a miniature kingdom of over 90 square miles (233 square kilometers). Progress has brought the mobile telephone and Internet, but life at Cawdor continues at its age-old, timeless pace, under Angelika's devoted, efficient management. This is the beating heart of Scotland, a guardian of ancient tradition.

But first, one age-old tradition—in the patriarchal, willful society of the Scottish clans—had to be broken, namely the convention that an estate should automatically be left to the heir of its family title. Hugh John Vaughan Campbell, 6th Earl and 24th Thane of Cawdor (1932–1993) felt that his wife Angelika, and not his son Colin, was the best person to preserve his life's work in the immediate future: to safeguard the family seat, protect its moral heritage and fabric, and communicate its ancient history to a wider public.

The 6th Earl's gesture—a shining testimony of true love—expresses his determination to see the business he founded continue and thrive. After a series of widely reported family storms, relations between the new owner of Cawdor Castle and her stepson, Colin Campbell, have entered more peaceful waters. Born in 1962, the 7th Earl and 25th Thane lives on the estate, on the banks of the River Findhorn, and is responsible for managing its game, and the hunting lodge at Drynachan. He has four

The eight days of grouse shooting on the estate are served by separate "bothies" or cabins hosting lunches of cold roast grouse accompanied by a range of salads. Trees are scarce on the moors: no one dares touch this vestige of an ancient mountain ash, known in Highland legend as a "witches' tree." A venerable old oak.

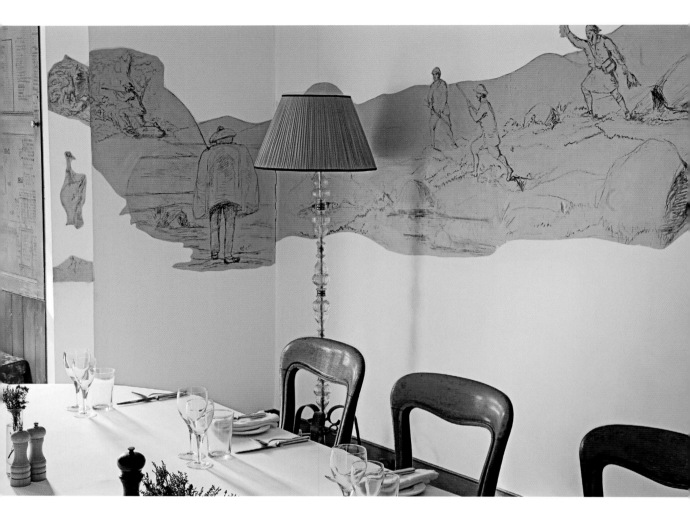

children from his marriage to Lady Isabella Stanhope, the daughter of the 11th Earl of Harrington, including the heir to the title, James Chester Campbell, Viscount Emlyn, born in 1998.

Cawdor's lairds have been Campbells since the forced marriage of their ancestor Muriel in 1510. They are, then, members of a clan—a so-called "armigerous clan," one with no traditional chief. This is not the case for the tutelary branch of the Campbells, under the clan leadership of the Earl of Argyll. Traditionally, Scottish society was governed by clan structures: the model prevailed unbroken until the defeat of the Highland clans by the English at Culloden in 1746. Prior to this, the clan—an extended family under a patriarchal leader—took precedence over the individual, and even his or her immediate family. If a crime was committed and its perpetrator was not caught, another member of his clan could be punished in his place.

In the hunting lodge at Drynachan, the more talented guests amused themselves by decorating the dining-room walls in the nineteenth century (above). An impressive assortment of chanterelle mushrooms: the picking seems to have been a success (facing page). Pages 144–45: Sunset over the Moray Firth, at the summer solstice—a reminder that the Highlands are on the same latitude as Saint Petersburg.

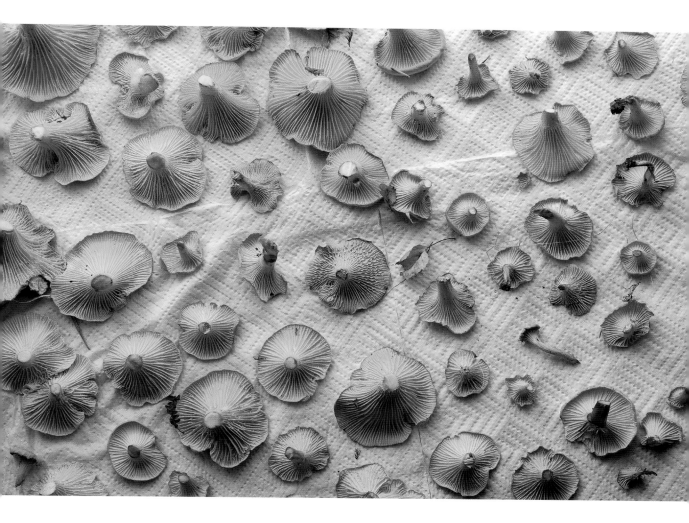

Each clan has its own symbols and emblems, notably a species of tree, a twig of which is worn pinned to the traditional Scots headgear, the tam-o'-shanter or glengarry. Clan membership is further proclaimed by the brooch used to fix the twig in place, bearing the clan's heraldic crest.

But more than the clan name, or the symbolic twig and brooch, membership of a Highland clan is proclaimed by the wearing of the tartan, a woolen fabric inherited from the early Celts, woven to a strict pattern: another tradition revived and formalized by the Romantics in the nineteenth century, when it had all but fallen from use.

More precisely, the tartan tradition as we know it today is the creation of Sir Walter Scott, the inventor of the historical novel. This influential figure—a veritable arbiter of fashion—persuaded King George IV to wear the tartan on his visit to Scotland in 1822, not only as a plaid thrown over one shoulder, in the Highland manner, but also as a kilt. Queen Victoria's consort, the German-born Prince Albert of Saxe-Coburg-Gotha, continued the fashion; his personal passion for Scotland led to the building of Balmoral, the royal family's neo-Gothic fantasy castle near Aberdeen. Some Scottish lairds were unconvinced, joking that "Germans have always enjoyed dressing up." When the English royal princes

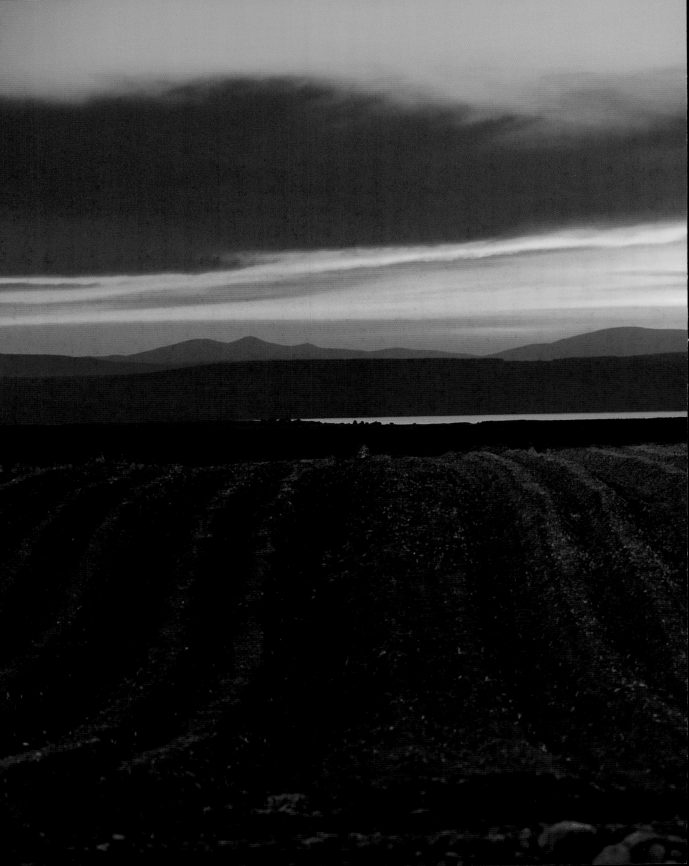

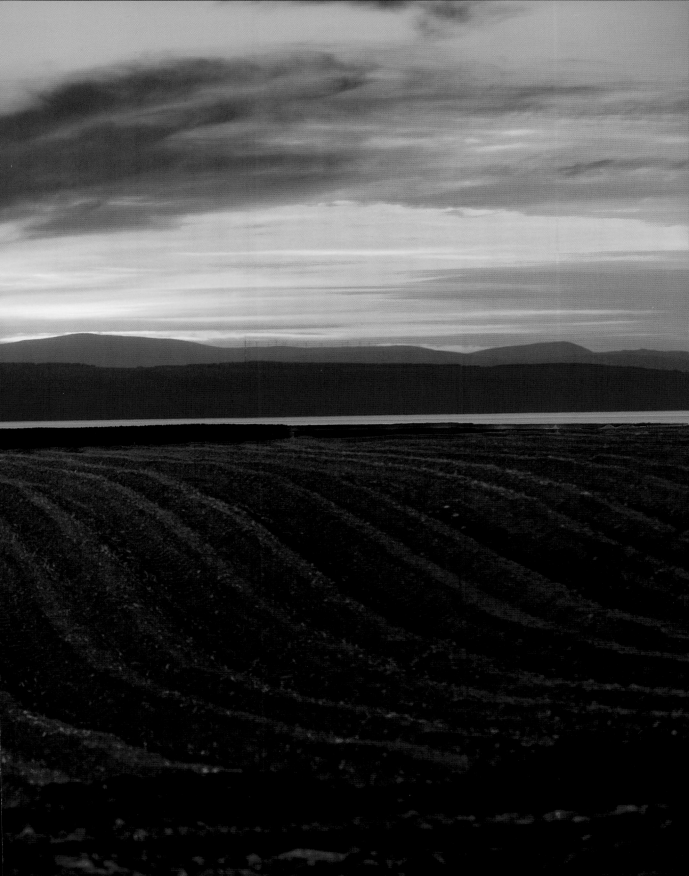

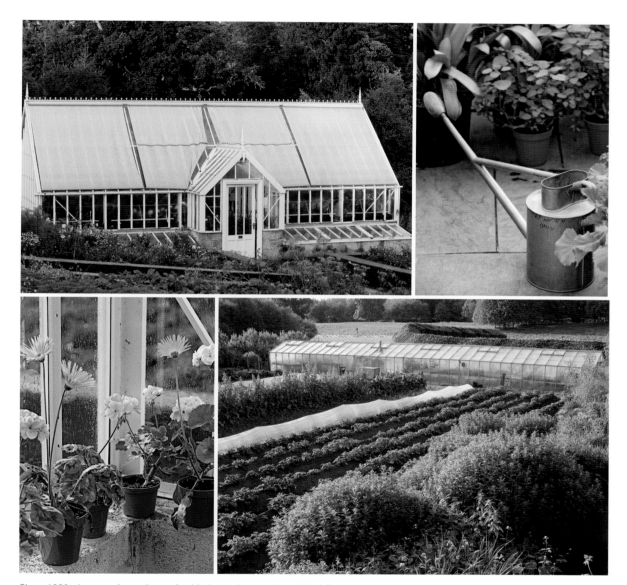

Since 1980, the organic garden at Auchindoune has employed six full-time gardeners. Auchindoune's Victorian-style greenhouse is devoted to vegetables all year round, while the Cawdor greenhouses are used to grow cut flowers for the castle, and winter vegetables (facing page and above).

wore the kilt rather longer than was traditional, out of modesty, the Highlanders poked fun at these "men in skirts." Traditionally, the kilt should always be worn three fingers above the knee.

In 1842 two brothers—self-styled Stuart Pretenders under the assumed names of John Sobieski Stuart and Charles Edward Stuart—published a catalog entitled the *Vestiarium scoticum*, codifying the attribution of each tartan pattern to a particular clan. They claimed—falsely—that it was a reproduction of an important historical document. So what modern tourists often mistake for an ancient tradition revived is in fact a product of nineteenth-century Romantic fashion.

The Cawdor tartan consists of quadrilateral grids of red and blue on a dark background of black, green, and blue squares. "Most clans have two tartans," explains Lady Cawdor, "the old tartan, and the new. The colors of the old tartan tend to blend more, because of the vegetable dyes used. A few years ago, at the foot of the north staircase, I discovered a fragment from a nineteenth-century door hanging in rather faded colors. It inspired me to recreate the old tartan of the Campbells of Cawdor."

Scotland is certainly much in fashion today: most of the world's leading couturiers have included kilts in recent collections, and tartan is seen everywhere: on neckties, vests, luggage, throws, and even

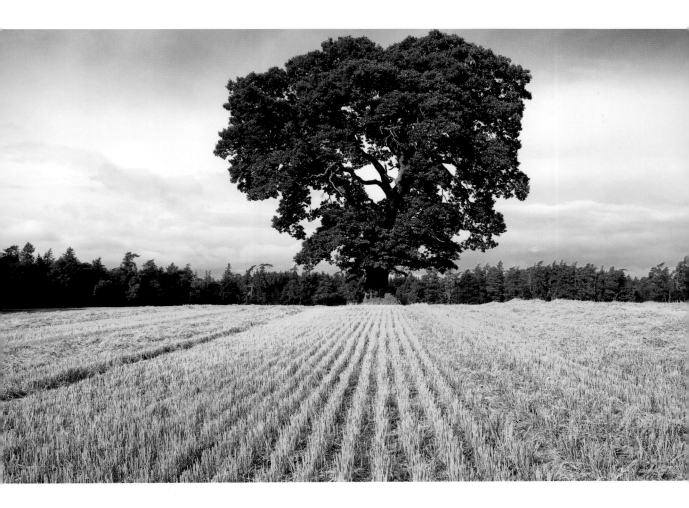

umbrellas. Tartan is also used in Scotland as a decorative sleeve for the bag or airsack on a set of pipes. It is not unusual at Cawdor, as at the Queen's residence at Balmoral, to be woken in the morning by the unmistakable sound of the piper.

Tartan and bagpipes are powerful emblems of Scottish culture that have, for the past thirty years or so, accompanied a growing and increasingly influential movement for Scottish independence from the United Kingdom: a movement whose prominent supporters include the actor Sean Connery. Wearing the kilt has become a gesture of defiance—

an assertion of the independent, proud Scottish spirit—at important family occasions, at the Highland Games (centered on drumming and piping competitions, and feats of strength including the throwing of tree trunks, known as "tossing the caber"), and on Burns Night, January 25th, when Scots celebrate the life and poetry of Robert Burns. This affirmation of identity harks back to the edict issued after Culloden by the London Parliament, banning the wearing of Scottish clan symbols.

The Battle of Culloden—the great turning point in the painful history of Scotland's incorporation

A dozen varieties of old apples grow on the estate, including Pitmaston Pineapple, Ashmeads Kernel, George Cave, and Egremont Russet (facing page). An ancient sycamore dominates one of the fields of barley, used to distill an excellent pure malt whisky (above).

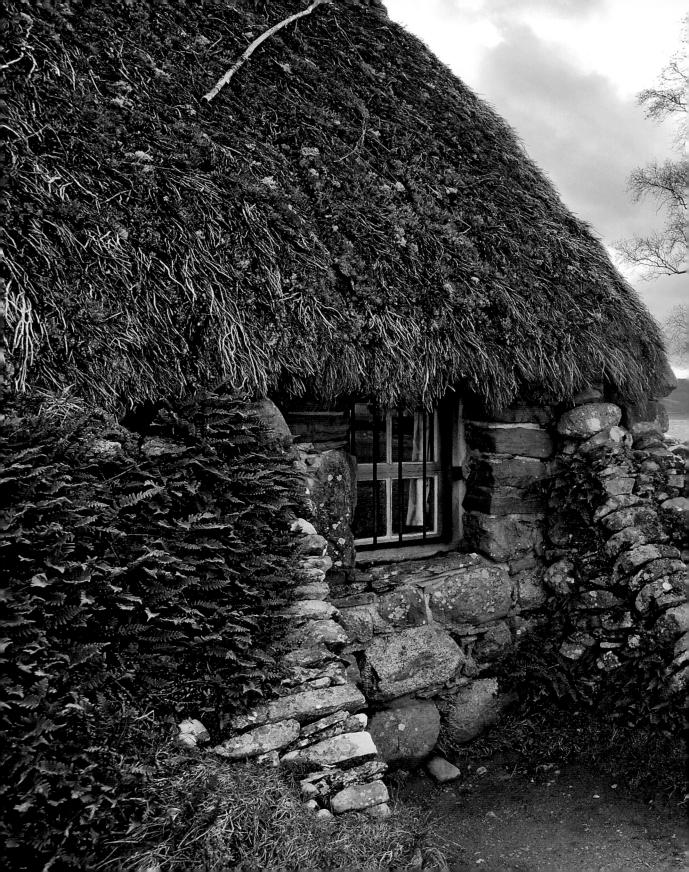

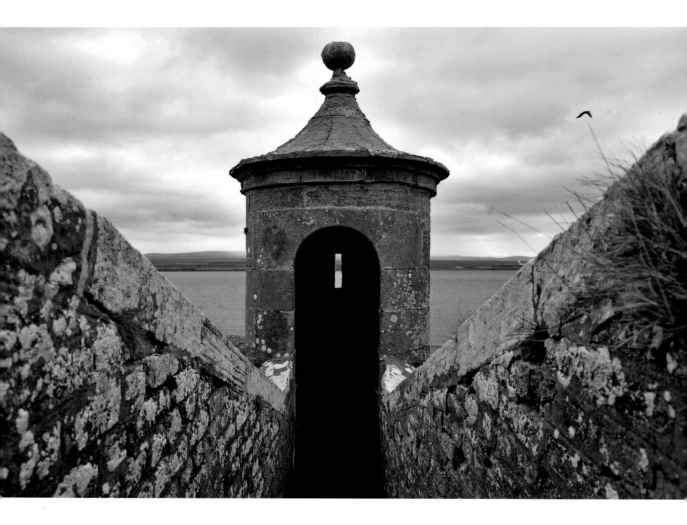

into the United Kingdom—took place on April 16, 1746, when British government troops under the Duke of Cumberland, son of King George II, crushed the army of the Pretender Charles Edward Stuart ("Bonnie Prince Charlie") at Culloden. The vast, marshy battlefield—piously preserved—is just a short distance from Cawdor.

The confrontation was as bloody as it was unequal: facing the British government troops (armed with repeat-action rifles, grenades, and heavy artillery guns), the Jacobites (mostly Highlanders) were equipped with little more than swords, daggers, axes, and huge, two-handed swords known as claymores. There could be no doubt as to the outcome: an out-and-out victory for the British army forces.

On the evening following the battle, surviving Jacobites—wounded or taken prisoner—were mercilessly executed. Fugitives were pursued into the woods, even into private homes, and slaughtered on the spot, their place of death commemorated to this

Culloden changed everything. Today, an ancient cottage roofed with heather still stands on the site (pages 150–51). In the middle of a wood, seventeen miles from the battlefield, a Highlander died of his injuries; loyal, unseen hands still bring flowers to the stone marking the spot where he fell (facing page). Fort George was England's answer to the last great Highland uprising (above).

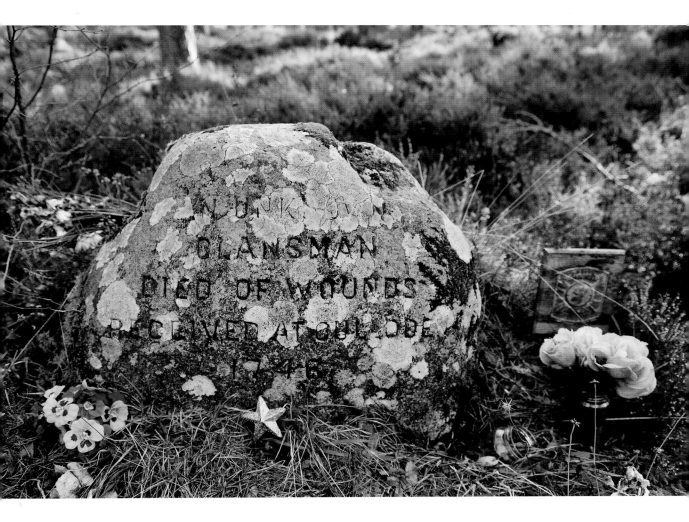

day by small stone cairns dotted across the landscape and decorated with flowers on the anniversary of the battle. It's one of the great ironies of history that survivors fleeing the horror used bridges built over the Highland streams by a celebrated English general, George Wade—part of a program of infrastructure designed to facilitate the infiltration of the Highlands by British troops. For months afterwards, the Highlands suffered merciless repression, deportations, the seizure of spoils, and show trials for the clan chiefs. Scottish culture was officially banned: the wearing of the tartan, the playing of the pipes. Clans swearing allegiance to the Stuarts were officially disbanded.

The battle of Culloden resonated painfully in the Highlands, but it was only the final, blood-soaked episode in the long history of the Stuart kings of Scotland—a tragic saga that ran and ran, from the fourteenth to the eighteenth centuries. The heart-rending description of the execution of Mary Stuart, Queen of Scots (and, for a time, Queen of France), is well known; it was carried out on the orders of her intransigent cousin Elizabeth I, the Tudor Virgin Queen. The Stuarts' family history is entangled with the long-standing religious conflict between the dynasty's Catholic supporters and the Scottish Presbyterians, intermittent allies of London. Tirelessly, and to virtually

At Pluscarden Abbey, twenty monks keep the flame of Catholicism alive in the Highlands. Their frugal meals are taken in silence. The community of White Benedictines cultivates its own orchards and kitchen gardens, dating from the eighteenth century (facing page and above).

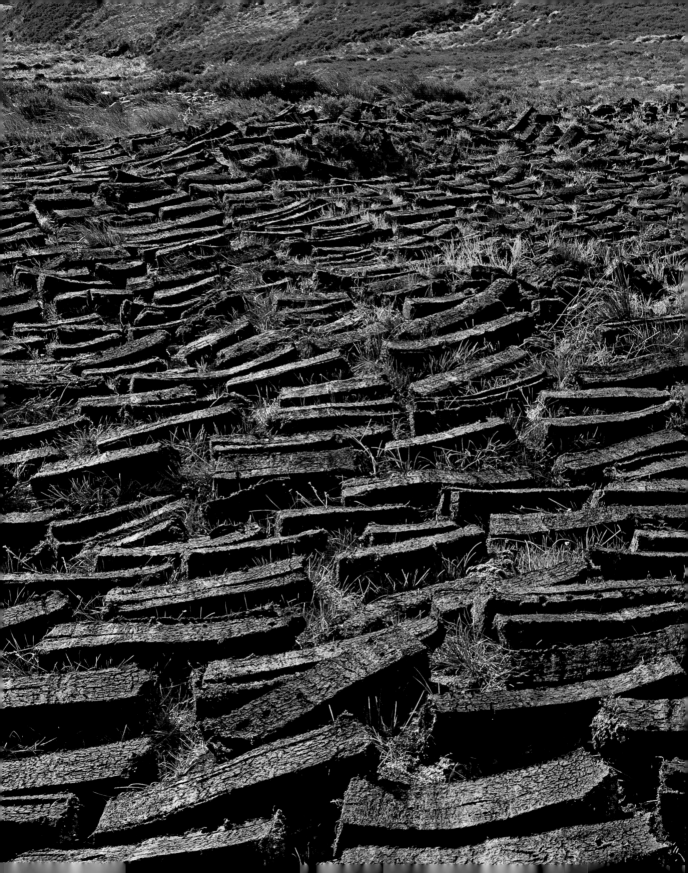

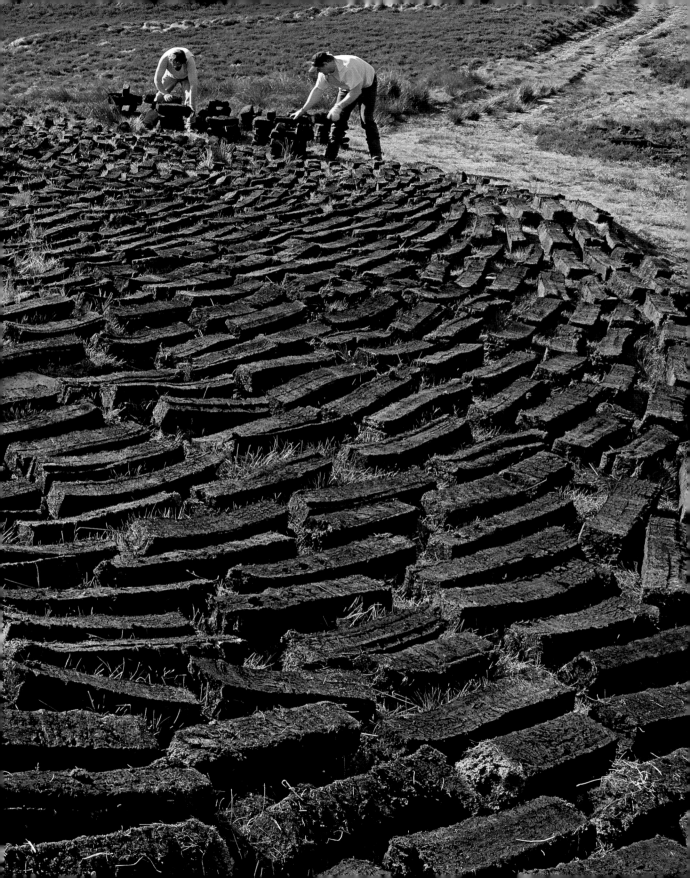

no avail, the Stuarts allied themselves with the nearest available Catholic monarchy, namely France, their partners in the so-called Auld Alliance. James VII of Scotland (and II of England) naturally turned to France when he was chased out of London after having been deposed in the revolution of 1688. James gave his name to the legitimist Catholic Jacobite movement, which was so ruthlessly put down at Culloden a century later.

The British carve-up of the Highlands is perfectly illustrated by the gigantic structure of Fort George on the Moray Firth—a Vauban-style citadel that formed part of a constellation of defenses designed to discourage any future attempt by the Jacobites or their allies to land on Scottish soil. The fort—a model of its kind—was completed in 1769, in anticipation of a Jacobite offensive that never came. It has never been disarmed and stands today as an active, pointless bastion against the seabirds and gulls, absurdly huge but imposing nonetheless. Visitors losing themselves in its vastness probably never pause to reflect that they are exploring the supreme symbol of Scottish humiliation.

The true secret of an excellent whisky is the purity of the water, filtered by the peat—the same peat that is collected, dried, and burned in local hearths. The clear waters of the Spey and Findhorn rivers support some of the world's best-known Scotch whisky distilleries, with their superb copper stills (pages 156–61).

This bloodthirsty history has left its mark. Even today, on Burns Night, Scots propose a toast to the health of their king "beyond the sea"—identified today through marriage as none other than the present Duke of Bavaria, Franz von Wittelsbach (who does not advance the claim himself).

Today, Scotland is largely Protestant, or Presbyterian. But pockets of Catholic "resistance" continue to thrive, including the Benedictine abbey of Pluscarden, established in the thirteenth century, where Lady Cawdor is a regular worshipper.

"When I first came to Scotland, I sensed a kind of ostracism with regard to Catholics," she says. "And then, quite naturally, I found Pluscarden, a place of peace and retreat." Lord Colum Crichton-Stuart, Marquess of Bute and himself a Catholic convert, supported the reinstatement of a Benedictine monastic community on the site, granting them lands inherited from the Earls of Fife, and paying for the restoration of the abbey.

During the Reformation, from the late sixteenth century, many Scots paid dearly for their Catholic faith. Traces of their persecution remain in every Highland castle, and notably at Cawdor, where the chimneypiece in the small dining room conceals a priest-hole—a hiding place for persecuted Catholic priests. An alternative, less dramatic version identifies it as a smokery for salmon and ham. But one use does not preclude the other.

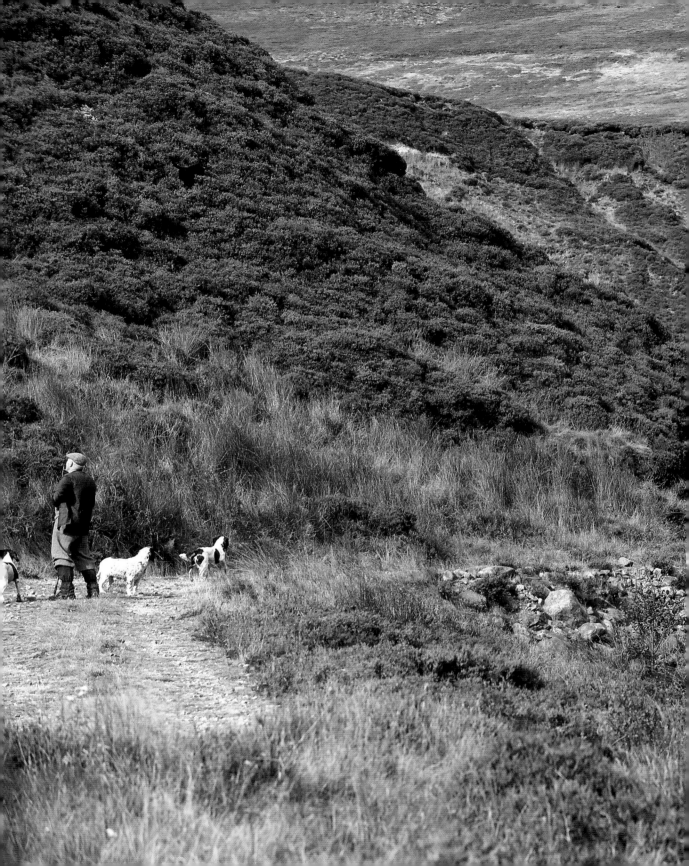

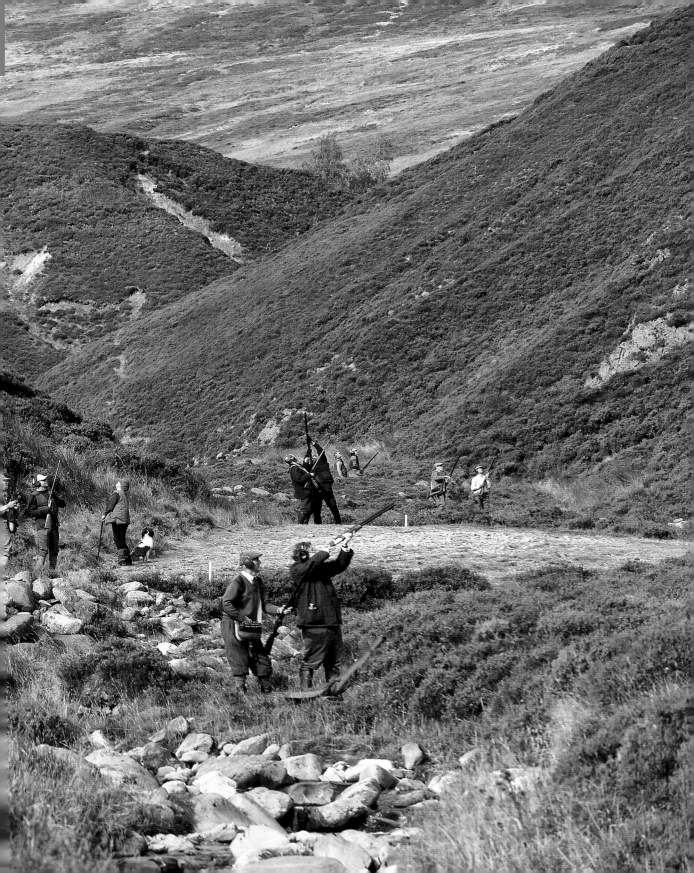

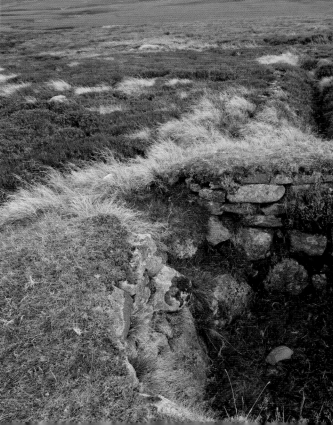

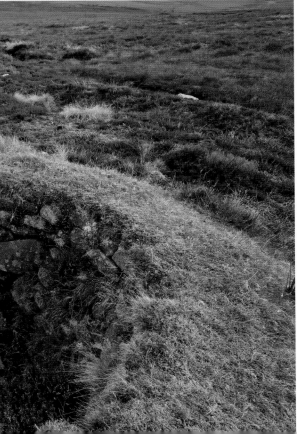

❧ GROUSE SEASON

The Dowager Countess beams, not a little proudly. "We are completely self-sufficient here," she says. "The estate supplies its own needs; we eat the game that's shot on our land, and the meat reared in our own pastures. Our fish comes from the River Findhorn; the vegetables and fruit come from the various orchards and kitchen gardens, which have been organic for three decades. Even the honey is collected by the monks at Pluscarden. Only the wine is French," she concedes, with a sly wink. Add to this, the wood harvested on the estate, wool from the local sheep, and whisky from one of the Highlands' top distilleries nearby, and it's a fair claim that the estate and region are capable of satisfying the needs of the castle's population and guests almost completely.

As a general rule, neighborly relations are difficult on a vast estate, where the next great house is an hour's drive away. "There is really no society here," admits Angelika, without the least sign of regret. "It's also the great advantage of living in the middle of nowhere—people don't drop in!"

Accepting an invitation to Cawdor takes a degree of courage, perhaps: guests at the castle can feel truly cut off from the world outside. The delicious sense of communion with nature, the comfortable accommodation, and the hostess's delightful hospitality are not always enough to convince the most hardened city dwellers. "I mostly entertain people whose company I enjoy, or who interest me for a particular reason," says Lady Cawdor. "Which probably explains the care I take over their welcome.

Traditionally, the day's bag is placed at the foot of the oak tree in front of Drynachan hunting lodge. Grouse butts are stone and turf hides carefully positioned to enable the guns to catch the grouse in flight. Grouse fly very fast and are one of the most difficult game birds to shoot. Grouse shooting attracts dedicated teams of guns, accompanied by grouse loaders and retrievers, moving through the heather with their dogs (pages 162–65).

I take enormous trouble over the menus; I consult all sorts of old 'spellbooks' and collections of recipes!" The result is a festival of tastes and flavors, concocted by Martin, the castle's head chef.

Angelika is a consummate hostess: there can be no question, of course, of serving the same guest the same menu twice—even years apart. Lady Cawdor keeps scrupulous records of guests and menus. An indispensable list of "loves and hates" details the fruit of her discreet observations at table.

Cawdor has always received its guests in fine style, as witnessed by the guest book, with an impressive line up of personalities, albeit at distant intervals. We recognize the signature of Queen Mary, the wife of George V (who was unable to resist a Chinese table at the castle, eventually returned with great difficulty by a lady-in-waiting), together with those of Queen Elizabeth the Queen Mother and the current sovereign, Queen Elizabeth II, on an almost neighborly visit from Balmoral with her husband and youngest son, Edward. The illustrious names of Hollywood stars and great thinkers stand alongside heads of government—including former French President Valéry Giscard d'Estaing, who often came to Scotland to shoot grouse.

The year at Cawdor revolves around the grouse season, starting on the Glorious Twelfth of August and ending in November. Cawdor has been a popular venue for experienced shots from all over Europe and even farther afield, since the sport began. Shooting parties are entertained at Cawdor in the finest tradition of the art, housed in old-fashioned hunting

Traditionally, a Highland croft is a small holding affording a simple living for its occupants. This is a timeless landscape of pasture, forest, and moorland (right). Pages 168–69: The pure waters of the burn (or stream) flowing through the heather on Drynachan Moor are as sweet-tasting as honey.

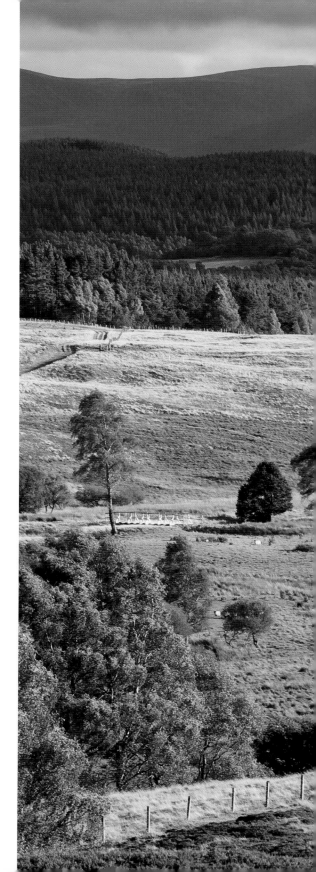

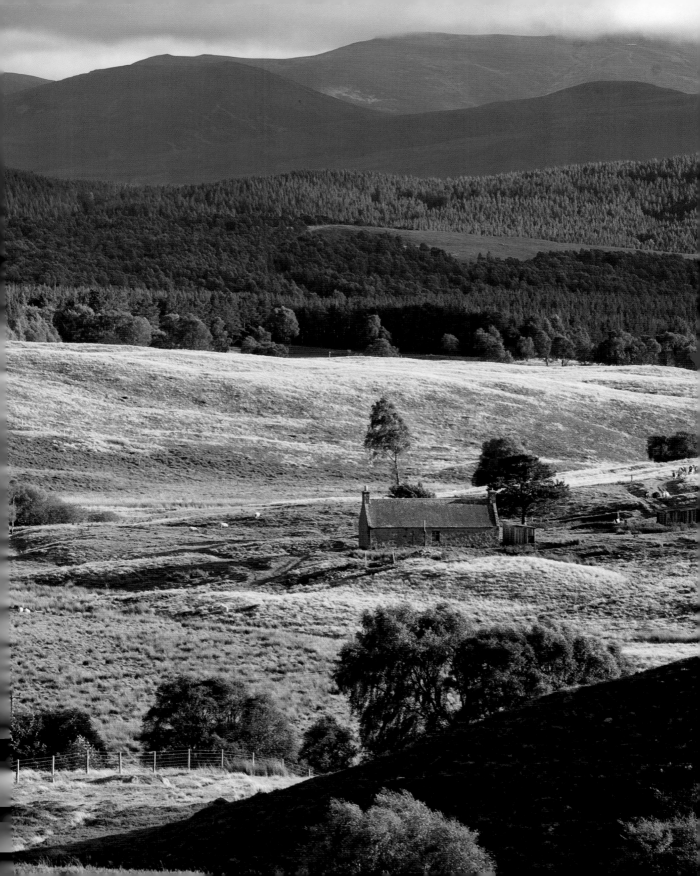

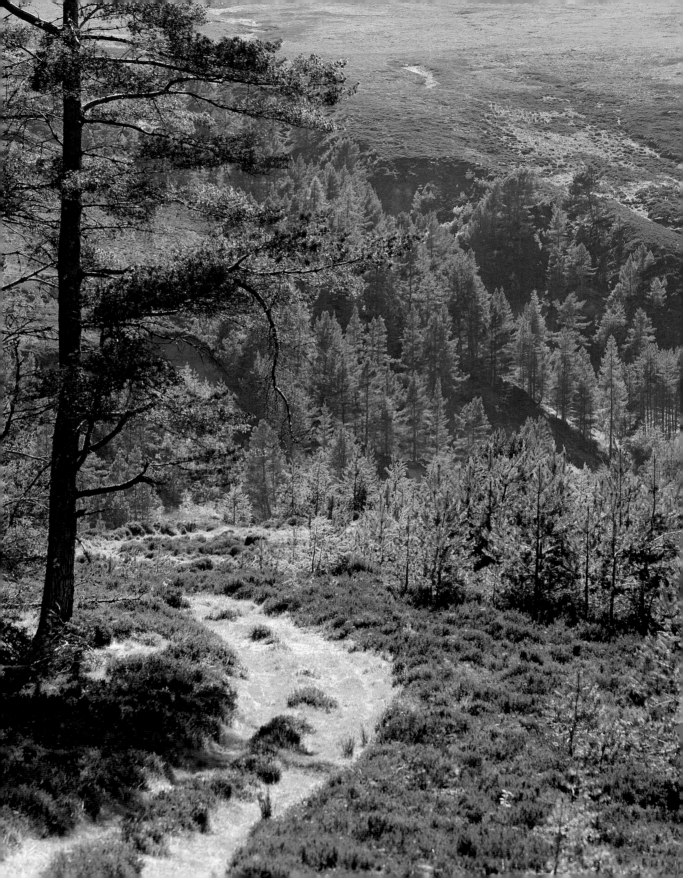

lodges like Drynachan, ideally suited to their purpose, and regaled with hearty, simple meals, always in impeccable taste.

"For a long time, three months of my year were devoted entirely to shooting," remembers Lady Cawdor. "We had our regular visitors: Baron Eric de Rothschild, David Campbell, Gérald de Waldner. The invitations were always for three full days of shooting: a Friday, Saturday, and Monday"—because in Scotland, no one would dare shoot on a Sunday.

Grouse shoots follow an exact, almost ritualistic timetable: breakfast is at 8 a.m., and beating gets underway an hour later. The guns are generally organized into teams of eight. At 11 a.m. precisely the guests—wherever they may be on the estate—are offered elevenses (a mid-morning snack): piping hot consommé with an optional dash of sherry or vodka, served with sausage rolls and mustard, or salmon sandwiches. Suitably revived, the party continues until a picnic lunch at 1:30 p.m., served at one of eight sites around the estate: hams, cured and smoked meats, grilled vegetables, and salads, washed down with fine wines. More traditionally, the midday meal on a shoot would consist of haggis with a tot of vintage malt whisky.

"Hugh adored that," remembers Angelika, nostalgically. The party is rarely back at the lodge before 5:30 p.m., just in time for tea. Dinner is served at half past eight; the dress code is refined and elegant, but comfortable and relaxed—velvet jackets and turtleneck sweaters for the gentlemen, dresses for the ladies.

"At the time, there was no question of shooting anything other than wild grouse," says Angelika. But climate change and the advent of that tenacious parasite, the tick, have taken their toll on the delicate grouse population. Now, the estate rears partridge for release during the shooting season.

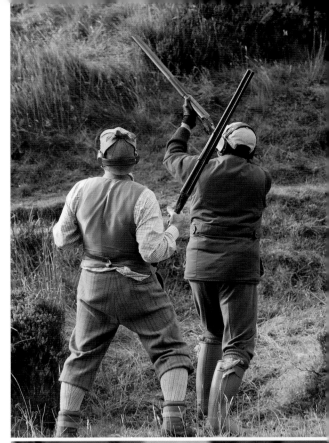

During a shoot—in the glen at Drynachan and elsewhere (facing page)—the guns choose their positions by drawing lots (right).

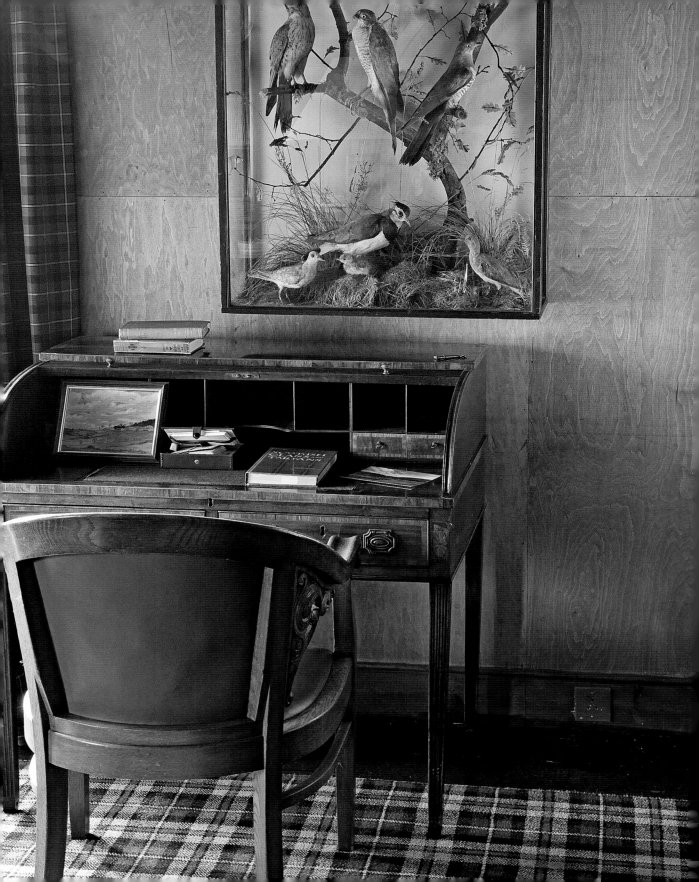

Pages 172–77: The hunting lodge at Drynachan, in the heart of the Highlands, can be rented for vacations. The accommodation reflects the building's rustic vocation and the nobility of the nearby castle. The lodge's unique atmosphere offers shooting parties and vacationers an unparalleled chance to relax in unspoiled natural surroundings. The only sound is the gentle rush of the River Findhorn. The lodge's "game book" has been carved into the window shutters since the nineteenth century.

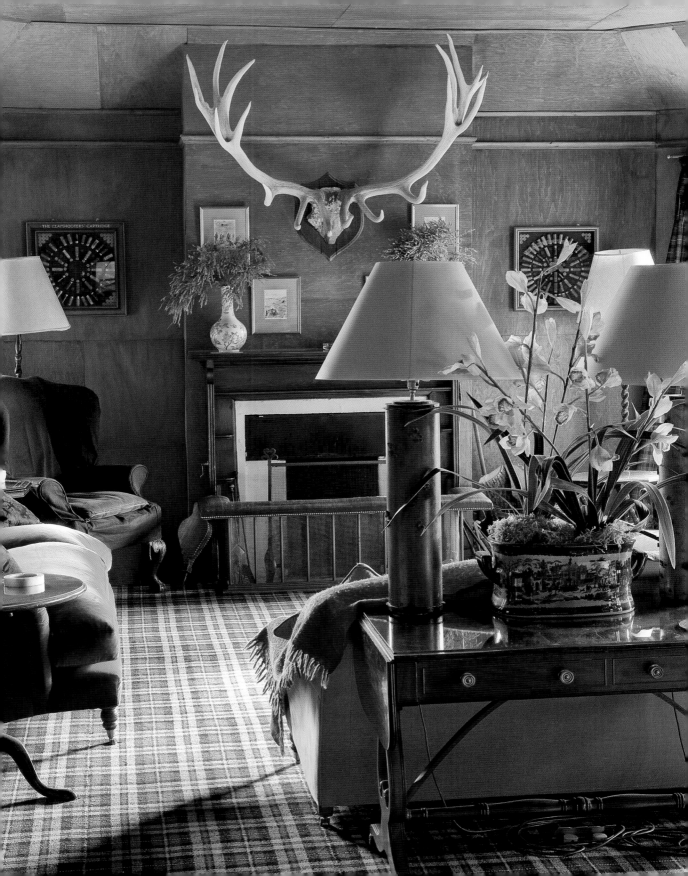

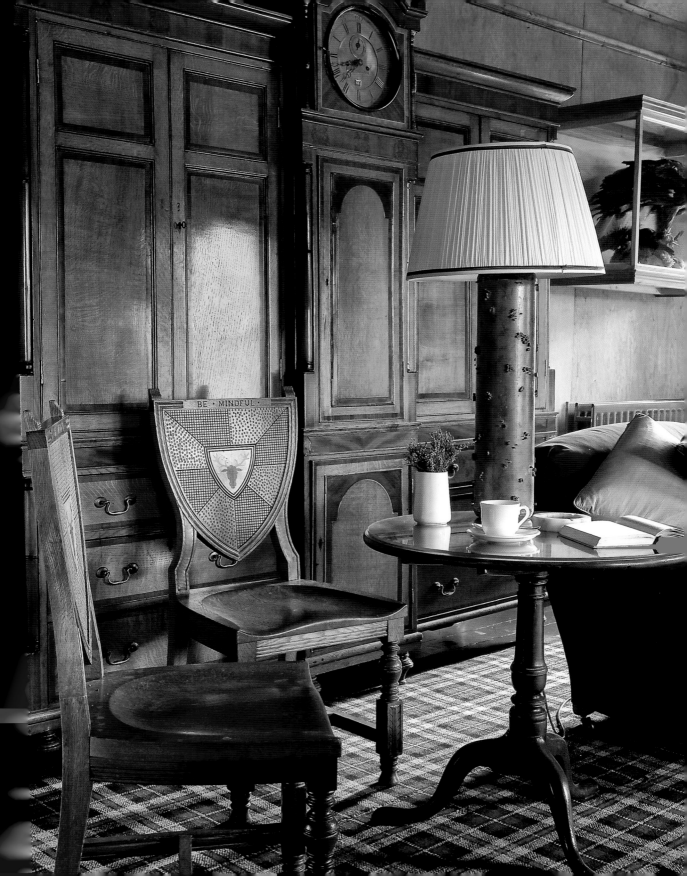

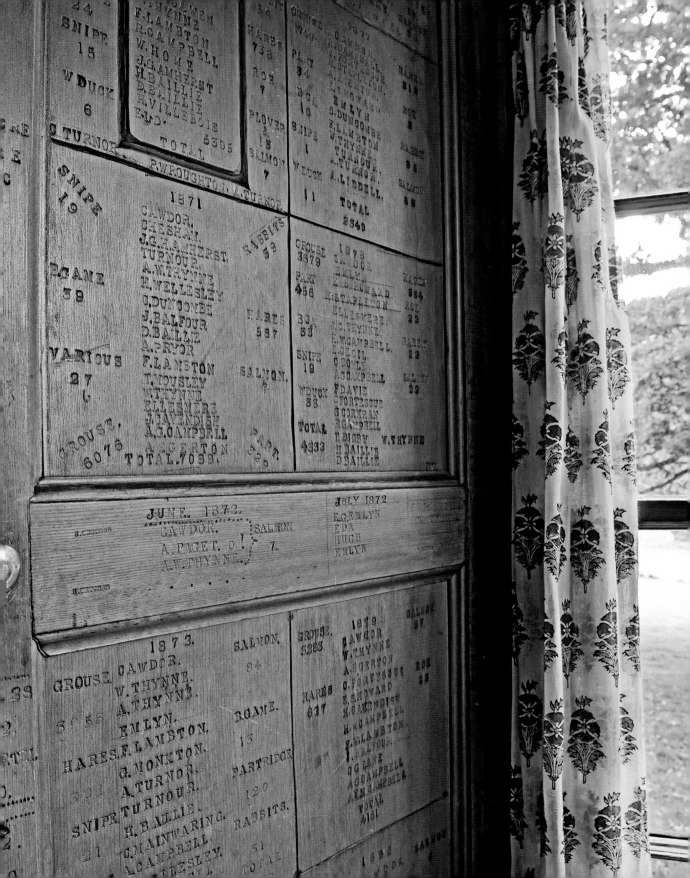

"The bag, always spectacular, easily runs to a hundred and fifty birds, and sometimes up to four hundred!" says Angelika. Part of the spoils is reserved for the castle table; in a typical season, the castle's entitlement generally amounts to 120 partridge, 70 hen pheasant, 36 grouse, 36 duck, and 40 hare from the surrounding moors. Added to this is the "big game"—around thirty deer, the choicest cuts of which furnish the chatelaine's table all year round—and the rest for the castle dogs.

"The real joy of shooting is the dogs," says Angelika, who takes the utmost care of her two Border terriers, Kim and Bessie, even cleaning their teeth every night. They follow her everywhere, and obey her commands to the last syllable. "The Cawdors have always been mad about dogs. In recent generations, the dogs have always been Labradors, Border terriers, and Jack Russells. Hugh had a black cocker spaniel named Bracken, who quite literally chose him as her master during a pheasant shoot at David Hicks's house in Gloucestershire."

Angelika's love of animals is everywhere apparent—from the red squirrels in the Wild Garden (her friend Prince Charles is a supporter of the

campaign to protect them from the invasion of their gray North American counterparts)—to the birds for whom she scatters crumbs and crushed peanuts several times a day on the parapet of the ancient Drawbridge. Another ritual among many, punctuating and shaping the life of this great house.

But the most sacred rite of all is of course the serving of afternoon tea—all the more welcome here,

in the gathering gloom of the early winter dusk. Guests choose from green tea from Mariage Frères, Earl Grey, Lapsang Souchong, Assam, or Fortnum and Mason's Royal Blend, served with bacon and tomato sandwiches, followed by scones topped with whipped cream, homemade jams, and heather honey. Best of all are the crumpets, crisp on the outside, melting within, served with a knob of *beurre aux crevettes*,

The curved line of the salmon's jaw indicates its age: it was caught (and immediately released) in the River Findhorn, on the last day of the season, as it swam upstream to spawn (facing page). A fishing boat is available to rent, extending over several miles. Fly-fishing devotees can break the surface of the still waters to their heart's content—provided they take only two salmon from the well-stocked river (above and pages 180–81).

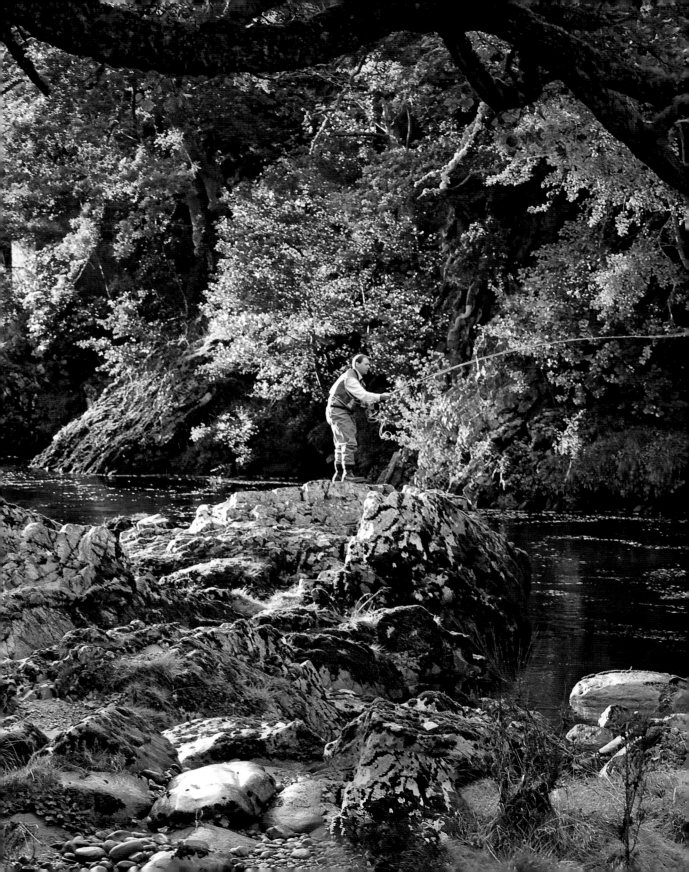

a delicious relish of fresh butter infused with prawn bisque. Not forgetting Cawdor's famous salmon sandwiches, a classic at every picnic, tea, and snack.

The salmon eaten at Lady Angelika's table is always wild, and always caught on the stretch of the Findhorn River flowing through the estate. Today, the Banchor Beat, or Laird's Beat (as it is known), can be booked by accomplished amateur anglers, including payment of "dues" in kind: twenty of the finest specimens caught. The splendor of the setting, the purity of the water, and the quality of its fish make this a dream destination for any fisherman. And the Highland salmon, like Highland whisky, draws bons vivants to Scotland from all over the world.

The Highlands are truly the birthplace of whisky, possessing the ideal combination of ingredients from which to distill the very finest nectars: abundant streams of the purest water, rich fields of barley, forests, and natural springs. A great whisky demands more than water, yeast, and malt; refined, ancestral skill is required, from malting to distillation in spectacular copper stills, before the coveted Scotch Whisky appellation can be granted.

Inland, some distance away from the peat bogs and the high moors of Cawdor, the cold, pure waters of the Pitillie Burn feed exclusive, long-established distilleries like Aberfeldy, founded by John Dewar in 1898, and still producing single malts and blends alike. The former is the product of a single distillation; the second is achieved through a blend of malt and grain whiskies, orchestrated by that magician of fine Scotch, the master blender. Tastings at Cawdor, using a special tasting cup, are an opportunity for fulsome appreciation of the sublimated notes of heather honey, incense, and toast, captured in the amber spirit.

A roulade of salmon tartare, and roast onion soup are among the classic dishes regularly served at Cawdor (left). Meals are invariably taken in the discreet luxury of the castle dining room (pages 184–85).

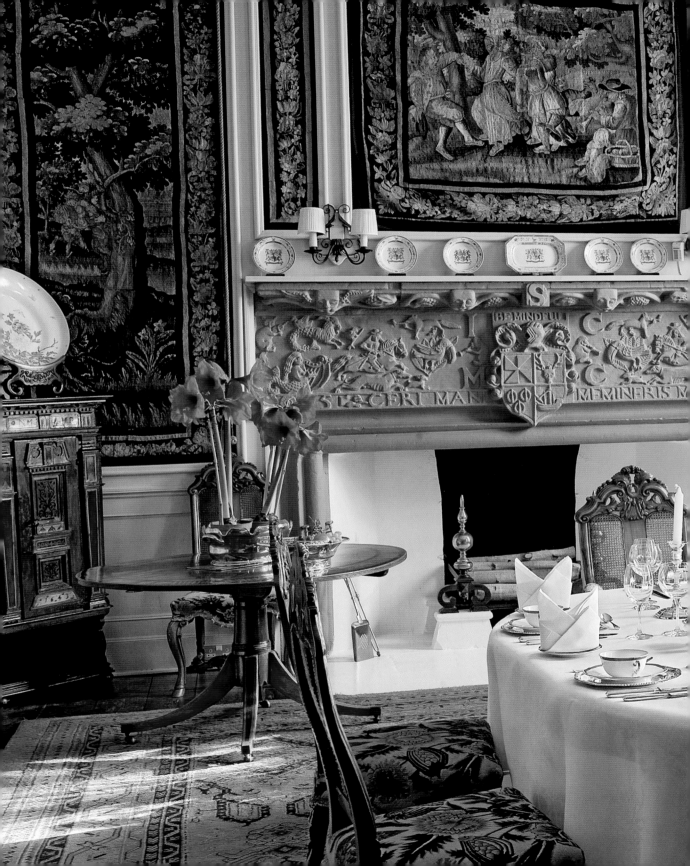

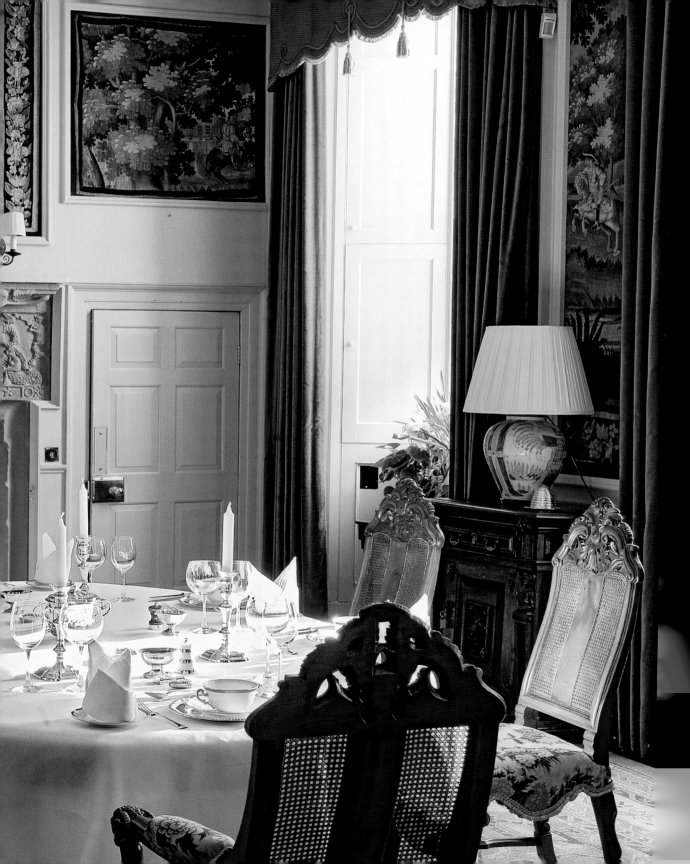

Indeed, a glass of fine Scotch could be said to contain the distilled essence of the Highlands: the crystal waters gurgling over mossy, ocher rocks; the russet bracken laden with dew in the pale, mauve light of dawn on the moors; the thick fleece of the curly-horned sheep, the impeccably turned-out shots, resplendent in their tartan neckties, leading immaculate dogs over the moors; the deep, mysterious lochs; secret, winding glens; and ancient peat bogs, capable of suspending the action of time itself.

Cawdor, with its vast history and many treasures, speaks the same language, conjures the same emotions; the estate and castle capture the spirit of the soil—the beating heart of Scotland.

Haggis, the traditional dish of the Highlands, is served with mashed potatoes (tatties) and turnips (neeps in Scots). It should be liberally basted with whisky (facing page). Cawdor's head chef, Martin Nelson, has presided over the castle kitchens for twenty-seven years. His rhubarb crumble is legendary (right). Page 188: Detail of the dining room, capable of seating up to twenty-two guests. Guests at the castle always dress for dinner. Men wear dinner jackets or velvet blazers during the hunting season and Hogmanay (the Scottish New Year celebrations). Cranachan is a traditional Scottish dessert of whipped cream and toasted oatmeal—delicious with a glass of dry Rieu (page 189).

RECIPES

The Recipes of Cawdor Castle.

"Scotland has some of the world's best ingredients and I am lucky enough to live virtually off our own land, supplemented by the surrounding organic farms." Angelika Cawdor

For all recipes I season the dishes with Maldon sea salt and Special Blend pepper from Hédiard.

◈ OATMEAL IN SCOTLAND

Oatmeal has a long history in Scottish culinary traditions because oats are better suited than wheat to the short growing season.
An annual grass cultivated since 2000 BC, oatmeal is still a mainstay of the Scottish diet.
The English lexicographer Samuel Johnson famously wrote in his Dictionary of the English Language *that the oat was "a grain, which in England is generally given to horses, but in Scotland appears to support the people," to which the Scottish riposte is "and England has the finest horses, but Scotland the finest men."*

OATCAKES MADE WITH ORGANIC ROLLED OATS
• 1 ¼ cups (100 g) organic rolled oats
• ²/₃ cup (50 g) organic pinhead oatmeal
• ¼ tbsp salt
• Pinch baking soda
• 1 tbsp (15 g) melted goose fat
• Warm water

Put all ingredients in a bowl, add salt and fat and rub in by adding water. Don't make it too dry. Roll out between two sheets of plastic wrap to the desired thickness, then cut into shapes and bake on the griddle or in the oven at 360°F (180°C) for 25 minutes.

OATMEAL PANCAKES AND CRISPY BACON
• 1 ½ cups (125 g) organic oats
• ½ cup (110 ml) skim milk
• 1 egg
• ½ tbsp parsley
• 1 tbsp coriander
• 4 tbsp unsalted butter
• 3 tbsp chopped shallots
• 3 tbsp chopped onion
• Organic back bacon (3 thin-cut rashers per person)

Bring the milk to a boil and pour it over the oats. Allow to rest for 10 minutes. Sir in the egg, parsley, coriander, salt, and pepper. Melt 2 tablespoons of the butter in a small sauté pan over a medium heat. Add the shallots and onion and cook until translucent. Add to the oatmeal batter. Melt the remaining 2 tablespoons of butter in a skillet. When hot, add the batter, 1 tablespoon per pancake. Cook until golden brown on both sides, about 30 seconds per side. Grill in a pan with a bacon press so that the bacon becomes nice and crisp and straight. Serve with the oatmeal pancakes.

◈ SALMON
Our salmon is caught in the River Findhorn. My fishing hole is called Banchor and, next to the river, a charming cottage that sleeps six is available for weekly renting (see address book). Wild salmon is so wonderful that I much prefer to eat it raw rather than cooking it.

WILD SALMON TARTARE WITH OATCAKES
• 1 fresh wild salmon fillet
• 1 tbsp mayonnaise
• A dash of lemon juice
• 1 tsp mustard
• Olive oil
• Small quantity of chopped gherkins
• Handful of snipped chives

Remove the bones from the salmon with a pair of tweezers. Cut into thin slices and then chop it with a large, sharp knife. Put the chopped salmon into a bowl and add just enough mayonnaise to give it the texture of a steak tartare. Add the lemon juice, mustard, olive oil, gherkins, and chives. Serve with the oatcakes.

Elderflower sorbet, made to a handwritten recipe from the 6th Earl Cawdor.
Page 190: Wild berries and orchard fruits—some of the ingredients for Hedgerow Jelly (see recipe).

CRANACHAN
- ²/₃ cup (60 g) coarse organic oatmeal
- 1 ¼ cup (300 ml) whipping cream
- 2 tbsp (25 g) superfine sugar or Scottish honey
- Malt whisky
- 8 oz (240 g) raspberries

Toast some oatmeal lightly in the oven, or in a thick-bottomed frying pan over a gentle heat. This gives it a pleasant, somewhat nutty flavor. Whip a bowlful of cream and stir in a handful or two of the toasted oatmeal, ensuring that it's not too oaty: the cream must predominate. Sweeten to taste and flavor with a shot of good Scotch whisky, preferably malt.
Throw in a few handfuls of fresh raspberries and you have an excellent dessert.

🦌 GAME
I am fortunate enough to have a lot of game: roe deer, blue mountain hare, grouse, partridge, and pheasant. I am suggesting just two recipes, which are not traditional, for partridge and pheasant.

CAWDOR PARTRIDGE BREASTS
- 4 partridge breasts
- 3 cups (175 g) fresh white breadcrumbs
- 1 ½ tbsp (10 g) Parmesan
- 2 eggs, beaten with salt and pepper
- Flour
- Olive oil (not extra-virgin) for frying

Place the breasts between two sheets of plastic wrap and flatten with a rolling pin.

In a wide, shallow bowl, mix the breadcrumbs and Parmesan. Put the seasoned eggs into another bowl. Heat around ½ inch (1 cm) deep of olive oil in a frying pan. Dip the breasts first in the flour, then in the egg mix and finally press them well in the cheese and breadcrumbs before frying in the hot oil. Cook for about 3 minutes each side, until deep golden brown and crunchy outside.

PHEASANT CURRY
- 1 pheasant, cut into 2-inch (5-cm) cubes
- 6 tbsp extra virgin olive oil
- Sea salt and freshly ground pepper
- 4 medium onions, thinly sliced
- 2 oz (60 g) piece of fresh ginger, finely chopped
- 4 large garlic cloves, finely chopped
- 1 tbsp cumin seed, freshly ground
- 2 tbsp coriander seed, freshly ground
- 1 tbsp ground turmeric
- 1 tsp ground cayenne pepper
- 1 cup (250 ml) whole-milk yogurt
- 1 firm apple, such as Granny Smith, peeled and grated
- 1 cup (250 ml) hot water

Heat half the oil in a casserole then brown the pheasant in batches, until nicely brown on all sides. Transfer to a platter and immediately season generously with salt and pepper. In the same dish, heat the remaining 3 tbsp oil, add onions and stir well. Cook over a moderate heat until the onions are soft and golden, about 15 minutes. Add the ginger and garlic, cook for a further minute, then add the cumin, coriander, turmeric, and cayenne and cook until the spices are fragrant, about 15 seconds.
Return the pheasant and juices to the dish along with the yogurt, apple, and hot water. Stir to blend. Cover and simmer gently until the meat is tender, about 25 minutes.

HAGGIS
In the absence of hard facts as to the origins of haggis, popular folklore has provided a range of fanciful theories. One is that the dish originates from the days of the old Scottish cattle drovers. When the men left the Highlands to drive their cattle to market in Edinburgh, the women would prepare rations for them to eat during the long journey down through the glens. They used the ingredients that were most readily available in their homes and conveniently packaged them in a sheep's stomach, allowing for easy transportation during the journey.

Haggis, which is arguably the national dish of the Highlands, can be excellent if made by a haggis champion butcher. I buy mine from Duncan Fraser in Inverness. It is packed and cooked in a sheep's stomach. You wrap it in aluminum foil and steam it over a pan of simmering water for 1 ½ hours. Traditionally you eat it with "tatties and neeps": a light potato (tattie) puree made with olive oil and a puree of "neeps," which outside Scotland are known as turnips. Most important of all is a dousing of whisky. We use Royal Brackla 10-year-old malt or Aberfeldy 15-year-old single malt.

✿ VEGETABLES

Cawdor has two vegetable gardens that have been organic for thirty years. At the castle we have our winter vegetables and at Auchindoune our summer vegetables. I am very keen on trying to conserve old varieties of vegetables and fruit. We are members of a wonderful organization called Henry Doubleday Research Association (www.gardenorganic.org.uk), which gives us seeds of heritage vegetables. These are varieties that are no longer available on the open market for commercial reasons, as well as family heirloom varieties that have never been sold to the public; all are safeguarded in their Heritage Seed Library.

ROAST ONION SOUP
- 4 medium onions
- 4 large garlic cloves
- 4 cups (1 liter) vegetable or chicken stock
- 1 tbsp Thai fish sauce
- Fresh ginger, about the size of a walnut, grated
- 2 small red chillies
- 6 lime leaves, rolled up tightly and shredded (or zest and juice of 1 lime)
- 13.5 fl. oz (400 ml) can coconut milk

Cut the onions, still in their skins, in half vertically. Put on a baking tray and roast in a hot oven 390°F (200°C) for 30 minutes, turning once. Add the unpeeled garlic and continue raosting for 15 minutes, until the onions are golden brown. Remove from the oven and peel the skins off. Put into a deep saucepan, separating the layers as you go. Skin the roasted garlic and add to the pan with the stock, fish sauce, ginger, chillies, and lime leaves. Bring to a boil and simmer for about 20 minutes. Stir in the coconut milk and bring back to a simmer. Blend in batches in a food processor. Serve hot.

SCORZONERA WITH MUSHROOMS
Scorzonera hispanica is a perennial member of the sunflower family, and has been cultivated as a vegetable since the seventeenth century. Its common names include black salsify, Spanish salsify, and viper's grass.

- 4 cups (750 g) Scorzonera, sliced
- Lightly salted partridge or chicken stock
- 8 oz (250 g) mushrooms, sliced
- Unsalted butter
- $^2/_3$ cup (150 ml) heavy cream
- Chopped parsley and chives
- Grated nutmeg
- Lemon juice

Braise the Scorzonera until the liquid is reduced to a syrupy consistency and then grate over the nutmeg. Fry the mushrooms in a little butter. Add to the Scorzonera along with the cream and herbs. Stir gently for a few minutes over medium heat, then season with salt, pepper, and lemon juice.

SALSIFY WITH RED CURRANTS
This ancient root vegetable, Tragopogon porrifolius, is high in vitamin B6, calcium, and magnesium and is therefore good for you. Its common names include salsify, oyster plant, vegetable oyster, and goatsbeard. Salsify ripens after the end of the red currant season, so I usually use my frozen red currants for this recipe.

- 8 oz (200 g) red currants
- 8 salsify (*Tragopogon porrifolius*)
- ½ cup (110 ml) chicken stock
- 1 ¾ oz (50 g) butter
- 2 tbsp sugar
- Salt and pepper

Destem the red currants and put in a small saucepan with 4 tablespoons of water. Bring to a boil, then immediately turn off the heat. Pour through a strainer into a bowl, pressing the currants to extract the juice. Discard the currant residue and set the juice aside. Peel the salsify and trim to an even size. Put in a saucepan of lightly salted water and bring to a boil. Cook for a few minutes then drain. In a casserole, combine the currant juice, chicken stock, half the butter, sugar, and salsify. Cover and cook over a medium heat for 5 minutes then uncover and raise the heat to high. Reduce the liquid, stirring to glaze the salsify. Add the remaining butter, freshly ground pepper, and salt if necessary.

WILD GARLIC RAVIOLI
The Wild Garden at Cawdor has a large amount of wild garlic in early spring, which I use in many recipes; one of my favorites is Wild Garlic Ravioli.

- Portion of homemade egg pasta
- 3 ½ oz (100 g) wild garlic leaves
- 4 oz (110 g) whole-milk ricotta
- 2 oz (60 g) Emmental cheese, grated
- 4 oz (110 g) whole-milk mozzarella, diced

- 1 oz (30 g) + 1 ½ oz (45 g) fresh Parmesan, grated
- 1 tsp salt
- Freshly ground pepper
- ¹/₈ tsp cayenne pepper
- 2 egg yolks
- 1 ¾ oz (50 g) unsalted butter

Blanch the garlic leaves, cool in ice water and squeeze dry. Place the garlic leaves, ricotta, Emmental, mozzarella, and 1 oz (30 g) Parmesan in a food processor and process until combined. Combine with salt, pepper, cayenne, and egg yolks. Place small mounds of the filling, no more than a rounded ½ teaspoon, onto the dough. Make 2 rows of mounds approx 1 in. (2.5 cm) apart, leaving ½ in. (1 cm) of pasta around the edges. Cover with the second strip and press firmly to seal the edges. Cut with pastry wheel and place on a lightly floured surface. Bring a large saucepan of water to the boil and add salt. Drop in the ravioli and cook for 3–4 minutes. Drain the ravioli and toss in butter. Serve with the remaining 1 ½ oz (45 g) Parmesan.

BLACK CURRANT LEAF SORBET
- Large handful of black currant leaves
- 1 ¼ cups (225 g) sugar
- 1 pint (475 ml) water
- Juice of ½ a lemon

Place the sugar and water in a large saucepan and bring to a boil to make a syrup. Add the black currant leaves. Remove from the heat, cover and allow to cool for 2 to 3 hours. Strain the liquid and add the lemon juice. Freeze in a ice cream maker.

ROAST RHUBARB AND APPLE CRUMBLE WITH CRÈME ANGLAISE
This is best made with tender young pink rhubarb, before the leaves become too large.

- 1 lb (500 g) rhubarb
- 1 large Braeburn apple
- ½ cup (100 g) vanilla sugar
- ½ cup (100 g) all-purpose flour
- 1 ¾ oz (50 g) butter, chilled and cut into small cubes
- ¼ cup (50 g) light muscovado sugar, or brown sugar
- Freshly ground nutmeg
- ½ cup (40 g) organic rolled oats

- 4 cups (1 liter) milk
- 1 vanilla pod, split
- 1 ¹/₃ cups (250 g) superfine sugar
- 10 egg yolks

Trim the ends of the rhubarb and cut into 2-inch (5 cm) chunks. Peel, quarter, and core the apple then cut into 1-inch (2 cm) chunks. Heat a heavy based sauté pan until very hot. Toss the rhubarb and apple in the vanilla sugar, then place in the saucepan in a single layer. Leave for a couple of minutes, then carefully turn once. Continue cooking for a further 3–5 minutes until just tender, remove from the heat and leave to cool.
For the topping, place the flour and butter in a food processor and grind briefly until they resemble fine breadcrumbs. Add the muscovado sugar and process again for a few more seconds. Grate the nutmeg into the mixture, add the oats, and blend again briefly.
Scatter the topping over the fruit; there's no need to press down. Bake in the oven at 375°F (190°C)

for 20 minutes until nicely browned. Leave to stand for 10 minutes. Meanwhile, make the crème anglaise. Bring the milk to boil in a saucepan with the split vanilla pod and ½ cup (100 g) of the sugar. Remove from heat and leave to infuse for 5 minutes.
Place egg yolks into a large bowl, add the remaining sugar and whisk for several minutes until pale and creamy. Pour in the milk in a thin stream, whisking briskly all the time. Return this mixture to the pan and heat gently, stirring continuously. Remove from heat at first sign of simmering. Strain if necessary. Serve with the roast rhubarb and apple crumble.

HOMEMADE GINGER ALE
- 1 lb (500 g) fresh ginger, unpeeled, cut into small cubes
- 2 stalks lemongrass, trimmed and roughly chopped
- 2 small fresh chillies, stems removed
- 2 cups (375 g) sugar
- 5 cups (1.25) litres water
- Soda water
- Lime juice

Place the ginger, lemongrass, and chillies in a food processor and blend until minced. Place the puree in a saucepan with the sugar and water. Bring to the boil over a high heat then reduce heat and simmer for about 15 minutes. Leave to cool then strain and chill.
Put ice in a jug, add the syrup, and then add soda water to taste.
Add a little lime juice if you like.

HEDGEROW JELLY

One of the joys of autumn is Pam Rodway's Hedgerow Jelly. So as not to have to scour the countryside for the ingredients, I have now planted a circular hedge with blackberries, rosehip, hawthorn, rowan, and sloe in the arboretum, where there are also crab apples and elderberries.

- 1 lb (400 g) crab apples
- 1 lb (400 g) blackberries
- 1 lb (400 g) elderberries
- 8 oz (200 g) rosehips
- 8 oz (200 g) hawthorn berries
- 8 oz (200 g) rowan berries
- 8 oz (200 g) sloe berries

- 5 ¼ cups (1 kg) sugar per 2 pints (1 liter) fruit juice

Remove the stalks and wash the fruit. Place the fruit in a saucepan and pour in water to come about halfway up the fruit.
Simmer until the fruit is soft, and then remove from heat and strain.
Add the sugar to the fruit juice and boil until set.

CAWDOR ELDERFLOWER CORDIAL

This is my husband Hugh's recipe.

- 100 elder flowers; whole umbels; best picked when flowers are about to drop
- 8 oz of citric acid
- 8 lbs of sugar
- 8 lemons & 2 oranges, sliced thickly
- small pinch of nutmeg, & a large pinch of salt
- 10 pints of boiling water

Nick a bloody great pan from the old Kitchen.
Make syrup with sugar & water. Cool.
Fling in all the other ingredients, raw.
Leave for two days, stirring now & then. Keep out spiders.
Strain, finely; bottle; seal with sellotape or wax.
Return bloody great pan to old Kitchen.
Makes about a dozen bottles.

Pages 198–99: The shifting sands of the sweeping beach at Nairn on the Moray Firth describe graceful, geometric patterns. Bathers unafraid of the icy water can swim alongside seals and bottle-nosed dolphins.

ADDRESS BOOK

"The Best Addresses in the Highlands."
Angelika Cawdor

❧ CAWDOR CASTLE

CAWDOR CASTLE
Nairn, IV12 5RD
Tel. +44 (0) 1667 404401
info@cawdorcastle.com
www.cawdorcastle.com
Open 10 a.m.–5:30 p.m.
May 1 to the second Sunday
in October
After visiting the castle
(drawing room, sitting room,
tapestry room, bedrooms, dining
room, etc.), you can explore three
splendid gardens (Walled Garden,
Flower Garden, and Wild Garden)
and stroll through the Big Wood,
where you can find a unique array
of lichens (more than 131 varieties).
The magnificent Tibetan garden at
Aunchindoune features a collection
of rare plants. The castle's restaurant
caters to visitors.

❧ OTHER PLACES TO VISIT

CULLODEN BATTLEFIELD
Six miles (9.6 km) from Cawdor.
The Battle of Culloden (April 16,
1746) was the final clash in the
1745–46 Jacobite rising between
the French-supported Jacobites
and the Hanoverian British
government. The battle that changed
the Highland way of life forever
and for which the English have still
not been entirely forgiven.
Open 10 a.m.–4 p.m. (Nov–Mar)
9 a.m.–6 p.m. (Apr–Oct)
Culloden Moor, Inverness, IV2 5EU
Tel. +44 (0) 1463 790607
www.nts.org.uk/culloden/
Culloden@nts.org.uk

CLAVA CAIRNS
Three prehistoric burial cairns
and standing stones dating back
to 2000 BC, situated just 1 mile
(1.6 km) southeast of Culloden
Battlefield and 5 miles (8 km) from
Cawdor Castle. Admission is free.
Culloden Moor, Inverness
www.historic-scotland.gov.uk

FORT GEORGE
Created against further Jacobite
unrest and as a direct result of the
Battle of Culloden, this glorious
eighteenth-century fortress was
built by the Adam Brothers.
Open 9:30 a.m.–4:30 p.m. (Oct–Mar)
9:30 a.m.–5:30 p.m. (Apr–Sept)
Ardersier, near Inverness IV2 7TE
Tel.: +44 (0)1667 462777

BRODIE CASTLE
Ancient seat of the Thanes of Brodie,
this sixteenth-century tower house
now belongs to the National Trust.
Open 10:30 a.m.–5 p.m. (Apr–Oct)
Near Forres, Moray, IV36 2TE
Tel. +44 (0) 844 4932156
www.nts.org.uk/Property/69/
brodiecastle@nts.org.uk

BALLINDALLOCH CASTLE
The beautiful sixteenth-century
home of the Macpherson Grant
family, lived in by the Lady Laird
of Ballindalloch, Lady Clare Russell
and her family.
Open 10:30 a.m.–5 p.m. (Apr–Sept)
Near Aberlour, Banffshire, AB37
9AX
Tel. +44 (0) 1807 500205
www.ballindallochcastle.co.uk
enquiries@ballindallochcastle.co.uk

EDEN COURT THEATRE
The largest art and entertainment
venue serving the Highlands.
Bishops Road, Inverness, IV3 5SA
Tel. +44 (0) 1463 234234
www.eden-court.co.uk

PLUSCARDEN ABBEY
The only medieval monastery in
Britain still inhabited by monks
and being used for its original
purpose. On sale in the abbey shop
is the best Highland heather honey.
Located 6 miles (9.6 km) west
of Elgin just off the B9010.
Sunday Mass is at 10 a.m.
Elgin, Morayshire, IV30 8UA
Tel. +44 (0) 1343890257
www.pluscardenabbey.org

Page 200: Plates and mugs copied from the castle's eighteenth-century *famille rose* Chinese porcelain service, on sale in one of Cawdor's three shops.

❧ BEST HOTELS

ROCPOOL RESERVE HOTEL
The first boutique hotel in the
Highlands.
Culduthel Road, Inverness, IV2 4AG
Tel. +44 (0) 1463 240089
www.rocpool.com
info@rocpool.com

CULLODEN HOUSE HOTEL
Traditional eighteenth-century
country house.
Culloden, Inverness, IV2 7BZ
Tel. +44 (0) 1463 790461
www.cullodenhouse.co.uk
info@cullodenhouse.co.uk

BUNCHREW HOUSE HOTEL
Beautifully located on the shores
of the Moray Firth.
by Beauly, Inverness, IV3 8TA
Tel.: +44 (0)1463 234917
www.bunchrew-inverness.co.uk

GOLF VIEW HOTEL
Situated in Nairn, our local seaside
resort.
63 Seabank Road, Nairn, IV12 4HD
Tel. +44 (0) 1667 452301
www.crerarhotels.com
golfview@crerarhotels.com

BOATH HOUSE HOTEL
Grade A-listed Georgian mansion
set in beautiful grounds.
Auldearn, Nairn, IV12 5TE
Tel. +44 (0) 1667 454896
www.boath-house.com
info@boath-house.com

❧ GOOD SELF-CATERING

CASTLE STUART
Seventeenth-century tower house
available for up to sixteen guests.
Castle Stuart, Petty Parish,
Inverness, IV2 7JH
Tel. +44 (0) 1463 790745
www.castlestuart.com

GEDDES HOUSE
Georgian mansion set in 1,000 acres
for up to seventeen guests.
Nairn, IV12 5QX
Tel.: +44 (0)1667 452241
Elizabeth@geddesonline.co.uk

BANCHOR COTTAGE
Traditional cottage overlooking
the Findhorn Valley, sleeps six.
Cawdor Castle, Cawdor, Nairn,
IV12 5RD
Tel. +44 (0) 1667 404401
www.cawdorcastle.com
info@cawdorcastle.com

CAWDOR ESTATE
Various cottages around the
Cawdor Estate.
Cawdor Estate Office, Cawdor,
Nairn IV12 5RE
Tel. +44 (0) 1667 4044666
www.cawdor.com
bookings@cawdor.com

❧ GOOD BED
AND BREAKFAST

KILRAVOCK CASTLE
The castle next door.
Kilravock Castle, Croy, Inverness,
IV2 7PJ
Tel. +44 (0) 1667 493258
www.kilravockcastle.com
info@kilravockcastle.com

GREENLAWNS
Victorian house with easy access to
Nairn beach and town center.
13 Seafield Street, Nairn, IV12 4HG
Tel. +44 (0) 1667 452738
www.greenlawns.uk.com
greenlawns@cali.co.uk

SUNNYBRAE
Small family-run hotel with
panoramic sea views.
Marine Road, Nairn, IV12 4ES
Tel. +44 (0) 1667 452309
www.sunnybraehotel.com
reservations@sunnybraehotel.com

❧ BEST RESTAURANTS

**ROCPOOL RESERVE, CHEZ ROUX
RESTAURANT**
New restaurant run by Albert Roux.
Culduthel Road, Inverness, IV2 4AG
Tel. +44 (0) 1463 240089
www.rocpool.com
info@rocpool.com

GLEN MORISTON HOTEL,
ABSTRACT RESTAURANT
20 Ness Bank, Inverness, IV2 4SF
Tel. +44 (0) 1463 223777
www.contrastbrasserie.co.uk
reception@glenmoristontownhouse.com

In Nairn/Auldearn:
BOATH HOUSE
1 Michelin star and 4 AA Rosettes
Auldearn, Nairn, IV12 5TE
Tel. +44 (0) 1667 454896
www.boath-house.com
info@boath-house.com

GOLF VIEW HOTEL
Recently awarded 1 AA Rosette
Seabank Road, Nairn, IV12 4HD
Tel. +44 (0) 1667 452301
www.crerarhotels.com
golfview@crerarhotels.com

THE CLASSROOM
Cawdor Street 1, Nairn IV12 4QD
Tel.: +44 (0)1667 455999

In Cawdor:
CAWDOR TAVERN
A charming traditional pub.
Cawdor, Nairn, IV12 5XP
Tel.: +44 (0)1667 404777

CAWDOR CASTLE RESTAURANT
Good Scottish food and delicious
home baking.
Cawdor, Nairn, IV12 5RD
Tel. +44 (0) 1667 404401
www.cawdorcastle.com
info@cawdorcastle.com

🍂 SHOPPING

Best Cashmeres

JOHNSTONS
Newmill, Elgin,
Morayshire, IV30 4AF
Tel. +44 (0) 1343 554000
www.johnstonscashmere.com

CAWDOR CASTLE WOOL SHOP
Cawdor, Nairn, IV12 5RD
Tel. +44 (0) 1667 404401
www.cawdorcastle.com
info@cawdorcastle.com

Best Tweeds

CAMPBELL & CO.,
THE HIGHLAND TWEED HOUSE
Beauly, IV4 7BU
Tel. +44 (0) 1463 782239
www.campbellsofbeauly.co.uk
enquiries@campbellsofbeauly.co.uk

Best Antiques

AULDEARN ANTIQUES
Lethen Road, Auldearn, Nairn
Tel.: +44 (0)1667 453087

IAIN MARR ANTIQUES
Beauly by Inverness
Tel. +44 (0) 1463 782372
www.iain-marr-antiques.com
info@iain-marr-antiques.com

Art Galleries

LOGIE STEADING
Forres, Moray, IV36 2QN
Tel. +44 (0) 1309 611378

www.logie.co.uk
panny@logie.co.uk

KILMORACK GALLERY
by Beauly, Inverness-shire, IV4 7AL
Tel. +44 (0) 1463 783230
www.kilmorackgallery.co.uk
art@kilmorackgallery.co.uk

Best Chocolate

THE SWEET NUT TRADER
21 High Street, Avoch, IV9 8PT
Tel. +44 (0) 1381 620840
sweetnut@btopenworld.com

COCOA MOUNTAIN
8 Balnakeil, Durness, Lairg,
Sutherland, IV27 4PT
Tel. +44 (0) 1971 511233
info@cocoamountain.co.uk

Best Organic Cheese and Eggs

WESTER LAURANCETON FARM
Forres, IV36 2RH
Tel.: +44 (0)1309 676566

Best Organic Vegetables

MACLEOD ORGANICS
Kylerona Farm, 8 Hillhead,
Ardersier, IV2 7QZ
Tel. +44 (0) 1667 462555
macleod.organics@virgin.net

Best Organic Shop

PHOENIX COMMUNITY STORE
The Park, Findhorn, IV36 3TZ
www.phoenixshop.co.uk

Hebridean wool—much prized for knitting—is collected annually from the Saint Kilda sheep grazing peacefully
in front of the castle (available online or from the castle's Wool Shop).

ADDRESS BOOK

Best Garden Centers

POYNTZFIELD HERB NURSERY
Black Isle, IV7 8LX
Tel. +44 (0) 1381 610352
www.poyntzfieldherbs.co.uk
info@poyntzfieldherbs.co.uk

SPEYSIDE HEATHER GARDEN
Dulnain Bridge, Inverness-shire,
PH26 3PA
Tel. +44 (0) 1479 851359
www.heathercentre.com
enquiries@heathercentre.com

Best Fishing

BANCHOR
Cawdor Castle, Nairn, IV12 5RD
Tel. +44 (0) 1667 404401
www.cawdorcastle.com
info@cawdorcastle.com

DRYNACHAN
Cawdor Estate, Nairn, IV12 5RE
Tel. +44 (0) 1667 404666
www.cawdor.com
bookings@cawdor.com

LETHEN, ESTATE OFFICE
Lethen, Nairn, IV12 5PR
Tel. +44 (0) 1667 452247
www.lethenestate.co.uk
lethenestate@btconnect.com

Best Shooting

CAWDOR ESTATE
Cawdor, Nairn, IV12 5RD
Tel. +44 (0) 1667 404666
www.cawdorcastle.com
info@cawdorcastle.com

Best Riding

LOGIE FARM RIDING CENTRE
Glenferness, Nairn, IV12 5XA
Tel. +44 (0) 1309 651226
www.angelfire.com/fm/logiefarm
logie@onetel.com

Best Golf

THE NAIRN GOLF CLUB
Championship course
Seabank Road, Nairn, IV12 4HB
Tel. +44 (0) 1667 453208
www.nairngolfclub.co.uk
bookings@nairngolfclub.co.uk

CASTLE STUART GOLF LINKS
New links course
Balnaglack Farmhouse, Inverness,
IV2 7JL
Tel. +44 (0) 1463 795440
www.castlestuartgolf.com
bookings@castlestuartgolf.com

CAWDOR CASTLE
Delightful nine-hole course
Cawdor, Nairn, IV12 5RD
Tel. +44 (0) 1667 404401
www.cawdorcastle.com
info@cawdorcastle.com

Best Distilleries

ABERFELDY DISTILLERY
Aberfeldy, Perthshire, PH35 2EB
www.dewarswow.com
Tel.: +44 (0)1887 822010

DALLAS DHU DISTILLERY
Forres Morayshire, IV36 2RR
www.historic-scotland.gov.uk
Tel.: +44 (0)1309 676548

A rhododendron flower.

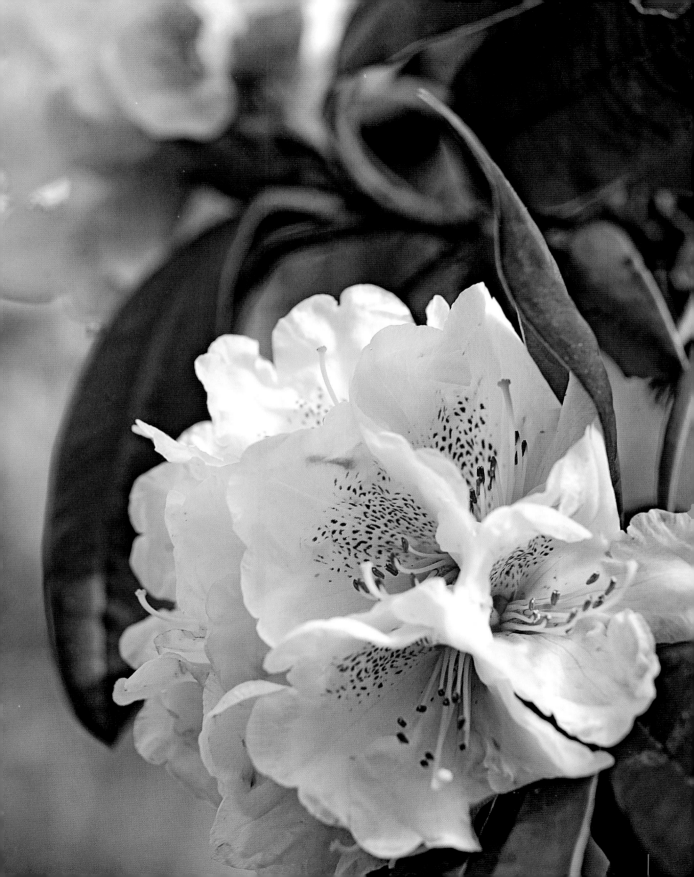

ACKNOWLEDGMENTS

The Editor would like to thank the authors, Stéphane Bern
and Franck Ferrand for trusting us, Angelika Cawdor for her welcome
and precious collaboration, Carine Ruault for overseeing
the reproduction of the images with such talent,
Isabelle Ducat who—with patience and imagination—
placed Guillaume de Laubier's remarkable photographs
onto the page, and Valérie Vidal who coordinated it;
without forgetting Kate Mascaro, Editor of the English language edition,
and Sophie Wise, who coordinated it.

Translated from the French by Louise Lalaurie Rogers
Design: Isabelle Ducat
Copyediting: Penelope Isaac
Typesetting: Anne-Lou Bissières
Proofreading: Chrisoula Petridis
Color Separation: IGS, Angoulême, France
Printed in Slovenia by Korotan

Distributed in North America by Rizzoli International Publications, Inc.

Simultaneously published in French as *Au cœur de l'Écosse*
© Flammarion, S.A., Paris, 2009

English-language edition
© Flammarion, S.A., Paris, 2010

10 11 12 3 2 1

ISBN: 978-2-08-030133-8

Dépôt légal: 02/2010